ICONS
AND THE MYSTICAL ORIGINS OF CHRISTIANITY

Richard Temple founded the Temple Gallery in London thirty years ago as a centre for the study, restoration, exhibition and collection of icons. He has published a series of books, catalogues and articles on the subject and also lectures widely. *Icons and the Mystical Origins of Christianity* represents the culmination of a lifelong interest in Christian mysticism.

ICONS

AND THE MYSTICAL ORIGINS OF CHRISTIANITY

RICHARD TEMPLE

ELEMENT BOOKS

For all seekers

© Richard Temple 1990

First published in Great Britain in 1990 by
Element Books Limited
Longmead, Shaftesbury, Dorset

Cover illustration courtesy of the Temple Gallery
Cover design by Humphrey Stone
Designed by Roger Lightfoot

Typeset by Selectmove Ltd, London.
Printed and bound in Great Britain
by Dotesios Printers Ltd, Trowbridge

British Library Cataloguing in Publication Data
Temple, Richard
Icons and the origins of Christianity.
1. Icons, history
I. Title
704.9482

ISBN 1–85230–195–3 pbk

Contents

Foreword

by Jacob Needleman

SACRED art may be defined as art that evokes and supports an inner movement towards contact with a greater reality. But it cannot do this automatically; it requires that we bring something of ourselves to it. We need to know how to look, failing which its action upon us will be distorted or blocked by our own subjective associations. The achievement of this present book lies in the help it offers Western people to look at the form of sacred art known as icons. It provides a lucid outline of many of the mystical or esoteric ideas that lie close to the heart of the Christian tradition. These ideas challenge us to think in a new way, not only about Christianity, but about life itself. And to think in a new way is the first step towards that unique event of the human psyche called seeing. Neither ideas nor images alone can cause us to see, but they can orient our intention and guide us towards the act of opening to the universal mystery that has neither name nor form.

Sacred art exists within the context of a tradition, which is to say that it communicates fully only to the man or woman who undergoes the range of experiences that are made available in the conditions of life created by the tradition. This is nowhere more true than in the case of the icons of Orthodox Christianity. Therefore, even a book as devotedly and honorably conceived as this one will not enable us to experience icons in the way that is possible for an Orthodox Christian. At the same time, however, all tradition, and therefore all sacred art, also deals with what is universally human. The icon, therefore, cannot but speak to the world – precisely because it speaks so deeply and precisely to the Christian. What Richard Temple has done is to make this extraordinarily pure art form accessible to every Western man or woman who is visited by the question of his own life and death, and who yearns to think and feel more deeply about who he is and why he is on earth. If, during or after the reading of this book, one makes the effort to 'just look' at icons, one may

undergo a fleeting, but extraordinary experience. From trying to see the icon, one may suddenly sense that one is seen by it. For a moment, we are under the regard of a greater presence. The language of religion may speak of this seeing presence as located 'in heaven' – but unmistakably, the call is to receive its action upon us from within. All ideas, all prayer, all ritual and all the compassionate traditions of mankind are meant to guide us again and again towards this experience which alone can bring 'the substance of things hoped for, the evidence of things unseen'.

Jacob Needleman

Preface

THE West, on the whole, has been unsympathetic to mysticism, tending to relegate it to the margins of our culture or attacking it as heresy. Yet the origins of icons are essentially mystical and it is this aspect of the question that I attempt to investigate in this book.

Western thought, developing by intellectual descent from Aristotle, St Thomas and the Scholastics, and the rise of science in seventeenth-century Europe, has created a civilisation of the mind that rejects intuitions and feelings that cannot be verified by sense-perception. But an alternative line, aiming at a civilisation of the whole man: body, soul and spirit, which developed from Plato, the schools of Alexandria and the mystics, has for centuries been an alternative stream, flowing, for the most part, invisibly underground. Perhaps now, as our materialism falters and seems to lead us into darkness, we are ready to seek out once more the kingdom of the spirit.

The study of the potential relevance of icons in contemporary culture has led me to explore areas of ancient history and thought that are generally considered to be obscure. Only in the writings of pre-Christian and very early Christian philosophy, and in the more recent exponents of the so-called 'universal tradition', have I been able to find keys that unlock what otherwise would remain, to me at any rate, incomprehensible. That is why more than half of this book is not about art but about ideas.

For me this has been a lonely but always fascinating voyage of discovery. It is of course a kind of inner journey and only now that it is more or less complete am I able to share some of its adventures.

This book then is a view based on what I personally have been able to find and what, after deep thought and long years of enquiry, I have felt was authentic and convincing.

The reader will see that I have been drawn towards the idea of a common universal truth, the *'Philosophia Perennis'*, which can be

understood as the source in which all religions and philosophies have common roots. Since conventional history and theology do not acknowledge this concept readers may wish to set the ideas I have put forward beside those of an Orthodox point of view. To this end they should read Ouspensky and Lossky's *The Meaning of Icons*.[1]

I hope the reader will accept my use of the conventional terms 'man' and 'he' when referring to humanity in general. No distinction between men and women or of any human classification is intended.

<div align="right">

R.C.C.T

January 1990

</div>

Acknowledgements

I am deeply grateful to my associates at the Temple Gallery and to everyone at Element Books for their help and encouragement in producing this book; also to those kind friends who looked at the manuscript at various stages and made useful suggestions. A special thanks is due to Gillian Bate who has been indefatigable with editorial assistance.

Photo acknowledgements: Covers and figs. 1, 2, 20, 27, 29, 32, 37, 42, Temple Gallery. 5, Trustees of the British Musuem. 6, Eton College. 7, 8, 10, 12, from Weitzmann, *The Monastery of St Catherine at Mount Sinai*. Vol. 1, Princeton, 1976 (photos John Galey). 9, 23, 34, 40, 41, 47, from Lazarev, *Moscow School of Icon Painting*. Moscow 1971. 14 (photo: Held), 15 (photo: Yale University Art Gallery), 16 (Michigan University photo), 17 (photo: Held), 18 (photo: Hassia), 19 (photo: Alinari), 21 (photo: Held), from Grabar, *The Beginnings of Christian Art*, London, 1976. 22, from Alpatov, *Frescoes of the Church of the Assumption at Voltovo Polye*, Moscow 1971. 25, from Saltykov, *The Andrei Rublyov Museum of Early Russian Art*, Leningrad, 1981. 31, from Pelekanidis et al., *The Treasures of Mount Athos*, Vol. 1, Athens 1974. 36, from Lazarev, *Pages from the History of Novgorodian Icon Painting*, Moscow, 1977. 43, from Lazarev, *Novgorodian Icon Painting*, Moscow 1969. 44, 45, from Underwood, *The Kariye Djami*, Vol 2, London 1967. 46, from Kondakov, *The Russian Icon*, Oxford, 1928. 48, from Bishop Dioscouros, *The Coptic Orthodox Monastery of St Antony the Great*, (photo: Mr Nabil Selim Atalla).

Figs. 2, 11, 13, 24, 26, 28, 30, 33, 35, 49–56 are from drawings in pen and ink by Barry Marshall.

Chapter 5, Hesychasm and the Philokalia, was first published in an abridged form in *Parabola: The magazine of myth and tradition*, Summer 1990.

PART I

The Mystical Background to Christianity

1

Spiritual Allegories

THE ideas offered in this book are founded on the understanding that the deepest meaning of the Christian drama lies in a spiritual rather than a historical interpretation and that the ultimate encounter with the mysteries of the gospel is not to be sought in historical time but in the present moment.

Doctrinal theology would give a different emphasis, stressing that Christianity is a 'historical religion' and that the 'faith' of Christians is founded on the 'facts' of the life of Christ. But since the earliest times there was an understanding that the literal events of scripture concealed deeply mysterious, hidden meanings that could reveal spiritual realities of a higher level than can be perceived in the ordinary world. A tradition of interpretation grew up around this understanding that often appears to contradict the literal sense of the gospel. Actually, the meanings are complementary but on different levels.

It is in the light of such an idea that the Russian theologian V. Lossky writes: 'among the variety of meanings that can be noted in the fathers of the first centuries, tradition sometimes receives that of a teaching kept secret, not divulged'. Lossky refers to the writings of Clement of Alexandria in the third century and also to the great Cappadocian bishop in the fourth century, St Basil, who openly acknowledged the idea of a hidden or esoteric meaning when he writes of 'the tradition that the apostles guarded in silence', or when he says of the gospels that 'the faithful did not always know their mysterious meaning'.[1]

The 'mysterious meaning' that St Basil speaks of is intended for

the inner and spiritual part of ourselves and not for our perceptions of the outer world which we make with the physical senses and with the rational mind. Throughout this book the outer world will be considered as only one aspect of reality, namely the external or material aspect, and we shall try to see that another world – no less real – is to be discovered in the domain of our psychology, or inner world. Further, from the spiritual point of view, the reality of outer life will be thought of as *less important* than that of the inner. This does not mean that we should deny outer life – for man is 'dual-natured' and belongs equally both to the inner world and to the outer world – but rather we should seek an even balance between the two.

The inner world, which is uniquely our own, is made up of the material we call our psychological life. It is dispersed among our thoughts, feelings, desires, emotions, dreams, fantasies, imagination, knowledge, memory, and so on. It is an inner universe whose subjective values are often entirely different from those of our outer lives. For example, in the case of memory, time can be stretched or shortened as we wish, and, in the world of our dreams, what we would normally regard as illogical or impossible in outer life happens easily. And many things are permitted in our thoughts which could not happen in what we call the real world.

Our psychology has many levels, varying from what goes on just below the surface through to deeper and deeper levels. Generally we know very little about these deeper parts of ourselves which we call the subconscious. This term is exactly the right one since most of what passes deep down in us takes place below the horizon of our consciousness. In our day science has recognised the importance of these unknown areas of psychology but makes no investigation of them unless we are ill. But, according to some traditional schools of thought, there is a further and infinitely more important aspect of the unknown in ourselves which can be called higher mind or super-consciousness. Modern science does not accept this concept though in medieval theology it was recognised under such terms as 'divine love' or the 'Holy Ghost' and, in the philosophy of antiquity, it was called 'divine energy'. However, even in antiquity, it was understood that such a higher possibility for man could only be reached through a voyage of discovery into the unknown parts of himself which normally are hidden below the threshold of consciousness; hence the Socratic 'Know thyself'.

At the base of all authentic spiritual teachings, including the spiritual sides of Christianity, is the demand that we should know

ourselves: in the darkness of our inner world we need the light of self-knowledge.

An important aspect of mystical Christianity, which it shares with all spiritual traditions, though it is not stressed in the doctrinal teachings, holds that it is only in the inner world, in his spiritual world, that a man can become what he truly is. But ordinary man, even while he continues to function externally, is inwardly asleep. Many injunctions in the gospel and in the Philokalia (a book we shall discuss in a later chapter) call man to 'watch' and to 'wakefulness'. And the gospels use even stronger imagery and speak not only of sleep but of death. The mysticism of Christianity is about our spiritual lifelessness and the possibilities of spiritual awakening and recovery from spiritual death.

It is towards the unknown inner world that all religious and philosophical teachings, in origin, have been directed. This is why many ancient philosophies hold that man's outer life is an illusion or a dream; the Hindu idea seems to be just that: 'end and beginning are dreams, birthless and deathless and changeless remaineth the *spirit* for ever.'[2] Plato, in a well-known analogy, likened our life to that of men living in a cave and mistaking their shadows on the wall for reality.[3]

The spiritual side of religion teaches that two principal factors conspire to prevent man from awakening to his inner life: (1) the bodily senses through which he perceives the world and (2) the faculty of mentation which he mistakes for consciousness. We shall make a more detailed study of these ideas in subsequent chapters, in particular the chapter on the Hesychasts in the monasteries of Mount Athos.

Since remote antiquity there has existed a language that can by-pass the level of ordinary mentation and which can speak directly to the subconscious levels of our being. This was the ancient tradition of parables in the forms of sagas, myths, and fables whose appeal is an enduring one because we unconsciously see and feel in them truths that can reach our innermost being.

The heroes of ancient legends, such as Theseus who entered the labyrinth and fought the Minotaur, or Hercules who cleaned the Augean stables, are archetypal symbols of the drama of spiritual adventure. The Augean stable is the disorder in our psychology; the Minotaur inhabits the dark side of our own being and the labyrinth is our unknown inner world. If we wish to awaken to a higher life we must first follow the example of Orpheus who descended into the underworld, or Christ who descended into Hell. In both cases there was a specific task to be achieved.

Orpheus had to rescue Euridyce, the lost half of himself who had fallen into the clutches of Pluto; Christ had to redeem humanity that had fallen under the power of Satan and Hades. These are not primarily important as historical events but as living realities or, at any rate, possibilities within ourselves.

The imagery of mythology and ancient legends is a psychological language that conveyed, in its allegories, descriptions of man's spiritual difficulties and the tasks he must undertake on his way to redeem himself from darkness and death. However, the psychological power of some ancient images no longer reaches us easily. For example, a description of shepherds and their flocks is today at best poetic; it is too far from our ordinary experience for us to to feel intuitively that it is a symbolic description of our psychological life. When we read in St Luke that there 'were shepherds abiding in the field, keeping watch over their flocks by night' (Luke II, 8) we have in our minds little more than a quaint and picturesque scene.

Yet images of this scene, dating from the almost lost origins of Christian art, traditionally have been passed down through the ages even to our own times and our task will be to search for their deeply hidden mysterious meanings.

An important allegory is contained in Luke's words. And in order to fathom their significance we need to understand that our inner world, that is, the state of our psychological life, is not as well balanced as it could be; our inner life is frequently disordered and chaotic; random thoughts, daydreams and associations, often coloured by lurid emotions, run on unchecked, creating false fears and inhibiting our interaction with life and distorting our relations with our fellow human beings.

This state of affairs is the background against which spiritual work takes place. No one who has attempted an exercise of finding inner silence will disagree that the first thing he finds in himself is noisy, confused, repetitious words and talking that he cannot stop. The exercise of quietening the mind is a primary task in the spiritual discipline of all the traditions: Buddhism, Sufism, Yoga and mystical Christianity. And it is in this search for inner order that we find the analogy, widely employed in antiquity, of the shepherd. Up till a few hundred years ago the idea had a different meaning from the pastoral idyll whose poetic sentimentality is almost all that remains for us today. Formerly the subtle effort of rounding up one's thoughts, confining them to an area where they cannot stray or get into danger, and keeping an eye on them, all of which are the first stages towards maintaining

a state of inner harmony, could be seen as analogous to the image of the shepherd and his sheep. The shepherd, in the imagery of sacred literature, is the inner guardian of the mind whose task is to watch over all thoughts and maintain an ordered interior state. We shall see further on how Orpheus, the archetypal shepherd, was an important image for the earliest Christians. Indeed, as we shall also see, to one group at least, he was synonymous with Christ. In classical mythology many heroes are described as being shepherds, especially at the beginning of their careers. Shepherding is the preparatory stage after which the significant events unfold. Thus, for example, when king Priam sends for his son Paris, who has to choose among the three Graces, we find that he is herding flocks with the shepherds.

Returning to St Luke's text we learn of other details, apparently specifying place and time, that tell us about the conditions in which this inner work is taking place: 'in the fields' and 'by night'. The Evangelist here is referring to the fact that the spiritual seeker begins his search in the circumstances of ordinary external life; 'in the fields' means literally 'outside' which we understand as *not within*, or where there is no access to the inner life. 'By night' is quite simply 'darkness' and in the special language of allegory we understand here all the psychological and spiritual implications of night and darkness.

'There were shepherds abiding in the field, keeping watch over their flocks by night' can be put another way as: 'There was a group of spiritual seekers working together in the difficult conditions of outer life and not able to see where they were going.'

The eleventh-century book illustrator was sufficiently interested in this scene to depict it as a separate image whereas it is more traditionally one of the 'secondary events' in the icon of the Nativity (see Fig. 1) where its meaning is usually overlooked.

We shall see further on that the allegorical method of understanding scripture was central to the mysticism of such men as the Jewish philosopher Philo, the Christian Platonist Origen and his pupils St Basil the Great and St Gregory of Nazianzus who compiled an anthology of their master's writings known as the *Philokalia of Origen*.[4] Other writers in this tradition were the Gnostics, the Christian neo-Platonist Dionysius the Areopagite and other schools of spirituality which we shall discuss in Part I. These schools were linked through their adherence to a tradition that, for them, was ancient. In this work, we shall be more concerned with the similarities that relate the thought of these teachings rather than the differences that separate them.

Later, and especially in the West, allegorism, together with a mystical approach to spiritual ideas generally, gave way, and sometimes seemed to disappear altogether, in the face of other doctrinal positions that insisted on a literal interpretation of religious literature.

Let us consider in the next chapter how, in our own times, perhaps in reaction to the extreme positions of scientific rationalism, the search for an esoteric sense, hidden within the forms of conventional religion, is undergoing a revival.

2

Esotericism and the Perennial Philosophy

IN the last hundred years, and more especially in the last fifty, there has grown up a body of literature around the idea of a universal philosophical tradition whose origins, it is said, pre-date all known religions and which is at the common root of all authentic spiritual ways. The sources of this literature seem to stem from the now rather discredited Theosophical movement in the 1880s and 90s, the period often referred to as the 'occult revolution'. But, even if the first Theosophists were flawed, interest in such ideas has continued to grow and it would be wrong to dismiss lightly such men as G. R. S. Mead, Arthur Edward Waite, or Rudolf Steiner who left the Theosophical Society and founded their own organisations such as the Golden Dawn, the Quest Society, and the Anthroposophical Society within which to develop their studies of the origins of Christianity and various forms of spiritual philosophy.

A good account of the ideas of the universal tradition is Aldous Huxley's *The Perennial Philosophy*.[1] Published in 1946, this book summarised the ideas that had been developing since the beginning of the century and which led towards the vision of a universal philosophical truth; it gained wide acceptance and remained something of a classic until the turn-around of ideas in the 1960s for which it had probably helped to prepare.

A little before this, in the 1930s, one of the perennial philosophy's most brilliant exponents was the curator of Indian art at the Boston Fine Arts Museum, Ananda Coomaraswamy. Although less influential in his day, Coomaraswamy's thought cuts deeper than Huxley's and his writings continue to grow in significance.[2]

According to him tradition is the central body of ideas that unite, among others, the thought of Plato, the Vedantic scriptures of ancient India, the Hebrew Torah and Talmud, Buddhist sacred texts, Sufi mysticism, the Gospels, and certain Christian theologians from the third century up until the end of the Middle Ages.[3]

Coomaraswamy cites early Christian writers who clearly recognised the universal tradition which, for them, was synonymous with Christianity.

> God is the word for whom the whole human race are partakers, and those who live according to Reason are Christian even though accounted atheists . . . Socrates and Heraclitus, and the barbarians; Abraham and many others. (Justin Martyr, second century)[4]

> The very thing that we now call the Christian religion was not wanting among the ancients from the beginning of the human race, until Christ came in the flesh, after which the true religion *which already existed*, began to be called Christian. (St Augustine, fourth century)[5]

We understand from the ideas of tradition that without the help of something beyond his ordinary sense-bound self man cannot apprehend truth. Truth is cosmic reality, and even at the material or human level, truth has a divine or 'higher' dimension which man must contact spiritually in himself before he can perceive reality. It is in this sense that Coomaraswamy tells us that '"worlds" and "gods" are neither places nor individuals but states of being realizable within yourself.'[6] Without the awakening of this faculty that lies dormant in the depths of his own soul man's view of the world is, according to all mystical teaching, a delusion.

Cosmology plays a central part in the ideas of the ancient universal tradition. But traditional cosmology has nothing to do with modern astronomy which measures and classifies but which produces statistics that have no psychological bearing on our lives; traditional cosmology, on the other hand, helps man to understand his relationship to himself and his fellow men, to nature and, beyond that, his potential relationship to the universe and God.

From the point of view of traditional ideas, modern astronomy, like modern science in general, approaches the phenomena it investigates from too limited a standpoint, in fact with one faculty only, namely cerebral mentation. Whereas ancient science, or sacred science as it is also called, holds that the function of mentation is an incomplete aspect of man and that, when developed

out of balance with the whole, it produces abnormalities and even monstrosities.

> Cerebral intelligence [writes R. A. Schwaller de Lubicz] is strictly limited by the boundaries imposed by the senses . . . The fundamental character of cerebral intelligence is that it is born of duality . . . Cerebral consciousness is the result of quantitative experience, a mechanical consciousness resulting from comparison.[7]

This feature of our mental functioning, which enables us to count, measure, compare and classify, is 'developed in the higher animal aspect of man'. This means that cerebral function is not true human consciousness and that higher and more real levels of consciousness still await us. 'Intelligence-of-the-heart', on the other hand, is independent of the senses and

> belongs to the great complex called life . . . We have borrowed the term 'intelligence of the heart' from the ancient Egyptians in order to designate that other aspect of man which allows us to penetrate beyond our animal limits and which, in truth, makes for human man's characteristic progression towards divine Man: the awakening of this original principle that lies dormant in every living human being.[8]

The silent aspects of tradition that we referred to earlier are those which were specifically designed to by-pass that level of mental functioning that can only comprehend words and logic. This is one of the proper meanings of the term esoteric. Esotericism is tradition's way of sealing the higher aspects of truth from the animal and mechanical parts of the mind which, at the lower level, can only distort and even destroy the higher meaning of the divine Word.

Here we encounter a difficulty in the approach to esoteric ideas. The low level of our psychology bars us from access to the higher world of the spirit; our spiritual faculties are insufficiently developed. The 'divine' part of ourselves needs a special education before it can recognise itself and the higher world to which it belongs.

In our approach to the deeper questions in our lives, we have allowed ourselves to avoid the disturbing implications that truth brings and now the propositions of esotericism, which are a search for truth, amount to a severe indictment of human civilisation. And so the teachings of esotericism are generally unacceptable. Esoteric ideas imply that everything we know in

the ordinary way amounts to nothing; P.D. Ouspensky, in a passage we quote below, remarks that 'pseudo-religion, pseudo-philosophy, pseudo-science and pseudo-art are practically all that we know'.

Apart from those we have already mentioned, a number of writers have written on the ideas of tradition and esotericism. Jacob Needleman, the editor of *The Sword of Gnosis*, says that for the authors 'the study of spiritual traditions was a sword with which to destroy the illusions of humanity'.[9] In my personal view, the case is stated with clarity and force by P.D. Ouspensky in the first chapter of his *A New Model of the Universe* from which the following quotations, with some abbreviations, are taken:

> The idea of a knowledge which surpasses all human knowledge, and is inaccessible to ordinary people, but which exists somewhere and belongs to somebody, permeates the whole history of the thought of mankind from the most remote periods.

> . . . All religions, all myths, all beliefs, all popular heroic legends of all peoples and all countries are based on the recognition of the existence sometime and somehow of a knowledge far superior to the knowledge which we possess or can possess.

> Schools of a particular kind were guardians of the knowledge, and it was protected in them against non-initiated persons who might mutilate and distort it, and was handed on only from a teacher to a pupil who had undergone a long and difficult preparation.

> According to tradition, the following historical personages belonged to esoteric schools: Moses, Gautama the Buddha, John the Baptist, Jesus Christ, Pythagoras, Socrates and Plato; also the more mythical – Orpheus, Hermes Trismegistus, Krishna, Rama, and certain other prophets and teachers of mankind. To esoteric schools belonged the builders of the pyramids and the Sphinx; the priests of the mysteries of Egypt and Greece, many artists in Egypt and other ancient countries; alchemists, the architects who built the mediaeval 'Gothic' cathedrals; the founders of certain schools and orders of Sufis and Dervishes; and also certain persons who appeared in history for brief moments and remain historical riddles.

> People of our time have four ways that lead to the Unknown, four forms of conception of the world – religion, philosophy, science, and art. These ways diverged long ago. And the very fact of their divergence shows their remoteness from the source of their origin, that is, from esotericism. In ancient Egypt, in Greece,

in India there were periods when the four ways constituted one whole.

The legend of Noah's Ark is a myth referring to esotericism. The building of the 'Ark' is the 'School', the preparation of men for initiation, for transition to a new life, for new birth. 'Noah's Ark', which is saved from the flood, is the inner circle of humanity.[10]

Ancient tradition holds that the cerebral mind is not the instrument for apprehending higher knowledge and the realities of the cosmos, nor can the kingdom of Heaven be known by the senses. Another faculty, only the embryo of which exists in us, has to be developed. This is the highest aim a man can have: to develop that faculty and become the recipient and guardian of that higher knowledge. Such an aim demands the participation of the whole of himself. At the same time, knowledge of the higher world can and does reach the ordinary level of humanity, but it appears among us in partly hidden forms, in the guise of something readily acceptable, where only seekers will look for a higher meaning. Thus an intermediary level exists; it is not the inconceivable Divine Realm, neither is it at the level of our animal nature. It is the world of traditions, ceremonies, rituals, symbolic myths and allegories; symbolic architectural and pictorial images, symbolic numbers, sometimes expressed in forms, or music, or colours.

Tradition sees all of what we call consciousness and subconsciousness as belonging to sense-bound, mechanical man – 'Adam' or unredeemed man; man living outside the influence of the higher world and whose life is lived on a horizontal plane, that is, on one level only.

The plays of Shakespeare, which are rooted in the consciousness of English-speaking people, are an example of the influence of higher tradition reaching deeply into the human psyche through the medium of ordinary culture.

Whatever we may think of Shakespeare's plays, and they have been subjected to the widest variety of interpretations, there is no doubt that they stand at the end of a line of tradition that goes back to Greek drama many centuries before Christ. And, like the theatre of ancient Greece, they can be understood as presenting us with images of situations whose ultimate meaning is hidden or esoteric.

Medieval and Renaissance thought, reviving ancient tradition, saw, in the symbolism of kingship and the state, an image of divine order and cosmic harmony. At the same time many of

Shakespeare's plays are studies of the 'inner cosmology' or spiritual psychology of man.

The idea of spiritual order and the work of maintaining order in the face of chaotic forces and disorder applies as exactly to the inner life of man as it does to the universe. According to traditional ideas there is a point where the incommensurate difference of scale between the macrocosm (the universe) and the microcosm (man) disappears.

A typical play presents us with this image: a good king is deposed or somehow cheated of his rightful throne by his evil or false brother and is obliged to go into exile on a remote island or to hide in an inhospitable forest. This scenario can be understood as an illustration of how the embryonic higher part of ourselves, which has the potentiality for spiritual development, has been neutralised and rendered ineffective by the lower and material part of ourselves. The kingdom is our own life but it is under the domination of material forces and barbarism. The place of banishment or hiding is the psychological limbo in which our true nature is imprisoned; we live away from the real world and far from our rightful sphere of influence. This picture of things 'all wrong' and 'not as they ought to be' is the representation of our actual inner reality. The way the protagonists of the drama address themselves to the problems of their situation will be understood in a different and interesting way when considered in the light that this symbolism suggests. The nature of the problem and the necessary conditions for its resolution, though possibly illogical on the material plane, will be deeply significant at the spiritual or esoteric level.

The poetic element has the function of opening our deep feelings. We definitely need to be in a certain emotional state in order to perceive certain truths. The problems posed by mistaken identity, by injustice and by the threat of disorder, engender in us feelings of bewilderment and anguish, while the resolution of the difficulty, the reappearance of order and symmetry as the right couples pair off, as brother and sister find each other again, as the kingdom is joyfully regained, evoke in us feelings of relief and pleasure and a satisfying sense of rightness.

It is possible that elements of this universal and traditional story originate in ancient Egypt: 'We learn from the Pyramid texts that Osiris, son of Nut the Sky and Geb the Earth, inherited his father's throne, but was overthrown by his brother Seth, principle of discord.'[11]

It will be seen that the tradition of esoteric or mystical ideas is universal to all religions. They appear in the most ancient myths and are thus older than human knowledge. As far as Hellenistic thought and early Christianity are concerned, we can conveniently take Egypt as the point of departure for the ideas we shall be studying. I. de Lubicz gives us the following suggestive account of the transmission of esoteric knowledge:

> The architecture of Egypt and of the East bears witness to undeniable achievements in geometry, mathematics and cosmogony. Of those civilizations, the most ancient and long lived seems to have been the period of the pharoahs; for the most ancient Greek and Chinese cultures were followed by geological cataclysms and floods, and have left no remains.
>
> About 3000 BC the Pyramid Texts were already speaking with authority of the constitution of man, his survival of death, and his relation to the life of the cosmos. Much later, Moses, who 'was learned in all the wisdom of the Egyptians' (Acts 7:22), included in the Pentateuch as much of it as was suitable for his people; and out of this tradition came Christianity.[12]

3

Hellenistic Philosophy

THE artistic, stylistic and, some would say, the spiritual origins of icons are to be sought in the historical period that goes back several centuries before the lifetime of Christ and which continues until the beginning of the fourth century AD. From the lifetime of Christ up until the latter part of this period Christians stood on the margin of history; they were an obscure minority group whose influence, socially and culturally, was not widely apparent until Christianity became the official religion of the Romans in AD 313.

'Hellenistic' is the generalised and somewhat ambiguous term that describes the religion, science, politics and arts of the Mediterranean and the Near East during the period of transition between the world of Antiquity and the Christian Era. It is the civilisation that results from the encounter between the culture of the ancient Near East with Greek thought.

In the six hundred years from 325 BC to AD 313, the period which we know as the Hellenistic era, we see several major shifts in the world outlook of thinking people that prepared humanity for the advent of Christianity as a popular religion.

The beginnings of this trend are already discernible from as early as the seventh century BC when citizens of the Greek city-states were resident in Babylon. By the fifth century BC the populations of Greek cities on the coasts of the Mediterranean and the Black Sea were models of Greek arts and politics for the local cultures. But the main impulse for the spreading of Hellenistic culture was to come with the Eastern conquests of Alexander the Great in the

fourth century BC when Asia, Scythia, Persia, Palestine, Egypt, and India became pervaded by Greek thought.

A later and very characteristic phase of Hellenism was the period from the middle of the first century AD up until the beginning of the fourth century AD. This period, in what was by now the Roman Empire, saw the decline of Graeco-Roman civilisation and a revival of oriental trends particularly in religious thought and tradition. Conventional religion in the later Roman period was often hardly more than a social routine. On the other hand, oriental mystical cults from Palestine, Egypt, Babylon and Persia flourished, creating a widespread religious syncretism that held many attractions for truth seekers. In describing this phenomenon Hans Jonas speaks of

> the spread of Hellenistic Judaism, and especially the rise of Alexandrine Jewish philosophy, the spread of Babylonian astrology and magic . . . the spread of diverse Eastern mystery cults over the Hellenistic–Roman world, and their evolution into spiritual mystery religions; the rise of Christianity; the efflorescence of the Gnostic movements . . . and the transcendental philosophies of late antiquity beginning with neo-Pythagoreanism and culminating in the neo-Platonic School.[1]

Yet a later Hellenistic phase can be postulated that corresponds to what Jonas calls 'Byzantinism as a Greek Christian Culture'.[2] Christianity has been called the heir to antiquity and we shall be returning often to this idea in more detail in our later discussions on icons.

Such were the basic concepts on which Hellenistic syncretism was founded and which Christianity inherited. However, by the time about which we are speaking (first to fourth centuries AD), we do not encounter these concepts in simple and absolute terms. Jewish, Babylonian and Greek ideas had interpenetrated each other at many levels producing, especially after the encounter with western thought, a seemingly endless variety of cults, religions, philosophies, beliefs and all kinds of systems for their interpretation and practice. The Mediterranean had become a melting pot for religious and philosophical ideas into which was cast every possible ingredient.

One of these ingredients was that element that later became what we know as Christianity. But at that time it had not the form by which we now recognise it. And thus an important question presents itself to us: what was Christianity in the period before the liturgy, before the doctrinal formulations of theologians and

before the canonisation of documents which contained fragments of the sayings and doings of Christ and which we call the gospels?

I believe the answer to this question lies hidden behind the historical events which constitute the development of Christianity during the first five centuries. This was the transitional stage during which the esoteric origins of the teaching became the cultural basis for western civilisation. It is a process lasting several centuries in which we have to hold in our minds the picture of early Christianity developing in a Hellenistic context. The first Christian writings, those of St Paul, followed later by the writings of the four Evangelists, demonstrate this. The literature of the New Testament, especially that of St Paul and of St John, is written by men whose minds were cast in a Hellenistic mould. This is also true of subsequent work by theologians of the early Church. All the great thinkers from the schools of Antioch and Alexandria in the second and third centuries, from Cappadocia in the fourth century, from Constantinople in the fifth, sixth and seventh centuries, were the heirs of Hellenistic intellectual traditions.

Other Hellenistic elements in Christianity find their origins in non-Greek sources. The concept and forms of the liturgy, which survives intact in the Orthodox tradition and only fragments of which are now retained in the western churches, was taken from the Egyptian Mystery religions.[3] It was from the Mysteries that the idea of an esoteric initiation passed into the church via neo-Platonism and Hermeticism. Even the outline of the life of Christ follows a classic mythological form: the obscure and mysterious birth of the god-man, his life among humans accompanied by miraculous events; his unusual or ritual death followed by descent into the underworld and subsequent ascension into the cosmic realm and eternity is a standard allegorical tradition which we find throughout the religious myths of the Near East, both in antiquity and during the Hellenistic period. Jonah, Mithra, Osiris, Dionysius, and Orpheus, among others, represent different versions of this universal symbol.

In trying to understand what it is that is universally symbolised, we shall look at the idea of a truth common to all religions, though expressed in different ways according to different historical and geographical circumstances. We will briefly survey certain aspects of the Hellenistic world, trying to understand what ideas from it passed into Christianity and into the cultural world outlook of both Eastern and Western Christian civilisation. Especially, we shall try to unpick the golden thread of esoteric tradition from the mass of tightly woven and often tangled material that makes up the amazing pattern of the origins of our history.

Authentic spirituality – the 'true philosophy' of antiquity – was a quest, through the science of self-knowledge and the application of precise psychological techniques, for steps in the ascending path of personal evolution, an inner search for the passage away from mental and emotional disorder towards wisdom and freedom from worldly passions, towards true knowledge of God and the Universe.

In the history of humanity, religions differ to the extent of setting whole nations against each other. But, at the level of the individual spiritual quest, the differences seem to be less or non-existent. The ultimate truths that spirituality seeks: knowledge of God, the Universe and Man, are the same regardless of historical time and regardless of race or culture and even of prevailing exoteric* religious belief. In studying the spiritual traditions within different religions, it soon becomes apparent that the methods of spiritual endeavour, such as silence, the state of being centred within oneself, exercises for the development of inner attention, various techniques for meditation and self-knowledge, seem to be essentially the same whether in India, Asia, Egypt or Europe.

The active search for the common universal truth, from which all religions and all philosophical teachings spring, lies at the roots of all human civilisation. All the 'ways' pointed out by the great sages and teachers: Moses, Buddha, Plato, Christ, Mahommed, only differ in that they start from different places; the goal at which they aim is the same. And the apparently insurmountable problems of spiritual ignorance, illusion and pretence that man encounters on the way, both in himself and in others, are also the same.

We will begin our acquaintance with Hellenistic thought with a brief glimpse of the teachings of Pythagoras who was born in 569 BC and whose religious and mystical ideas were founded on ancient traditions from Egypt, Babylon and, probably, India. His influence, as we shall see, is beamed into the heart of third-century AD neo-Platonism and is reflected in the depths of Christianity.[4]

As a young man Pythagoras formed an attachment to the great Ionian philosopher Pherekydes who was his teacher and 'most important influence' and who had 'strong affinities with the Levant and the philosophies of the East'. It was from him that Pythagoras received the cosmic imagery of the One, of the upper atmosphere (personified as the god Zan, sometimes transformed into Eros, the

*Exoteric: the 'outer circle' of humanity. The exoteric and esoteric were sometimes shown as a diagram consisting of two concentric circles

creator of the Cosmos), of time (personified as Kronos) and of the earth (personified as the goddess Cthonie).

> Another interesting facet of Pherekydes' philosophy was his emphasis on caves and hollows in Chthonie as receptacles of the divine hand of creation. For the later Pythagoreans and Plato the symbol of the cave became a potent mystical vehicle through which the enigmatic truths could be conveyed. Apart from the three components of creation already mentioned: Zan, Kronos and Chthonie, Pherekydes introduced the elements of air, fire and water which acted upon the 'pentekosmos' or 'pentemychos', the five primeval caverns which completed the creation. Together with the patent number symbolism here the image of the cave comes to the fore. For the ancient Greeks the cave was sacred to many gods . . . Mystic rites were conducted in them, and *they were regarded as the focal points of cosmic energies and for the reception of metempsychosing psyches returning and leaving the earth.*[5]

This tradition is maintained in early Christian literature and iconography. In the second century an apocryphal gospel appeared which later became highly influential in the establishment of the Byzantine iconographic canon. The *Protevangelium Jacobi*, contrary to the tradition of St Luke, relates that Christ was born in a cave:

> And he [Joseph] found a cave there and brought her [Mary] into it, and left her in the care of his sons and went out to seek for a Hebrew midwife in the region of Bethlehem . . . And he found one . . . and he went to the place of the cave, and behold a dark cloud overshadowed the cave. And the midwife said: 'My soul is magnified today, for my eyes have seen wonderful things; for salvation is born to Israel.' And immediately the cloud disappeared from the cave, and a great light appeared, so that our eyes could not bear it. A short time afterwards the light withdrew until the child appeared.[6]

Icons of the Nativity depict this version of the event where the cave does indeed seem to be the 'focal point of cosmic energies' (see Fig. 1).

Our commentary so far introduces several important ideas which suggest ways of approaching the icon of the Nativity's deep meaning: *psycho-spiritual* ideas represented by the shepherds; *cosmic* ideas represented by the cave and the birth of Christ; the idea of a *divine, unifying principle* represented by the light which, as the icon shows, flows down into the cave from the higher realm and illuminates the world; the idea of *hierarchical order* represented by the

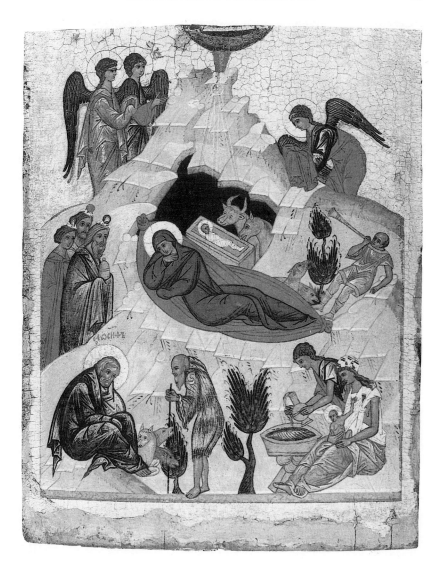

Figure 1. The Nativity. Novgorod School, 15th century. Private collection, New York. The imagery follows the apocryphal Prot-evengelium rather than the gospel and shows Christ born in a cave in the desert. According to Pherykedes (the teacher of Pythagoras) caves were 'focal points for the exchange of cosmic energies'.

heavenly realm, the sky, the mountain, the earth and the cave, each one set above the other in a continuous, ascending ladder linking man to God. Recent scholarship in Russia shows how medieval icons are based on the subject for which Pythagoras is most famous: *harmonious numerical proportion.*[7]

Persian and Babylonian influences on the philosophy of Pythagoras are apparent and it is supposed that as a young man he went to Egypt and was initiated into the priesthood there.

All the sources of knowledge that Pythagoras studied, both eastern and western, led him not only to an understanding of the cosmos but also to the ability to formulate his knowledge into a communicable teaching. Pythagoras was a religious mystic and one of the world's great spiritual teachers. He was a messenger from above. The teaching that he formulated and which developed and influenced humanity, down to even the present day, had the aim of calling man away from the level of ignorance, illusion and deceit on which he ordinarily lives and to find that higher part of himself that is capable of uniting with the higher, or divine, parts of the universe.

The means for communication from the divine to the human is, at the beginning, necessarily symbolic. The human mind is not able to receive higher knowledge without first being prepared. It is just in this preparation that the disciplines and methods of monasteries and religious schools consist. In a Zen Buddhist analogy the seeker is compared to a thirsty man who has no cup with which to receive the tea he is being offered by the master. The master cannot pour it on to his hands for it would burn them, nor can he spill it on to the floor where it will be wasted. First of all the pupil has to acquire a cup into which he can receive the tea. It is one of man's illusions that he thinks he already has the vessel that will be capable of receiving truth and higher knowledge. In the absence of our ability to receive truth directly we are offered symbols: myths, legends, parables and so on, which will not burn us. One of the things that Pythagoras learned from the Egyptians was the use of symbolic methods of teaching. He was later to develop a method of 'presenting abstract truths in an enigmatic way' by the use of cryptic and mysterious sayings, known in antiquity as *akousmata*, and which resemble the *koans* or riddles given as themes for meditation in Japanese Zen monasteries.[8] Some of Christ's sayings have this quality. For example, 'Cleanse first that which is within the cup and platter, that the outside may be clean also' (Matthew XXIII, 26).

Pythagoras transmitted divine truths through the study of number and number symbolism. For Pythagoras, number – a concept synonymous, for him, with the stars – was the ultimate symbol with which to formulate knowledge about man, his dynamic relation with the universe and eternity, and with the ultimate deity: the One. If God is symbolised by number as one, then duality begins with creation. All numbers, like all creation, are contained within the concept of multiplicity. The opposition of unity and multiplicity are seen as a harmonious and perfect balance. Pythagoras' work on music and the science of sound vibrations illustrates the laws that regulate the relationship between multiplicity and unity. The action of the laws, rightly applied, is that of producing order out of chaos. Music, therefore, is traditionally considered a sacred art and is associated with sacred rituals since it symbolises, and actually illustrates, the laws of the universe. This principle passed into the Christian liturgy and was not abandoned until the end of the Middle Ages. It explains the essential qualities associated with Gregorian chanting and the older forms of Byzantine and Russian Orthodox singing. Later Pythagorean teaching, that of the so-called neo-Platonists, was also to apply these theories of the blending of vibrations, that were understood to accord with cosmic laws, to light and colour, and this, together with the mathematical basis of form and proportion, became a basis of all the arts in Hellenistic times and passed naturally into early Christian art and icon painting.

The teachings of Pythagoras aimed to bring man's life into line with cosmic harmony. For this it was necessary to exercise discipline at several levels simultaneously. To be admitted into the circle around Pythagoras was to submit to conditions similar to those in a Christian Hesychast or Zen Buddhist monastery: the disciple was no longer concerned with the world and its possessions, he was engaged in a struggle with the demands of the body, refraining from too much sleep, from eating meat, from sexual licence, and so on. With this there would be psychological and spiritual exercises of silence, contemplation, control of thoughts and mastery over passions. All this had the aim of creating a higher level of consciousness which would become a receptacle for higher knowledge.

The ancients were concerned with the laws of the universe and its energies and we should not be distracted by the fact that sometimes they personified or deified them and at other times treated them as abstract symbols. These images and forms need not strike us as either primitive or contradictory. Even if the language in which

they are expressed now reminds us of the nursery, we should remember that it is the language that is anachronistic and not the ideas conveyed in it.

Pythagoras taught within a tradition that understood the whole of the universe as functioning harmoniously and according to laws that were symbolised as muses, daimons, gods, and so on. Beyond these was a level of primal reality which Pythagoras formulated in terms of Number and which Plato was later to call Forms or Ideas and which, later still, Plotinus would call Divine Thoughts. Below this level were those intermediate realms through which man was connected with the divine. We shall see further on that in Christianity the corresponding idea would be found in writings such as the *Celestial Hierarchies* of Dionysius the Areopagite.

Ancient oriental traditions described the great cosmic realities as personified or deified anthropomorphic beings. Greek philosophy, on the other hand, tended to categorise them as abstract ideas or numerical symbols, whereas Greek religion, like later Roman religion, and, later still, Christianity, employed the oriental system of personification. It will help us very much if we see that these different spiritual, philosophical and scientific languages are in search of the same ineffable reality. They are symbolic languages whose function is to give provisional descriptions to what is, by its nature, indescribable. But many misunderstandings arise from taking literally what is meant to be understood symbolically.

In order to comprehend higher reality another function must be developed that by-passes or transcends ordinary thought. Sometimes this is referred to as the mystical or intuitive faculty; or sometimes as insight. In any case it involves a *state of knowing* or the *experience of knowing*, or *gnosis*. We shall discuss this idea further in a later chapter.

We have seen briefly already the outlines of the plan of the cosmos that, in one form or another, represented reality to the minds of Hellenistic men and women. Reduced to its simplest form this plan gives us the idea of *higher* and *lower*. It was stated by the mysterious Hermes Trismegistus in the formula 'As above, so below'. And in the Lord's prayer we say 'in Earth as it is in Heaven'.

Pythagoras taught that order and number in the universe demonstrated universal laws which, when understood, could be applied either on the cosmic scale or on the level of the individual psyche. An example of this would be how the laws of proportion, derived from knowledge of the cosmos, could be

expressed in musical vibrations which aroused kindred harmonies in the psyche of the hearer. Thus 'the musical ratios also represented the parts of the psyche, not just that of the individual, but also the cosmic psyche which animated the universe'.[9] The idea of a unifying principle of relationship everywhere in the universe, from the highest to the lowest, is at the root of all subsequent Hellenistic cosmological systems and passed into Christianity.

Of great importance to the history of religion in ancient Greece and to subsequent developments in Hellenism and Christianity, is the mysterious and semi-legendary figure of Orpheus. The Orphic school dates from the sixth century BC and commentators from as early as Herodotus in the fifth century BC have noted close analogies between Orphism and Pythagoreanism. One modern writer categorically states that 'the Pythagoreans were a sect of Orpheus' school'.[10]

Orphism is said to be the origin of mysticism. In order to understand what this means we shall consider what it was that Hellenistic people thought was the soul, where it came from, where it went after death, and what was its relation with the body. The Hellenistic idea of the soul was taken on by Christianity and, in so far as we have ideas on the soul, it is more or less the one we hold today. When our children ask us, what is the soul? we in the West tell them that it is an invisible part of us that will 'go to Heaven' (or possibly Hell) after we die. The distinction between the earthly, perishable body and the independent immortal soul was developed by Plato. The neo-Platonists understood man as consisting of three parts: body, soul and spirit. It was this latter idea that passed into the teachings of St Paul and the mysticism of the Alexandrine school, the Desert Fathers and the Cappadocian Fathers. But the idea of the body and soul (only) is the one that has remained in the popular imagination. The Jews had no such teachings and consequently, for them, the idea of the Resurrection presented many difficult problems.

The historically observable origins of the idea of the soul lie in the Mystery Religions of antiquity, e.g. Orphism and the even more ancient cult of Dionyius.

In speaking about Orphism and the Mystery Religions of the seventh century BC, we should remember that we are considering a time when man's psychological outlook, especially in matters of religion, was fundamentally different from our own.

To understand the Mysteries we must endeavour to recapture the ancient mind which in religious matters expressed itself spontaneously in symbolism where we would speak more concretely. The line of demarcation between symbol and fact, the objective and subjective, was not deliberately drawn. In fact in ancient realism the identity of subjective and objective was not questioned.[11]

The same writer goes on to recount the Orphic version of the Dionysius myth, emphasising the need to understand its allegorical significance.

A splendid example of the *idealising power of religious symbolism* is presented in the treatment of the Zagreus-myth of the wild Thracian Dionysiac religion by the Orphic mysteries. No more unpromising material could have been chosen than this repulsive story, which, told in various forms, represents Zeus as seducing, in the form of a serpent, his 'only-born' daughter, Persephone, from which amour was born the Cretan Dionysius-Zagreus with the horns of a bull. This infant god, destined by his father to be world ruler, was kidnapped by the envious Titans, sons of Earth, torn limb from limb, cooked and eaten. His heart, rescued by Athene, was brought to Zeus, by whom it was swallowed, and became reborn as the Theban Dionysius, son of Zeus and Semele. Zeus then blasted with lightning the earth-born Titans, from whose ashes arose mankind. *The Orphics moralized this myth into a symbol of man's composite nature, consisting of evil, or Titanic, elements and the divine, or Dionysiac elements.* From the former man must, through self-renunciation, liberate himself and return to God, with whose life he may be united. The body is the tomb of the soul: salvation consists in rescuing the divine, Dionysiac, spark from the enveloping evil matter, and so securing escape from the round of reincarnation to which the soul is subject.[12]

Many ideas which are at the roots of Hellenistic and Christian mystical thought appear in this allegory, apparently for the first time: the idea of the body being the tomb of the soul: the soul's origin is both divine and eternal, that freedom consists of releasing the soul from matter, which is synonymous with evil; and the idea of the necessity for redemption or salvation.

Also the idea of allegory itself enters here into the workshop of philosophy. 'Allegory', Angus tells us, 'was the application of philosophy to mythology.'[13] It was the mystical interpretation of the ancient Mysteries which, in earlier times, had not needed explanation; the assumption is that they had provided *direct experiences* of what the mystics later sought through philosophical and mystical means. Does this mean that *gnosis* was achieved through

the Mysteries, by-passing, or, at any rate, not emphasising, the processes of thought and speculation? At least this would explain the extraordinary atmosphere of mystery and reverence that surrounds the figure of Orpheus and his school and the fact that, whatever were the ceremonies and practices of the Orphics, they are one of history's best-kept secrets. Outside the circle of actual participants, no one has ever known what they were.

Many of the ideas that we observe in Pythagoras were given further impetus by the great genius of Plato in the fourth century BC. His view of the universe as set out in the *Timaeus*, is considered to be Pythagorean. It was the mystical and religious or, perhaps one might say, Pythagorean aspects of Plato that inspired and influenced the Platonic revivals of the later Hellenistic period, in particular the neo-Platonists, the Gnostics and the Christians of the third century AD.

According to Plato, and all subsequent mysticism, man can only know reality when he has freed his soul from the fetters of the senses. The true 'home' of the soul is not the body but a very high place in the Universe called the Realm of Forms or, sometimes, Ideas. Hence the idea of the soul's ascent from darkness and the lower world, symbolised by the cave. The ascent is through a series of steps or stages that begins with training the mind and the body. This involves strict adherence to the moral virtues: justice, prudence, temperance and courage; the practice of contemplation of Truth, Beauty and Goodness; purification of the body through music, which includes the

> decisive importance of education in poetry and music: rhythm and harmony sink deep into the soul and take the strongest hold there, bringing that grace of body and mind which is only to be found in one brought up in the right way; and purification of the mind through education in mathematics and dialectic proper, the 'search for the essence of things'.[14]

We will mention here one further idea, originally from Pythagoras and developed in middle Platonism by the Stoics, which stressed that all of nature is a manifestation of God and that the world is a unity. Angus quotes Epictetus where he asks, 'Don't you think that all things have been brought into unity?' 'Certainly.' 'Well, don't you suppose that the things of the earth are in sympathy with the things of Heaven?'[15] He goes on to say that with pantheism is

linked a semi-philosophical, semi-astrological doctrine of nature mysticism which never died out in ancient theology. According to this conception, men have in themselves the same 'elements' which exist in principle in the deity and through which they are in 'sympathy' with the deity. Wherefore the religious mind is quickened to perceive that 'the things of earth are in sympathy with the things of heaven', that the natural is but a manifestation of the divine, and that through the contemplation of material objects, especially the heavenly bodies, the soul may be elevated towards God. The writer of the fourth gospel, familiar with these views, says 'if I spoke to you about things on earth, and you do not believe, how will you believe if I speak to you about things in heaven?'[16]

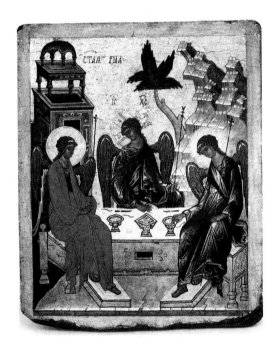

Figure 2. The Old Testament Trinity. Novgorod School, *c.*1500. Private collection, New York. Abraham addressed the three young men who appeared to him as 'My Lord'. The Jewish philosopher Philo identified them as the Father of the Universe, God as the Creative Power and the Lord as King.

A Stoic or middle-Platonist philosopher of great stature and a profound influence on early Christian writers was Philo. A Jew and an upholder of the Mosaic tradition, he was Greek-speaking and lived in Alexandria around the middle of the first century

AD. He brought to Platonism a doctrine of God that was to be immensely influential on the Christian vision of the deity.

Until now the supreme being had been an undefined abstract and mystical concept: Pythagoras' ecstatic vision of the One, or Plato's 'not so much an idea of God as an idea of the divine'.[17] With the Stoics we get the idea of the Logos and from Philo, whose background was Jewish monotheism, we get, for the first time in philosophy, God as a being: the Existent One. Philo's appellation here is (in Greek) *to on*,[18] letters which are found a few centuries later on the icons of Christ Pantocrator within the nimbus around his head. According to Philo, God is unknowable in his essence but observable in his energies,[19] a formula which was adopted three hundred years later by the great Cappadocian Father, St Basil.

A further connection between Philo and Orthodox theology can be observed in the icons of the Trinity which, in iconography, is represented by the three angels who appeared to Abraham foretelling the birth of his son (see Fig. 2). Philo was the first to point out that Abraham used the singular, addressing them as 'my Lord'. Philo identifies them as the Father of the Universe, God as the creative power, and the Lord as king.[20] Philo's intellectual heirs in Alexandria were the Christian Platonists Clement and Origen; and through them his gift to all ages has been the allegorical method of interpreting the deeper meanings of sacred imagery in literature and art.

The following commentary on a well-known fifteenth-century icon of the Trinity is made in the spirit of Philo and the Christian Platonists of Alexandria.

'The Lord appeared to Abraham near the great tree of Mamre while he was sitting at the entrance of his tent.' This first appearance of God to man is described in Genesis XVIII. The text tells us that this was 'in the heat of the day' and continues: 'Abraham looked up and saw three men standing nearby. When he saw them he hurried from the entrance of his tent to meet them and bowed low to the ground.' Abraham and his wife Sarah receive the three men and prepare a special meal for them. They foretell the birth of a son to Abraham and Sarah despite the fact that she is 'beyond the age of child-bearing'.

From our perspective in the late twentieth century all this seems hardly more than a quaint tale. It is only when we dismiss the literal meaning from our minds – as the Alexandrines would have insisted – and try to find the psychological symbolism, that we begin to see the power of the story and understand that a profound inner mystery is being described.

Why did the three men appear by a tree and why are we told that Abraham was sitting at the entrance of the tent? One might think that the tent is of little significance, let alone where Abraham was sitting in relation to it. But these are clues telling us about Abraham's incomplete spiritual state. The tent has the same significance as the idea in icons of architecture which, by denoting enclosed space, tells us that the event is not out in the world but within and hidden. What we are shown is actually taking place in the 'inner chamber of the soul'; it concerns access to the 'Kingdom of Heaven' which, according to Christ, is 'within you'. The presence of the tent implies that Abraham had access, or potential access, to such a place within himself. However, he had not yet fully entered; he was 'sitting' – which may imply spiritual passivity – 'at the entrance'. The 'heat of the day' may mean that he was distracted by external conditions and difficulties. Something further was needed to help him increase the activity of his spiritual energies.

Is this provided by the tree which, according to some readings, is an oak, a traditional symbol of strength? At any rate it is at this moment that the three men appear. Abraham washes their feet with water, which suggests a disengagement from earthly contact since the feet are that lower part of ourselves that touch the earth, i.e. material life. Water, through its clarity and cleansing powers, is a traditional symbol for truth.[21]

Abraham then has fully realised – as we must – that the appearance of God is a spiritual event that takes place when we make the psychological transition from the external world to the spiritual life within ourselves.

Such events happen according to a definite process which depends on an increasingly intense spiritual energy. The narrative, unfolding such a process, now accelerates. Abraham 'hurries into the tent' and tells Sarah to 'be quick' and to prepare bread.

Here we are told of strangely precise, and in the case of the quantity, unusual details: 'Get three seahs [about 22 litres] of fine flour and knead it and bake some bread.'

Baking bread symbolises the coherent interaction of three different elements uniting to make one whole; in this case flour, water, and fire. It is Abraham and his wife Sarah who have to carry out this work, not the visitors who are already so perfectly harmonious that they are one and whom Abraham addresses as 'my Lord'.

In the mystical realm to which the allegory refers, there is no sex discrimination in the references to men and women.

'Man' and 'woman' are to be understood as active and passive
aspects of spiritual energy. Thus the Abraham and Sarah whose
actions are described here are two different aspects of the
same individual: Abraham the spiritual archetype rather than
the historical person.

The Russian icon speaks exclusively in the rarefied language of
mystical knowledge. The design emphasises the perfect accord
of the three men who, since the tenth century, are shown in
their divine aspect, that is, as angels. The stillness of their
eternal contemplation conveys to us an activity that is taking
place outside time and not in sense-perceived, three-dimensional
space. Most of the narrative detail has been omitted. On either
side, in the background, are Abraham's 'tent' (now a house)
and a mountain. In the centre is a tree, unexpectedly quiet and
still.

The tree is the symbol of life itself: a silent presence responsive
to nature and the laws of creation; sensitive to the slightest
movement of the air; nourishing the atmosphere above it
and nourished by the earth below. It represents the eternal
cycle of life and growth, of regeneration and transformation.
Its annual 'death' and 'rebirth' echoes the mystery of true
becoming.

Let us briefly try to picture the variety of cultural, religious
and mystical traditions that Philo, or any inhabitant of
Alexandria, would have come across at any time between
the first and fourth centuries AD. For Alexandria was the
microcosm of the intellectual world. It was divided into
quarters, each one of which maintained the knowledge of
an ancient culture. In the Greek part were the University,
the Museum, and the Library containing three-quarters of a
million books. All of these institutions were richly endowed
and maintained by large numbers of scholars, students and
staff. Here, as we have seen, were neo-Platonists, Greek
philosophy's greatest school at the time, descended, through
Plato and Pythagoras, from remotely ancient and dimly
perceived sources such as Orphism and Pharaonic Egypt.
In the Egyptian quarter there was another museum known
as the Serapeum where non-Greek learning and the Mystery
Religions themselves were secretly taught. In another quarter
was the Jewish colony from whose schools of mysticism and
philosophy came the Septuagint (the translation into Greek
of the Old Testament) and the school from which came

Philo himself. Elsewhere there were Christian churches and brotherhoods of fanatic monks as well as Essenes, Therapeuts, Gnostics, and other psychological and philosophical religious schools such as the community at Fayum, about whom nothing is known except that they left behind a series of hauntingly beautiful and uniquely spiritual portraits. There were also Christian-philosophical groups in free exchange with truth-seekers from the Greek schools producing such men as Clement and Origen.[22]

Clement lived and taught in Alexandria at the end of the second century. He is seen as the link between Philo, to whom he referred as 'the Pythagorean', and by whose Platonism (or Pythagoreanism) he was deeply influenced, and Origen, his even more renowned pupil. Clement was the first Christian writer to see that the Logos that had manifested itself in Christ had also previously manifested itself both to the Jews, in the Old Testament traditions, and also in the philosophy of the 'Pagans'. It was from such an idea that Augustine, among others, claimed that such men as Plato had been 'Christians before Christ'.[23]

Origen was active during the first half of the third century as a writer, theologian and teacher. There is a tradition that he and Plotinus had been fellow students of the mysterious Platonist Ammonius Saccas. Origen was the greatest Christian thinker of his day. It was he, above all, who gave allegorism as the key that could unlock the deepest spiritual meanings of sacred literature. So great was his influence that an anthology of his writings on that subject was compiled by two of his most eminent pupils, the Cappadocian bishops St Basil the Great and St Gregory of Naziansus.[24]

Philosophy in Alexandria, or the Alexandrine school as it is called, gave rise to three distinct religio-philosophical systems: (1) Christian Platonism; (2) neo-Platonism; and (3) Gnosticism. All of these contributed, either knowingly or unknowingly, to Christianity. Each one of these schools of thought, to a considerable extent (but not exclusively), was built on Pythagorean–Platonic foundations and was largely esoteric both in content and in appeal. In fact it is only by using the ideas of esotericism as a key that the truths of the perennial philosophy can be unlocked from these otherwise sometimes incomprehensible, and often discredited, writings from the dim and remote past.

Such unlocking of ancient wisdom was one of the special-
ities of the Alexandrine School. Further on we will see Philo's
description of how one esoteric school, the Therapeuts in the
first century AD, determined the 'deeper meanings' of scripture
through allegorical interpretation. Philo notes that this was a
tradition established by the founders of that sect in ancient
times.

It is today widely accepted that allegory plays a significant
role in the events of the gospels, while the parables themselves
are a form of allegorical teaching. The allegorical method was
central to the third-century Christian Platonists of Alexandria,
Clement and Origen, who

> regarded Allegorism as having been handed down from Christ and
> a few chosen apostles, through a succession, not of Bishops but of
> Teachers. They employed it boldly . . . with the serious object of
> correcting the literal, mechanical, hierarchical tendencies of the day.[25]

Both Clement and Origen, taking a traditional approach, held
the view that the New Testament was to be interpreted at several
different levels of which the first, and least important, was the
literal meaning. They understood that, even at this level, some
of the events were fictitious and not actual history; the former
being 'invented by the Holy Ghost to convey moral and mystical
truths which earthly things could not sufficiently typify'.[26] The
literal reading of the scriptures was aimed at the body or the level
of perception of the senses. Beyond the literal meaning was the
moral meaning which was for the soul: it was, as we would say
today, psychological. Thirdly there was the mystical or spiritual
level which was seen as distinct and separate from the psychological
plane. This was in turn divided into allegorical, 'prefiguring the
history of Christ and his church', and anagogical*, 'typifying the
things of a higher world in which everything of this earth has its
anti-type'.[27]

For Origen these distinctions are based on

> Solomon in the Proverbs [who] gives a rule respecting the divine
> doctrines of Scripture to this effect: 'Do thou thrice record them with
> counsel and knowledge that thou mayest answer with words of truth
> to those who try thee with hard questions.' A man ought then in three
> ways to record in his own soul the purposes of the Holy Scriptures; that
> the simple may be edified by, as it were, the *flesh* of scripture (for thus

*Anagogical: Leading to a higher level.

we designate the primary sense), the more advanced by its *soul*, and the perfect by the *spiritual* law.[28]

In support of the allegorical method and against literalism, Origen quotes from St Luke's gospel: 'Woe unto you lawyers! for ye took away the key of knowledge: ye entered not in yourselves, and them that were entering in ye hindered' (Luke XII, 52). Here 'entering in' has to be understood in the mystical sense of turning inwards, towards the spiritual, and away from the outer which is the literal, sense-perceived, world.

Origen affirms that 'our weakness cannot . . . approach the hidden glory of the truths concealed in poor and contemptible language'. He says:

> Very many mistakes have been made because the right method of examining the holy texts has not been discovered by the greater number of readers . . . because it is their habit to follow the bare letter.[29]

And it is necessary to understand that the allegorical methods of the Old Testament were also used in the New Testament:

> Wherever the Word found historical events capable of adaptation to these mystical truths, he made use of them, but concealed the deeper sense from the many; but where in setting forth the sequence of things spiritual there was no *actual* event related for the sake of the more mystical meaning, Scripture interweaves the imaginative with the historical, sometimes introducing what is utterly impossible, sometimes what is possible but never occurred . . . Not only did the Spirit thus deal with the Scriptures before the coming of Christ, but . . . He has done the same with the Gospels and the writings of the Apostles; for not even they are purely historical, incidents which never occurred being interwoven in the 'corporeal' sense.[30]

> And who is so silly as to imagine that God, like a husbandman, planted a garden in Eden eastward, and put in it a tree of life, which could be seen and felt . . . And if God is also said to walk in the garden in the evening, and Adam to hide himself under a tree, I do not suppose that any one will doubt that *these passages by means of seeming history, though the incidents never occurred, figuratively reveal certain mysteries.*[31]

We forget that the function of religion is to reveal higher mysteries. But in its engagement with human affairs, it has a tendency to lose sight of its divine source. There is always misunderstanding when religion, in its involvement with social questions and the need to provide moral and ethical guidance,

forgets that its prime function is to act as a channel for the descent of a cosmic impulse, the active force of the Creation, personified, in the case of Christianity, as Christ the Son of God and the Logos of the Universe.

If, as the sages maintain, it is beyond the capacity of the ordinary mind to grasp this mystery, then clearly we need to develop another faculty in ourselves if we are not to live in spiritual ignorance. It is just this faculty that mystics like Origen, by rigorous spiritual disciplines, strove to open in themselves and in others. Without it our life forces must inevitably be dissipated among the literalism of the mind and the destructive passions in the heart. The violence of these energies creates for us the illusion that we act significantly. But it is difficult to free oneself from such illusion, just as it is easy to see literally when something more mysterious is intended.

In 587 Origen was formally anathematised by the Church and his writings were banned.

4

The Gnostic Vision

ALEXANDRIA was the main centre of the movement, or group of movements, that we know as Gnosticism and which was to become, for several centuries, widespread in the Roman Empire and in the Christian world.

Much misunderstanding surrounds the term Gnosticism which is ambiguous and can denote a variety of meanings. It is a convention today that when used with a capital letter it refers to specific religious societies or cult groups who identified themselves by their allegiance to particular and apparently rather unorthodox beliefs. Used in a general sense the word *gnosis*, meaning knowledge of God, which is used by Paul in the New Testament and by subsequent Christian writers, indicates a special condition of spiritual knowing as distinct from ordinary mental knowing. Such knowing has nothing to do with ordinary thought; it is an event beyond words or any conceptual forms and takes place in silence. Consequently there can be no adequate description of gnostic experience and everything said or written about gnosticism is likely to be unsatisfactory, if not misleading. True gnosis is not exclusive, either to Orthodox Christianity or to the 'heretical gnostic cults', and the distinctions between the two are sometimes blurred.

In this chapter we shall briefly summarise some of those aspects of gnosticism that lay stress on the cosmological and psychological approaches to understanding spiritual meanings in Christianity and we shall see that it is relevant to our general survey of

Hellenistic thought and to our search for the current of authentic esotericism.

Gnosticism must be of special interest to anyone investigating the origins of icons since the first images of Christ that we hear of were those that belonged to a Gnostic group called the Carpocratians. We learn from the writings of the second-century bishop of Lyons, Irenaeus, that this sect possessed images of Pythagoras, Aristotle and Christ.[1] Unfortunately none has survived.

During the second and third centuries a variety of different Gnostic sects proliferated around the Mediterranean. Their tenets and dogma often had little in common and their doctrines seem unnecessarily complicated and even confusing. This made them an easy target for the theologians and dignitaries of the more conventional and established religious authorities, both pagan and Christian, who lost little opportunity in castigating and even persecuting them. At the same time, the authorities feared them, and the language used against them by some Christian Fathers was excessively violent. We shall try to see if there was not some explanation to this other than the over-simplified and negative version that officially has been given to history.

The Greek word *gnosis* means knowledge and, in philosophical language, knowledge of God. This is quite different from knowledge about God. To know a person is not the same as knowing about that person. In the latter case the knowledge is only data acquired from an external source, whereas gnosis is the *state of knowing*. Gnosticism can also be understood as the training, techniques and, perhaps eventually, the practice of knowing God.

Assuming that such a state is possible for human beings, we may ask here, who or what was God as understood by Hellenistic people? To the Jews, whose traditional religion was founded on the monotheistic principle, the idea of 'the one God', 'the Father', 'Yahweh', this was not a problem; but to others in the Hellenistic world the question of a supreme deity was not so clearly defined. In Greek and Roman religion the gods were hardly more than mythologised heroes whose careers had started as very human beings. Above them was a pantheon of greater gods presided over by Zeus or Apollo. We learn from the great third-century AD neo-Platonist philosopher Plotinus of an interesting symbolic word-play associated with the name of the greatest god. The

passage begins with a call, typical of Plotinus, to a comprehension beyond the senses and beyond the intellect. We should note that the word 'intellect' (without the capital letter) means ordinary mentation whereas 'Intellect' means the spiritual realm.

> As one wishing to contemplate the Intellectual Nature will lay aside all the representations of sense and so may see what transcends the sense-realm, in the same way one wishing to contemplate what transcends the Intellectual attains by putting away all that is of the intellect, taught by the intellect, no doubt, that the Transcendent exists but never seeking to define it.
>
> Its definition, in fact, could only be 'the indefinable': what is not a thing is not some definite thing. We are in agony for a true expression; we are talking of the untellable; we name, only to indicate for our own use as best we may. And this name, The One, contains really no more than the negation of plurality: under the same pressure the Pythagoreans found the indication in the symbol 'Apollo' ('a' = not; 'pollon' = of many) with its repudiation of the multiple. If we are led to think positively of The One . . . there would be more truth in silence.[2]

In Egypt the idea of an ultimate creator of the universe existed as a cosmic force or unknowable power who appeared under different names. Atum, Ammon, or Ptah stood at the head of a pantheon consisting of eight, nine or fifteen deities of second degree. According to one writer, the Egyptian gods could be understood as 'qualities or manifestations of the same indefinable principle'.[3] In philosophy, as we have seen, the idea of God as The Being does not generally appear until Philo and middle-Platonism in the first century AD.

At the same time there was present in all religious and philosophical systems the idea that God is unknowable. So what was it that could be *known*? One answer, which we have mentioned, which was made use of by the Gnostics, came from an idea at the centre of Stoic philosophy and widely held throughout the Hellenistic world, and which was derived from the principle that everything in the universe is connected to everything else and that God is everywhere. From this it follows that if one thing is really *known* in the gnostic sense, then the knowing can proceed by stages from one thing to all things.

According to gnosticism, in order to enter the state of *knowing* it is necessary to get rid of everything I think I know. All the acquired knowledge I have is not really my own; it is not *me*. Furthermore it is a burden and an obstacle because it gives the illusion of knowing

with none of the spiritual benefits of real knowing.

This reverses the commonly held view of the world and, naturally, those who believe in the world as it appears to us will hardly accept such an idea. It is not surprising that gnosticism provoked, and still continues to provoke, incredulousness and derision. The outer teachings of the Gnostics, in the forms of fantastic cosmogonies and weird myths were shocking enough, but to teach that inwardly, spiritually, man is absolutely ignorant, that he knows nothing, is going nowhere and that his life has no meaning was felt, understandably, to be seditious and subversive.

And yet Christ said, 'A man must lose his life in order to save it', and 'unless a man is born again of the spirit, he will not enter the kingdom of heaven'.

The idea of 'losing one's life' led the Gnostics to reject all the values of life that the world holds dear.

> The Gnostics saw themselves as rebels, misfits in a malign system on a cosmic scale. And like rebels in society they felt compelled to act provocatively, to express their inability to submit and to attract others away from the system's stranglehold. They deliberately set about standing everything on its head, inverting all standards, beliefs and preconceptions.[4]

In order to understand what Gnostics thought and believed, let us see a typical gnostic myth summarising man's situation. It goes something like this. It is an error and a grave misfortune for man to have been born into this universe. His origin and rightful dwelling place is somewhere quite other and beyond this universe which is alien to his nature and imprisons him in its darkness. Terrible powers in the form of great cosmic beings called 'Archons' act to keep man in subjection and prevent his escape. He who rules over this situation is none other than the 'jealous God' of the Old Testament who wickedly refuses to acknowledge his inferiority to the Greater God of Light and who insists 'there is no other God but me'. However, the Greater God of Light dwells in a much higher place than this universe; his is a universe utterly beyond anything we can know. And yet it is man's true home and its ruler is his true father. Man is thus faced with a twofold task. First, he must realise the truth of his situation and secondly he must outwit the Archons and escape altogether from this universe to that higher place where he rightfully belongs.

In another mythologising account of the human condition the great powers are personified and, under such human passions

as grief and fear, they commit various errors, in particular miscegenation, the lamentable results of which are reflected at the level of human life.

> He made a plan together with his authorities which are his powers, and they committed together adultery with Sophia (Wisdom), and bitter fate was begotten through them which is the last of the terrible bonds. And it is of a sort that they are dreadful to each other. And it is harder and stronger than she with whom the gods are united and the angels and the demons and all the generations to this day. For from that fate came forth every sin and injustice and blasphemy and the chain of forgetfulness and ignorance and every difficult command and serious sins and great fear. And thus the whole creation was made blind, in order that they may not know God who is above all of them. And because of the chain of forgetfulness their sins were hidden. For they are bound with measures and times and moments, since fate is lord over everything.[5]

It is not difficult to detect here the flavour of that older tradition which belongs to the Mystery Religions. Also it is obvious that, like the older myths, they allegorise truths the understanding of which is essential to man's spiritual evolution: man is bound in the 'chain of forgetfulness', the 'terrible bond' of his loss of genuine consciousness.

> To sum up the essential position of the Gnostics . . . let us say that in their eyes the evil which taints the whole of creation and alienates man in body, mind and soul, deprives him of the awareness necessary for his own salvation. Man, the shadow of man, possesses only the shadow of consciousness. And it is to this one task that the Gnostics set themselves, choosing paths which were not only unorthodox but which, moreover, greatly scandalised their contemporaries: to create in man true consciousness, which would permit him to impart to his thoughts and deeds the permanence and the rigour necessary to cast off the shackles of the world.[6]

It is suggested that by these definitions gnosticism contains elements of esotericism and that the esoteric origins of all true religion, including Christianity, as we shall see, are essentially gnostic. It is surely this that provoked Jung to claim that 'the central ideas of Christianity are rooted in gnostic philosophy'.[7] Other scholars have made equally bold assertions: 'we shall see gnosticism as a universal element in religion and, some of us would add, the most central';[8] 'all the research has shown that Christianity, Judaism, neo-Platonic philosophy, Stoicism,

Epicureanism and Hermeticism have all served Gnosticism'.[9]

Gnosticism is the practical application of esoteric ideas to oneself with the aim of inner transformation. One scholar tells us that 'the very centre of gnostic religion . . . is the discovery of the transcendent inner principle in man and the supreme concern about its destiny'. And further:

> Gnostic 'knowledge' is not just theoretical information about certain things but is itself, as a modification of the human condition, charged with performing a function in the bringing about of salvation. Thus gnostic 'knowledge' has an eminently practical aspect. The ultimate 'object' of gnosis is God: *its event in the soul* transforms the knower by making him a partaker in the divine essence.[10]

G.R.S. Mead writes that 'Gnosis was to be attained by definite endeavour and conscious striving along the path of cosmological and psychological science'.[11] *Conscious striving* and *cosmological and psychological science* refer to special techniques and inner disciplines which we may guess at by analogy with such techniques that we know of in Zen or Yoga practice. There is also a proximity with those disciplines partially described in the Philokalia which we will discuss in a separate chapter. Here we shall briefly discuss the cosmological aspects of gnostic teaching.

We have seen, in touching on Pythagorean and Platonic ideas how a dualistic view of the universe appears which some writers consider to originate in Persian Zoroastrian religion: God and creation; spirit and matter; good and evil. In all Hellenistic thought the relationship between God and his creation is seen according to a scheme, the details of which vary, but of which the central idea always includes the sense of *higher* and *lower*. God is 'higher' than the creation; man is 'lower' than God. At the same time man and God cannot communicate with each other because the scales of their existence are incommensurate; the distances between them are too great. However, in all religious systems there are intermediary beings who are higher than man but lower than God; these are variously named in different systems as gods, angels, spirits, demons, saints, cosmic beings, and so on. In systems that are primarily philosophical the intermediate states tend to be abstract conceptions, such as the Platonic Forms or Ideas. In astrological-religious systems they are celestial intelligences, e.g. the stars, planets, sun and moon; while in other religious systems they are personified or

deified anthropomorphic beings such as saints, angels, heroes and gods. There are also symbolic zoomorphic beings such as the zodiacal forms. Most systems include combinations from these groupings.

We have seen that, according to the Platonic mystical scheme, man's spiritual ascent is from the cave and darkness to his soul's true abode in the realm of Forms and Ideas. This realm is not as high as the ultimate Good, but it is higher than the stars. The Platonic scheme places man, the earth and the higher realms in the following order:

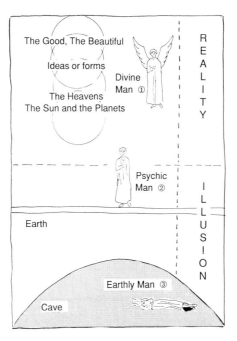

Figure 3. Scheme showing three stages of Man in the Universe according to Plato. This 'cosmology' was later incorporated into Christianity. (See Fig. 13.)

Later we shall see how this plan of the universe is the basis for the elaborate Gnostic and neo-Platonic cosmic scheme which, in turn, passed into Christianity.

Although the Gnostics used the same Platonic principles as Hellenistic philosophy, they were freer and more subjective in their symbolism and terminology. In Gnosticism there was little obligation to conform doctrinally and each sage was free, if he wished, to create his own version, creating new poetic images

and sometimes elaborating details into highly complex schemes. They have been sneered at for this and accused of debasing Plato and of 'inventing' fantasies. However, as the mystics repeatedly point out, no man can give a final description of God and the great cosmic powers.

According to esoteric ideas gnostic 'knowledge' of divine things can only be achieved by degrees and through spiritual techniques concerned with psychic and psychological energies that have to be experienced and known within oneself. This is why, according to the idea of the correspondence of everything in the universe, knowledge of the universe begins with self-knowledge. We are able to observe the development of this idea in Greek philosophy by middle-Platonists such as Philo and the Stoics, but there is no doubt that it is central to traditional esoteric teachings of far greater antiquity.

The Gnostics who worked out their own versions of the cosmic correspondence were working from their own intuitive faculty and poetic creativity.

Henri Corbin has pointed out that

> critics have at their disposal only two categories, *believing* and *knowing*, and they identify gnosis with knowing alone. It is thus completely overlooked that between believing and knowing there is a third mediating term, everything connoted by the term inner vision, itself corresponding to this intermediary and mediatory world forgotten by the official philosophy and theology of our times: the *mundus imaginalis*, the *imaginal* world.[12]

The symbolism and imagery of the Gnostics was the product of an artistic creativity of a high order.

The following Gnostic psalm gives a mystical vision of the universe in which everything, from the highest to the lowest, is dependent on the cosmic level that precedes it.

> All things depending in spirit I see;
> All things supported in spirit I view;
> Flesh from soul depending;
> Soul by air supported;
> Air from Aether hanging –
> Fruits born of the deep –
> Babe born of the womb.[13]

If we take 'flesh' as humanity and 'womb' as the source of life in the universe, the images lend themselves to a scheme of

ascending and descending steps or stages that span the whole universe and which can be expressed as a diagram that reflects the Platonic cosmic plan even though the levels have different names.

<div align="center">

Womb (The Deep)

Babe

Aether

Air (Fruits)

Soul

Flesh

</div>

An interpretation of this psalm is attributed to the Valentinian school of Gnosticism, an account of which is given by the second-century Christian writer Hippolytus.[14] From this we can briefly glimpse something of the picturesque nomenclature of Gnostic allegory. We learn that the 'Soul' is that of the Demiurge or the 'material forces of aetheric space'. Higher than the Demiurge is the Spirit, and beyond that is the Great Limit or Boundary which separates the 'Pleroma' or 'World of Reality' from the Kenoma or phenomenal universe. Beyond the Pleroma, which is also known as the 'Living Aeon' and the 'World of Ideas', is the 'abyss' or 'Great Depth', also sometimes known as the 'Silence', in which is 'God Beyond Being, The Father'. In diagrammatic form it may be represented thus:

<div align="center">

The Father (God Beyond Being)

The Abyss (The Great Depth, The Silence)

The Pleroma (World of Ideas, The Living Aeon)

Horos (The Great Limit, The Boundary)

Sophia (The Spirit)

The Demiurge (Material Forces of Aetheric Space)

The Flesh (Matter)

</div>

For both Hellenism and Christianity this represents a diagrammatic concept that we shall meet in various guises throughout this book and which the Gnostics themselves called the Great

Chain of Being. In neo-Platonism it is called the Doctrine of Degrees; and in Christianity it is known, through Dionysius the Areopagite, as the Divine Ray or the Hierarchy. We shall see that in other schools of knowledge it has other names and that, although the nomenclature differs, the principle of cosmic dependency or relatedness is common to all Hellenistic thought. We shall see in later chapters that in icons it is the background to the 'stage-setting' on which the Christian divine drama is enacted.

It will help us to see this better if we now turn from cosmology to that other aspect of gnosticism identified by Mead as 'definite endeavour and conscious striving' and which we may understand as the psychological side of gnostic teaching. Actually psychology and cosmology are the same in gnosticism; the subject of study remains, and only the focus of our vision changes from the macrocosm to the microcosm. This reveals the mysterious idea that, according to the Law of Correspondences, man the microcosm is in the universe while, simultaneously, the universe – or macrocosm – is in man. This principle is found in all esoteric teachings without exception and accords with all that is authentic in gnostic tradition. By studying the universe man studies himself and by studying himself man studies the universe. Through self-knowledge man may come to know the All.

> Examine yourself that you may understand who you are, in what you may exist, and how you will come to be . . . it is not fitting that you be ignorant of yourself. And I know that you have understood because you have already understood that I am the knowledge of the truth . . . you will be called 'the one who knows himself'. For he who has not known himself knows nothing, but he who has known himself has at the same time achieved knowledge about the Depth of the All. [15]

Knowledge and self-knowledge are synonymous, they are the cosmological and psychological aspects of the same gnosis.

Absence of knowledge is called ignorance and is symbolised in gnosticism, as it is in the gospels, as blindness, darkness, and sleep. The condition of sleep, together with its concomitant state of dreaming, perfectly illustrates the pitiful reality of man imprisoned in psychological darkness. Of course man does not see this reality, and especially not about himself, which is why in gnosticism man is called on to *wake up*.

Those who are in the sleeping state dream of all kinds of disturbances which become the causes of 'terror', 'doubt', and 'division', but

> when those who are going through these things wake up, they see nothing, those who were in the midst of all these disturbances, for they are nothing. Such is the way of those who have cast ignorance aside from them like sleep, not esteeming it anything . . . This is the way each one has acted as though asleep at the time he was ignorant. And this is the way he has come to knowledge as if he had awakened. Good for the man who has 'come to' and awakened and blessed is he who has opened the eyes of the blind.[16]

The next passage, taken from the gnostic teacher Sylvanus, indicates that self-knowedge shows man that he has a three-fold nature consisting of earthly, psychic and divine aspects; to live merely in the flesh is to be just animal, whereas to live in the higher part of himself is to be human; the soul must struggle to find the balance between body and mind. In this text 'body' corresponds to 'earthly' and 'mind' corresponds to 'divine'; the psyche or soul is the intermediary state which is human.

> Know yourself, that is, from what substance you are . . . understand that you have come into being from three races: from the earth, from the formed and from the created. The body has come into being from the earth with earthly substances, but the formed, for the sake of the soul, has come into being from the thought of the divine. The created, however, is the mind which has come into being in conformity with the image of God.[17]

In this teaching, which is traditional both to Hellenistic thought and to Christian theology, we can see the idea of man's 'higher self' and 'lower self'. These ideas are considered to have been absorbed into the teaching of St Antony, the founder of desert monasticism in the fourth century and from which the Philokalia tradition, which we shall be considering in the next chapter, is thought to originate.[18]

However, from the point of view of the Perennial Philosophy there are no historical origins. Reality exists independently and timelessly in a way that is incomprehensible to human perception. It enters the horizontal line of time from a point vertically above the present moment: eternity. The truth takes on the forms of thought and language currently in use at the moment it enters

history and the gnostic view is that we should not be distracted by one or another historical context since spiritual reality can only be experienced in the present.

Let us return to our study of gnostic ideas on self-knowledge. According to traditional esoteric ideas, man as we know him is 'natural man' and is incomplete until he transcends his natural self. As he is, man is a product of the laws of nature only and, as such, he cannot participate in the life of his own higher self; he is not properly in touch with that part of him that belongs, not to nature, but to the cosmos and eternity. Thus it is said that man is incompletely formed. It is here that incomplete man is confronted with the first step he has to take in the next stage of his evolution from 'natural man' to 'spiritual man'; he must be born again 'of the spirit'. The new birth will not be a natural birth but a psychological one. At the present stage man is spiritually at the level of 'ignorance' or 'darkness'; all his spiritual perceptions cannot be other than false and his psychology is chaotic; his inner world is one of confusion and disorder. It is exactly at this point that man must begin to *know himself*, that is, to see the truth about himself and his situation. At the same time we can see why this first step is so difficult. No one willingly sees that he is not what he thinks and has always believed himself to be. We forget the words of the psalmist: 'I am a worm and no man' (Psalm XXII, 6).

A person will only turn to such a teaching if he or she has come to a point of disillusionment with conventional ideas and yet who remains a seeker. Today, in the West at any rate, the lures of material comfort and material security are still thought to be worthy of our life's main aim. But in the third century there was no such affluence to keep ordinary people comfortably asleep. The old ideals of Roman republicanism, with all the benefits of citizenship, were in decline. This had led to serious social and economic breakdowns and, in some cases, the actual collapse of civilisation. Thinking men and women despaired at the tyranny and injustice of an all-powerful and corrupt bureaucracy while a cynical government presided over a world declining irreversibly into disorder and poverty.[19]

This is the period in which we see the proliferation of philosophical societies, religious cults, gnostic groups, various exoteric and esoteric schools such as the Therapeuts and the school of the Essenes from which came John the Baptist and possibly Christ. We see a variety of communities who, having abandoned the

dubious benefits of the cities and material existence, lived a simple and contemplative life together under the guidance of spiritual teachers and who shared everything in common. There was nothing specially new about such communities; Pythagoras' school at Crotona in the sixth century BC was an obvious forerunner of these.

Another example, in the first century AD, is the society known as the Therapeutae who are described in some detail by Philo in *The Contemplative Life*. He refers to them as 'philosophers' and compares their life favourably with the more primitive or decadent practices of other religions.

> I will say as much as is proper concerning those who embrace the life of contemplation.
> The Therapeutae profess an art of healing superior to that in use in cities for that only heals bodies, whereas this heals our souls as well when laid hold of by different and scarce curable diseases, which pleasure and desire, and grief and fear, selfishness and folly, and injustice and the endless multitude of passions and vices inflict upon them.
> The Therapeuts strive for the intuition of that which is, to transcend the sun which men perceive and gaze upon the light beyond.
> They take the step of renouncing their goods and are no longer enticed away by anyone. They make their abode outside the city walls in woods or in enclosed lands in pursuit of solitude.
> Now this natural class of men is to be found in many parts of the inhabited world, both the Greek and the non-Greek world sharing in the perfect good.
> In Egypt there are crowds of them especially around Alexandria. They who are in every way the most advanced come to the Therapeutic fatherland to a spot high on a plateau overlooking lake Mareotis immediately South of Alexandria.
> The dwellings of the community are very simple, not close together as in towns and not so far apart, but pleasing to those who seek solitude.
> In each dwelling there is a sacred place called a shrine or monastery (a small chamber or cell) in which solitude they perform the mysteries of the holy life . . . They always remember God and never forget him . . . Thus many of them, even dreaming in their sleep, divulge the glorious teachings of their holy philosophy. Twice daily they pray, at dawn and at eventide; at sunrise they pray for a joyful day, joyful in the true sense, that their minds may be filled with celestial light. At sunset they pray that the soul may be fully relieved from the disturbances of the senses and the objects of sense, and that, retired to its own consistatory and council chamber, it may search out the truth.

The entire interval between early morning and evening is devoted to spiritual exercise. They read the Holy Scriptures and apply themselves to the ancestral philosophy by means of allegory, since they believe that the words of the literal text are symbols of a hidden nature, revealed through its underlying meanings.

They have also writings of men of old, who were the founders of their sect and left behind many memorials of the type of treatment employed in allegory, and taking these as a sort of archetype they imitate the method of this principle of interpretation.

The interpretations of Holy Scripture are made in accordance with the deeper meanings conveyed in allegory. For the whole of the law seems to these people to resemble a living being with the literal commandments for the body, and for its soul the invisible meaning stored away in words. It is in the latter that the rational soul begins especially to contemplate the extraordinary beauties of the concepts through the polished glass of the words, unfolds and reveals the symbols, and brings forth the thoughts bared into the light for those who are able by a slight jog of the memory to view the invisible through the visible.[20]

Philo himself was not a full member of the Therapeutae but seems to have belonged to one of their outer groups whom he occasionally visited for what today we would call a retreat:

I too have oftimes left my kindred and friends and country, and have gone into solitude in order to comprehend the things worthy to be seen, yet have profited nothing; but my soul was scattered or stung by passion and lapsed into the very opposite current.[21]

We learn from this candid fragment of self-knowledge that the spiritual exercises of the Therapeutae were just those that begin by showing a man the first and, for some, the greatest obstacle in the path of self-knowledge: the pain of seeing his own inner psychological disorder. This spiritual tradition was, as we shall see, also that of the Christian Fathers, whose desert communities, founded in the third century, are but one link in a mystical chain of schools that stretches back to Pythagoras and the Mystery Religions. It linked with Christianity in the Egyptian desert, was later connected with Mount Athos and, after the fourteenth century, also passed into Russia where it was still to be found at the beginning of the twentieth century in the tradition of the *startzi* or 'elders'. We are outlining here the historical existence of Hesychasm. However, its real existence, as we have suggested, is not measured in time but in men's souls.

We shall see in our study of the Philokalia that the attainment

of self-knowledge was considered to be the pre-condition for knowledge of God and that such *gnosis* was based on the development of a special psychic force called attention. Esotericism teaches that only the power of inner attention can assist spiritual rebirth, that is, birth of order out of inner chaos.

According to traditional ideas the action of attentive self-seeing is an action that corresponds to the divine emanation or 'light' by which God illumines the chaos and darkness in the genesis of the cosmos (*kosmos* is the Greek word for 'order'). If man is 'created in the image of God', in other words, if man is intended to be the microcosm of the universe, then he is called to something immeasurably higher than his present situation. In the gnostic view, although God's messengers, including Christ, do all they can to help man fulfil this destiny, he himself also has a vital part to play; his cosmic evolution will not happen automatically and as a result of someone else's work; no one will do it for him.

The various descriptions of the creation in gnosticism, like their prototype in Genesis, are allegories that contain the elements of a struggle between opposed forces, sometimes personified as archons and so on, sometimes presented in the form of abstract images such as forces of light and darkness, or as higher and lower powers. If we accept that any description of the origin of the world must be allegorical, that is, an image to help us see the 'invisible through the visible', and if we accept the idea of the correspondence between macrocosm and microcosm, then the creation of man, meaning here the spiritual birth of man, takes place according to the same laws that created the universe.

This means that the cosmic event that is described in allegorical terms is not only the creation of the world, it is also a description of the event that has to take place within a man who puts into practice the work of his own spiritual evolution. The cosmic situation has to be internalised so that the creation of order out of chaos begins to be engendered from within. This internalising of cosmic events is called 'self-correction', 'work on oneself', and also 'the art of arts and the science of sciences'. It gives a man self-knowledge and leads eventually to his spiritual evolution.

Behind the theory of gnosticism lie esoteric ideas; but, paradoxically, they cease to be esoteric when spoken of or written about. Connected with this is an idea that has ever been the cause of misunderstanding, as much in antiquity as today. This misunderstanding explains the persecutions by Romans of philoso-

phers, by emperors of Christians, by Christians of 'heretics' and much else that is violent in religious and intellectual matters. The question concerns the problem of transmission of 'inner vision' and the knowledge acquired through spiritual work. Such knowledge cannot be transmitted by ordinary means; as soon as it is written about it ceases to be inner vision and becomes outer knowledge; for the person to whom it is addressed it will not be inner knowledge; he can find that himself only through his own inner experience. When knowledge has become internalised in the gnostic sense it becomes real understanding; but understanding cannot be given by one person to another; the moment understanding is externalised it reverts to being ordinary knowledge, that is, facts or information. Such data can be stored in anyone's memory regardless of whether they understand it or not. Therefore to transmit higher knowledge in the ordinary way is to distort it. And it was for this reason that the mysteries either could not be uttered or were manifested in a disguised form.

However, understanding can be shared by people when they have an education and a culture in common. For example, our social or national identities are based on this principle; the shared common experience and training is also an essential component of a religious or philosophical school and is perhaps the main reason for the formation of such communities as existed two thousand years ago and from which evolved the first Christian monasteries.

We have referred to the idea that higher knowledge becomes distorted in the process of transmission. The degree of distortion depends on the degree of understanding (or the lack of it) in the person to whom the knowledge is given. It was in order to protect their knowledge as much as possible that its guardians created elaborate and difficult conditions for their candidates. Not only the mind but the entire being of the student, including 'body' and 'soul', were subjected to long and arduous disciplines. Such training had the aim of raising his understanding to a level where higher knowledge could be received better. It is an ancient principle and one is reminded, for example, of the five years' silence enjoined on candidates for initiation into the school of Pythagoras. Originally the idea of initiation was part of a practical exercise designed for a specific and wise intention. Later the meaning was lost and the 'initiations' became empty rituals.

Higher knowledge can be written about in books and can be spoken about, but these are only descriptions. One who seeks

higher knowledge will only find it in himself, through what he personally is able to experience:

> Abandon the search for God and the Creation and other matters of a similar sort. Look for him by taking yourself as the starting point. Learn who it is within you who makes everything his own and says 'my God' and 'my mind and my soul and my body'. Learn the sources of sorrow, joy, love, hate . . . if you carefully investigate these matters you will find him in yourself.[22]

5

Hesychasm and the Philokalia

ALMOST unknown in the West there exists an extensive literature from the Christian mystics of the East. Some of this has been translated into English, as well as into other European languages, but only comparatively recently. The writings contained in the anthology known as the Philokalia date from the fourth to the fourteenth century. They are the advice and practical teaching of the Byzantine monastic spiritual tradition, the actual techniques of mysticism from spiritual guides to their direct followers. Unlike western and most other mystical writings, those in the Philokalia are neither poetic nor self-consciously literature; they are private documents of a technical nature that were preserved within the Mount Athos monasteries purely for the use of spiritual seekers of later generations. They did not appear in a 'popular edition' until the end of the eighteenth century when the five-volume Philokalia (in Greek: 'love of the good') was compiled by monks on Mount Athos and published in Venice in 1782. Thus they were almost completely unknown until many centuries after they were written and long after the influence and grandeur of Byzantium had passed. In the early nineteenth century the Philokalia was translated into Russian, though Russian monks would have been familiar with it in Greek from at least as early as the fourteenth century. Selections from the Russian version were first translated into English only as recently as 1964,[1] and a complete version in three volumes, translated from the Greek, has been available since 1984.[2]

Some terminology in religious language today can be misleading.

Terms such as 'adultery' and 'flesh' are phrases that now have quite other meanings than were originally intended. For many, such expressions are associated with those ideas of repressive morality on which so much of present-day religious thinking seems to be built. In the Philokalia their true meaning is psychological and allegorical. To understand the Philokalia it is necessary to free oneself of all the ideas of pseudo religion. The hypocrisy and pretence of so-called Christian morality have no place in this psychologically precise teaching. The Philokalia writings contain the basic esoteric ideas that relate to what has been said in the previous chapters. These ideas are not so deeply hidden as in the Old Testament and in the gospels because, as has been pointed out, the texts of the Philokalia were for private use between monks already committed to the path of esotericism. Many passages are commentaries on biblical texts. Their meaning is somewhat obscured for us now because the terminology employed in the English language tends to fall on a series of associative mechanisms in the mind that repudiates such ideas as 'carnal lusts', 'wrestling with demons', 'suppression of passions' and so on. Even concepts such as 'sobriety', 'fasting', 'tears', and 'humility' seem sentimental and pious in our commercial and materialistic times.

It is because of this obscure curtain of automatic associations in our inner world that the 'truth' for which the Christian mystics so patently strove seems unappealing even to those who search in themselves for meaning in their spiritual lives. Today such people are likely to be drawn to oriental esoteric traditions such as Zen, Sufism or Yoga. The very appeal of these paths for many Westerners is the absence of luggage (in the form of associations) on the spiritual journey.

A careful study of the Philokalia, especially if undertaken in the light of a re-interpretation of certain key phrases, will reveal a true and valid way whose methods and techniques, as well as the resulting states of being, are strikingly similar not only to oriental mysticism but to the esoteric and gnostic systems of late antiquity. The esotericism practised on Mount Athos and in Russia has in our times been described as Christian Yoga; it would be even more accurate to describe it as the perennial philosophy or the universal mystical tradition that, in Europe and the Mediterranean, preceded official Christianity by at least a thousand years.

The Foreword to the Philokalia, written by the English translators, begins promisingly. 'The "Philokalia" shows the way to awaken attention and consciousness', and further, 'the primordial condition

and absolute necessity is to know oneself. To gain this knowledge the beginner must be alive to the many sided possibilities of the ego.'[3] Theophan the Recluse, the nineteenth-century translator of the Russian version, and himself a Hesychast (from the Greek *hesychia* = 'silence'), refers to the 'secret life in Christ which is the only truly Christian life'.[4] By the 'secret life' he means the practice of the ideas in the Philokalia which he calls the 'essence of Christianity'. Writers in the Philokalia make the following promises: 'I will impart to you the science of eternal, heavenly life',[5] and 'if you wish to acquire within you your own lamp shedding the mental light of spiritual knowledge . . . I will show you a marvellous spiritual method or means to achieve this, a method not requiring physical labour or exertion, but demanding spiritual work – attention of the mind and thought'.[6]

But the present-day reader of the Philokalia will not find in it a basic introduction to spirituality laid out step by step in easy stages. It is not a primer. In antiquity and in medieval times readers of the Fathers were men who had already passed through the stages of questioning and doubting the values of the existing material world; they had renounced the world and were already on the path towards spiritual knowledge. The Philokalia texts are writings shared among men who were already working together on themselves towards a spiritual ideal. But the missing first steps can be reconstructed from the many passing references in the text.

The ideas in the Philokalia are based on traditional and ancient esoteric teachings about man: what he is and what he can become. According to these ideas man is regarded as a 'tripartite being' consisting of mind, body and soul. Sometimes the term 'spirit' replaces 'mind'. Each of these three aspects of man are in turn subdivided into various categories; for example, one of the subdivisions of the soul is the 'thinking part'. This terminology comes from Platonism and is standard Hellenistic thinking; it is an example of how we have to be careful of certain words that today are differently understood. For example, we think of the term 'mind' as meaning the function of thought, whereas in the Philokalia 'mind' is the same as 'spirit' and is understood as something much higher than mentation. Elsewhere we read that the soul is referred to as subdivided into 'three powers': the 'thinking part' (which we would call the mind), the 'excitable (or energetic) part', and the 'desiring part'.[7] The mind (or spirit) is similarly subdivided into three parts.

The student of the Philokalia also sees that the terminology is

not always consistent, sometimes the same word is employed to convey different meanings – we have seen that we have to to be particularly careful of the word 'mind' – and sometimes there are different words having the same meaning. But behind this apparent lack of precision we can sense a far more important aspect of the teaching than verbal accuracy. The truth of the ideas in the Philokalia can only be reached through practice and experience; there are frequent exhortations to trust neither words nor the 'reasoning power of the mind'. Man is considered to have higher mental or spiritual possibilities than ordinary logical thinking which is considered to be tied to, and on the same level as, the bodily senses. In ordinary life we live according to the perceptions of the senses and what we call rational thought; but the method of the Philokalia calls us to an inner turning towards a state of being not dependent on the external world. This special interior state is referred to as 'prayer', 'sobriety', 'passionlessness', 'silence', and so on. And in order to maintain this state in himself a man must wage a ceaseless and 'unseen warfare' against 'imagination', 'thoughts', and the 'aimless circling of the mind'. The weapon with which he guards his inner state against the endless distractions of the mind is attention.

The Fathers distinguish several kinds of knowledge that correspond to the different aspects of man. There is 'natural knowledge' or the state of knowing that relies on the evidence of the senses, but the Hesychast is called to renounce natural knowledge and to submit himself to a series of disciplines that are contrary to his natural inclinations. Instead of gratifying the desires of his mind and his body he must practise 'fasting, prayer, alms, reading the divine scriptures, virtuous life, struggle with passions and so on'.[8] By these means a man begins to collect 'what is useful for the journey into true life'.[9] He also begins to acquire a 'second degree of knowledge' sometimes known as 'contra-natural knowledge'. The attainment of this new knowledge leads to 'mastery over desires' or self-mastery and also self-consciousness. There exists a third degree of knowledge called, in the Philokalia, 'supra-natural knowledge'. This corresponds to what has been called elsewhere objective consciousness. It is 'the degree of perfection . . . a man becomes finer, acquires that which is of the spirit, and in his life comes to resemble the invisible powers which perform their service not through sensory actions but through vigilance of mind. When knowledge soars above earthly things and the cares of earthly activities, when it begins to experience thoughts belonging to what is within and hidden'.[10]

We call natural knowledge the knowledge the soul can receive by using natural methods and powers to investigate and examine creation and the cause of creation, as far as this is possible of course for a soul tied to matter. For the energy of the mind is weakened by its closeness to, and fusion with, the body, as a result of which it cannot have direct contact with intelligible (spiritual) things but needs to form images for thinking of them. And the natural function of the imagination is to create images, which have extension and volume. Thus since the mind (mentation) is in the flesh it requires corresponding images for forming judgements about them and understanding them.

But supra-natural knowledge is knowledge which enters the mind by a way which transcends its natural means and powers, or in which the object of knowledge is transcendent in relation to the mind tied to the flesh, so that such knowledge is clearly the attribute of an incorporeal mind (The Blessed Theodore, date unknown).[11]

It is impossible that spiritual knowledge should be received by mental knowledge, it cannot even be experienced in feeling by a man who zealously exercises himself in natural knowledge. If any such wishes to approach this spiritual knowledge, he cannot come nearer to it until he renounces natural knowledge with all its subtle twistings and manifold methods . . . on the contrary the habits and ideas of natural knowledge are a great hindrance for him . . . The spiritual knowledge is simple and does not shine in natural thoughts. Until the mind is freed of the multitudes of thoughts and has achieved the single simplicity of purity, it cannot experience spiritual knowledge (St Isaac of Syria, sixth century).[12]

Spiritual mysteries are above knowledge and cannot be apprehended by the physical senses or the reasoning power of the mind (St Isaac of Syria, sixth century).[13]

What we are always meeting [in spiritual work] is subtle and incomprehensible, and cannot be embraced by knowledge of our mind in the states in which we involuntarily find ourselves (St Isaac of Syria, sixth century).[14]

The question arises, how can the mind be freed? How can natural knowledge be renounced? It is at this point that the candidate for Hesychasm has to abandon 'knowledge' and theoretical studies. He must begin the journey in practice; he must start acquiring that other kind of knowledge which only comes through the techniques of inner silence, contemplation and non-attachment. Altogether new possibilities arise here that have little to do with words and ideas. But his practical spiritual work must be carried out under the instruction of a teacher or superior. Again, it cannot be stressed too often, it is a matter of experience and not of theory.

The instructor is one who has himself already travelled along the path and who, from his own practical knowledge, points out the way. In a literal sense he is a guide.

> If you wish to contemplate the mysteries, cultivate the commandments by actual practice (St Isaac of Syria, sixth century).[15]

> Knowledge without corresponding practice is still insecure. All is made firm by practice (St Mark the Ascetic, fifth century).[16]

> You will never learn the work of spiritual striving by words alone (St Abba Dorotheus, sixth century).[17]

> Accept without fail the words spoken from experience, even if the speaker is not learned in books (St Isaac of Syria, sixth century).[18]

> Do not utter before God anything which comes from knowledge . . . The wise in the world have renounced their knowledge . . . All suffering wisdom is not acquired by book learning (St Isaac of Syria, sixth century).[19]

> Do not trust your knowledge (St Isaac of Syria, sixth century).[20]

> Confide in a man who has studied the work in practice rather than to a learned philosopher, who reasons on the basis of speculation with no practical knowledge (St Isaac of Syria, sixth century).[21]

> He who works from hearsay or reading and has no practical instructor works in vain (St Gregory of Sinai, fourteenth century).[22]

> Having the word of God means the state of contemplation and not abstract theology (St Simeon the New Theologian, tenth century).[23]

> The man ministers the gospels who, having participated in them himself, can actively pass on to others the light of Christ (St Gregory of Sinai, fourteenth century).[24]

Just as the the mystical path in ancient India was called the 'Way of Self-Knowing', or the essence of Greek religious thought is summed up in the formula 'Know Thyself', so does self-study play a central role in Hesychasm. This aspect of Christian spirituality has scarcely been acknowledged by the Established Church and few theologians have stressed its importance. Yet in the Philokalia, among the earliest writings, we find

> Do you wish to know God? learn first to know yourself (Abba Evagrius, fourth century).[25]

Self-study is the basic pre-condition:

let us desire the renewal of our inner spiritual man . . . let us wish at all hours to watch over ourselves (St Isaac of Syria, sixth century).[26]

Self-watching has to be precise:

a man . . . must observe his thoughts and notice on what they lay emphasis and what they let pass, which of them, and in what circumstances, is particularly active, which follows which and which of them do not come together (Abba Evagrius, fourth century).[27]

A man engaged in the practice of watching over himself soon discovers that

through neglect the mind has acquired the habit of wandering hither and thither (St Gregory of Sinai, fourteenth century).[28]

and that

the mind has in itself a natural power of dreaming and can build fantastic images of what it desires in those who do not apprehensively pay attention (St Gregory of Sinai, fourteenth century).[29]

It is soon apparent that man is not as he should be; as he is in his present state he is a kind of misfit not properly entitled to the name of man.

He alone can be called a man who can be called intelligent (true intelligence is that of the soul), or who has set about correcting himself. An uncorrected person should not be called a man (St Antony the Great, third century).[30]

Such is the condition of man. Caught between two worlds, that of the visible sensory world, 'the flesh', and that of the invisible world, 'the spirit', he falls between the two. He is not just an animal and is not yet properly a man. He has a 'soul' which is in darkness and enslaved by his attachments to the material world. From the visible world and the perceptivity of the senses come 'thoughts' which crowd out his inner life with their agitation and noise so that inwardly he can have no peace; he can only stagger about in a confused and 'drunken' state.

With the idea of an 'uncorrected person' we have the psychological meaning of 'fallen man'. Man is trapped in darkness; he must work for his own salvation for no one else will do it for him. The method proposed in the Philokalia puts into practice

the method of redemption which is essentially taught in the gospels.

It can be said that Hesychast practice provides an essential preparation for understanding the gospels because in a quotation reminiscent of Origen,

> few have the power to understand the meaning and significance of the scriptures (St Simeon the New Theologian, tenth century).[31]

The condition of man would be hopeless were it not for the fact that

> In creating man God implanted in him something divine – a certain thought like a spark, having both light and warmth, a thought which illumines the mind and shows what is good and what is bad. This is called conscience and is a natural law . . . Through the fall men covered up and trampled down conscience, therefore arose the need to rekindle this buried spark (St Abba Dorotheus, sixth century).[32]

The tool for rekindling the spark is attention. It is by attention on himself that a man can withdraw the powers of his mind from their state of dispersion among the senses and the multitude of thoughts they give rise to. Attention is the magic talisman that makes the proposals of Hesychasm practical possibilities.

> The holy Gospels are the image of attention (Hesychius of Jerusalem, fifth century).[33]

> Some have called attention the safe keeping of the mind, others the guarding of the heart, yet others sobriety, yet others mental silence (Nicephorus the Solitary, fourteenth century).[34]

> Attention is: the appeal of the soul to itself; the beginning of contemplation; serenity of mind, or rather its standing firmly and not wandering; cutting off thoughts; the treasure house of power to endure all that may come; the origin of faith, love and hope (Nicephorus the Solitary, fourteenth century).[35]

> Some of the Fathers call this doing silence of the heart, others call it attention, yet others sobriety and opposition to thoughts, while others call it examining thoughts and guarding the mind (St Simeon the New Theologian, tenth century).[36]

> Bring the mind from its customary circling and wandering outside and quietly lead it into the heart by way of breathing (The Monks Callistos and Ignatius, fourteenth century).[37]

Wealth is brought to the soul from the daily practice of attention (Hesychius of Jerusalem, fifth century).[38]

Here we approach the heart of Hesychast mysticism. Let us refrain from comment as much as possible and let the Fathers speak for themselves so that their voices may be heard within our own interior silence.

The next group of quotations lays stress on the senses and the need for the attention to watch over thoughts that arise from them and to prevent them from disturbing inner silence.

If you wish to come to knowledge of the truth always urge yourself to rise above sensory things . . . thus compelling yourself to turn inwards. You will meet principalities and powers which wage war against you by suggestions and thoughts (St Mark the Ascetic, fifth century).[39]

I enter a state where my senses and thoughts are concentrated (St Isaac of Syria, sixth century).[40]

It is impossible to subjugate these external senses to the authority of the soul without silence and withdrawal (St Isaac of Syria, sixth century).[41]

Sensory perception, or the perception of sensory images belongs to the *man of action*, who labours over attaining virtues. Non-perception by the senses, or being unmoved by sensory perceptions belongs to the *contemplative* who concentrates his mind on God (St Maximus the Confessor, seventh century).[42]

God the Word appears in an unknown way not according to the order of sensory events (St Maximus the Confessor, seventh century).[43]

The power of irrational love of life, or animality, has become so deeply rooted in human nature through the senses, that many regard man as being no more than flesh, which is capable of enjoying only the present life (St Maximus the Confessor, seventh century).[44]

Never let ourselves be robbed by the sensory (The Blessed Theodore, date unknown).[45]

To the senses we prescribe what they have to receive and in what measure; this practice of spiritual law is called self-mastery (St Gregory Palamas, fourteenth century).[46]

Silence kills the outer senses, but brings inner movements to life (The Monks Callistus and Ignatius, fourteenth century).[47]

Look beyond the limits of the sensory (The Monks Callistus and Ignatius, fourteenth century).[48]

> The loosing of the senses lays fetters on the soul; fetters on the senses gives freedom to the soul (Theoleptus, Metropolitan of Philadelphia, fourteenth century).[49]

Many things in the Philokalia are said about 'passions'. This word has not quite the same meaning as it has in ordinary language, though it is related to emotional impulse. The passions that Hesychasm speaks of are, for the most part, invisible movements of psychic energy between the mind and emotions related to the senses. Only a man engaged in inner work, in the search for self-knowledge, can begin to throw light on this kind of activity taking place within himself but beyond the sight of his ordinary consciousness. Special attention is necessary to see what goes on beneath the surface, attention that itself has to be cultivated by long practice and exercises. Without it a man cannot know himself psychologically, and descriptions he may come across will mean little to him unless he himself is interested in the path of self-knowledge. This is why documents like those that constitute the Philokalia were kept secret for so long; they have almost no meaning outside the circles in which they were used, or worse, they are easily misunderstood and misused.

What we like and dislike – our opinions, attitudes and beliefs – are nearly always sustained by, as well as being the results of, that form of emotional identification that the Hesychasts call passion. Up to a point we are aware of these results but we do not suspect their psychological origin. Our fixed, inner emotional attitudes are the bricks with which are built the walls of our spiritual prison; it is because of them that we are not free to move inwardly, to open to all the newness and richness of life and people around us.

Passions exist in the different components and subdivisions that constitute man. There are 'passions of the excitable part; bodily passions; passions of speech and tongue; passions of mind; passions of thought'.[50]

> Passions are like dogs, accustomed to lick the blood in a butcher's shop; when they are not given their usual meal they stand and bark (St Isaac of Syria, sixth century).[51]

> An object is one thing, a representation is another, passion yet another. An object is for example a man, a woman, gold and so forth; a representation – a simple memory of some object; passion – either an irrational love or an undiscerning hatred of these things. It is against such passions that monks wage war (St Maximus the Confessor, seventh century).[52]

Every passion is composed and born of some sensory object and the senses (St Maximus the Confessor, seventh century).[53]

Recall the powers of the soul from their dispersion among objects of passion (The Blessed Theodore, date unknown).[54]

First comes *impact* (contact, action when a thing thrown hits the thing at which it is thrown): then comes *coupling* (joining together: attention is fettered to the object so that there exists only the soul and the object which has impinged on it and occupied it); next comes *merging together* (the object which has impinged upon the soul and occupied the attention has provoked desire – and the soul has consented to it – has merged with it); then comes *captivity* (the object has captured the soul which desired it and is leading it to action like a fettered slave); finally comes *passion* (sickness of the soul) inculcated in the soul by frequent repetition (repeated gratification of the same desire) and by habit (Philotheus of Sinai, date unknown).[55]

The state of 'passionlessness' is not a passive silence but a highly active one maintained by all the powers of attention and spiritual vigilance.

Passionlessness means not only not feeling passions but not accepting them from within (The Monks Ignatius and Callistus, fourteenth century).[56]

The best method to resist passions is to plunge deep into the inner man and remain there in seclusion, constantly tending the vineyard of one's heart (St Isaac of Syria, sixth century).[57]

The first passionlessness is refraining from evil actions; the second is totally renouncing all thoughts of mental consent to evil; the third is utter stillness of passionate desire; the fourth is complete purification from even the barest and simplest images (St Maximus the Confessor, seventh century).[58]

A man seeking self-knowledge and enlightenment by the means at his disposal through the Hesychasts must also be constantly engaged in mental warfare or the

secret war of the mind (St Isaac of Syria, sixth century).[59]

Without the discipline of attention the mind is in a disorganised and dispersed state as the Fathers never cease to remind us.

Thanks to its habit of turning among thoughts the mind is easily led astray (St Nilus of Sinai, fifth century).[60]

No one can overcome the wandering of thoughts, save only by spiritual knowledge . . . Our mind is volatile, unless it is tied to some meditation it never stops wandering (St Isaac of Syria, sixth century).[61]

Thoughts change instantly one from the other; what gives them power over us is mostly our own carelessness (St Gregory of Sinai, fourteenth century).[62]

We would strive to be empty, even of thoughts which appear to come from the right, and in general of all thoughts, lest thieves are concealed behind them (Hesychius of Jerusalem, fifth century).[63]

The science of sciences and the art of arts is the capacity to master harmful thoughts (Hesychius of Jerusalem, fifth century).[64]

Strive with all your efforts to cultivate the virtue of attention, which consists in watching and guarding the mind and establishing a blessed state of the soul free of fantasies (Hesychius of Jerusalem, fifth century).[65]

Although our outward aspect is appropriate for prayer we follow thoughts that lead us astray, for we kneel and appear to those who see us to be praying; in our thoughts we imagine something pleasant, graciously talk with friends, angrily abuse enemies, feast with guests, build houses for relatives, plant trees, travel, trade, are forced against our will into the priesthood, organise with great circumspection the affairs of the churches placed in our care, and go over most of it in our thoughts, consenting to any thought that comes along (St Nilus of Sinai, fifth century).[66]

Written in the early fifth century these last remarks are a direct piece of self-observation that lives on the page with the freshness of truth. It is by such examples that self-knowledge is a teacher.

A constant theme in the Philokalia is the duality of man composed of senses and sensory perceptions in his outer and visible life, and of a soul or inner and invisible life. The outer world belongs to perishable matter; the inner world belongs to God:

Since man is composed of soul and body he is under the action of two laws, that is the law of the flesh and the law of the spirit; the law of the flesh has a sensory action and the law of the spirit

has a mental or spiritual action. Moreover, acting in a sensory manner the law of the flesh habitually links man with matter, whereas the law of the spirit, acting mentally or spiritually, brings about direct union with God (St Maximus the Confessor, seventh century).[67]

Alone of all visible and invisible creation [man] is created dual. He has a body composed of four elements, the senses and breath, and he has a soul invisible, insubstantial, incorporeal, joined to the body in some ineffable and unknown manner; they interpenetrate and yet are not compounded, combine and yet do not coalesce. This is why man is both mortal and immortal, both visible and invisible, both sensory and intellectual [i.e. spiritual], capable of seeing the visible and knowing the invisible creation (St Simeon the New Theologian, tenth century).[68]

But man's capability of 'knowing the invisible creation' depends on the arousing and the sustaining of his inner faculties. Unlike his animal nature which develops by itself, man's spiritual side comes to him incomplete and as a possibility only. An entirely new universe exists beside the one that he knows through physical perception, but he has to find it himself. In the following extract, which shows clearly the idea of two worlds, the word intellect should not be taken as meaning the function of thinking. Intellect here has the sense found in Platonic philosophy where it means 'higher intelligence' or spirit.

[There are] two worlds, the visible and the invisible . . . Two suns shine in these two worlds, one visible and the other intellectual. In the visible world of the senses there is the sun, and in the invisible world of the intellect there is God, who is called, and is, the truth. The physical world and everything in it is illuminated by the physical and visible sun, but the world of the intellect and those who are in it are illuminated by the sun of the truth in the intellect. Moreover physical things are illuminated by the physical sun and things of the intellect by the sun of the intellect separately from one another, for they are not mixed with or merged into one another – neither the physical with the intellectual nor the intellectual with the physical (St Simeon the New Theologian, tenth century).[69]

The Fathers frequently use *outer* and *inner* as images of the visible and invisible worlds:

It is not outside themselves that those who seek the Lord should seek but in themselves (St Maximus the Confessor, seventh century).[70]

Collect the mind which is dispersed by the senses and introduce it within (St Gregory Palamas, fourteenth century).[71]

Listen how persistently those fathers advise men always to lead the mind within and hold it there (St Gregory Palamas, fourteenth century).[72]

Strive to enter your inner chamber and you will see the chamber of heaven, for the two are the same and the one entrance leads to both (The Monks Callistus and Ignatius, fourteenth century).[73]

You see brother, that not only spiritual but general human reasoning shows the need to recognise it as imperative that those who wish to belong to themselves, and to be truly monks in their inner man, should lead the mind inside the body and hold it there. It is not out of place to teach even beginners to keep attention in themselves and to accustom themselves to introduce the mind within through breathing. For no one who thinks rightly would dissuade those, who have not yet attained contemplation, from using certain methods to lead the mind into itself. In those who have not undertaken this work the mind, when collected within, often jumps out, so that, just as often, they have at once to bring it back; but in those who are not practised in this work, the mind slips away, since it is extremely mobile and hard to hold by attention to singleness of contemplation. Hence some advise them to refrain from breathing fast, but to restrain their breath somewhat, so that together with their breath, they may hold the mind inside, until, with God's help, through training, they accustom the mind not to go out into its surroundings and mingle with them, and make it strong enough to concentrate on one thing. However, this (restraining of the breath) naturally follows attention of the mind (or accompanies it) as anyone can see; for if one meditates deeply on something, the breath goes in and out slowly, especially in those who are silent in body and spirit. For these, keeping spiritual Sabbath and resting from all their activities, as far as is fitting, suspend the diversified movements and powers of the soul, especially in relation to collating information, to all sensory receptivity and, in general, to all movements of the body, which are in our control (St Gregory Palamas, fourteenth century).[74]

An important idea is introduced here which is the role of the body in spiritual work. The writer speaks of being 'silent in mind and body' and of 'suspension of all bodily movements'. The body is the ground on which all movements of the mind and soul take place. In itself the 'body is not evil',[75] indeed 'your body is the temple of the Holy Ghost which is in you' (I Cor. IV, 19). Attention must be given to the body so that it remains

in a 'good orderly state'.[76]

The aberrations and fanatic physical deprivations that one sometimes hears of are symptoms of decadent forms of monasticism. They originate from the simple disciplines to which it is necessary to subject the body and the world of sensory perceptions that belong to it, and they are examples of how a balanced teaching can be distorted through wrong understanding. If disciplines for the body are taken to extremes, and without the corresponding mental work, aberration easily occurs.

If the relationship of the mind and the body has gone wrong the Fathers say, 'You should blame your thought and not your body, for if the mind had not run ahead, the body would not have followed.'

> Those who have acquired the passionless state of the soul through this very body and are diligent in contemplating the One Who Is, as far as is in their power, again with the help of the body, profess the bounty of the creator (Abba Evagrius, fourth century).[77]

> The mind cannot become silent without the body (St Mark the Ascetic, fourth century).[78]

> The inner man usually accords with the outer (the outer movements and postures) (St Gregory Palamas, fourteenth century).[79]

> Do not believe that inner thoughts can be stopped unless the body is brought into a good, orderly state (St Isaac of Syria, sixth century).[80]

From the many references in the Philokalia it is evident that special exercises were given for breathing, posture, repetition and movement. Such exercises cannot be learned from books; only an authorised guide or a teacher has the right, and the psychological insight, to give a particular exercise. What will suit one candidate, and perhaps help him take a necessary step in his development, will not necessarily suit another. The teacher must have knowledge, not only of different exercises, but of the special needs corresponding to the different types he instructs. But as a general principle manual labour is considered always useful, not so much in itself, though that can have its value; but more important is the possibility provided by the conditions of the task for bringing attention to both the physical as well as the mental state in which the work is carried out.

> A body labouring at some piece of work keeps the thought close by, since the task of thought, like that of the eyes, is to watch over that

which is being done and help the body act faultlessly (St Nilus of Sinai, fourteenth century).[81]

An aspect of the Hesychast method that has received some attention in recent times is the exercise of repetition using the so-called Jesus Prayer. While not denying the importance of such an exercise it should not be taken out of the context of the total teaching. The mere repetition of a phrase, unaccompanied by the right kind of inner attention as well as, in some cases, the right kind of work for the body, is in danger of becoming mechanical. There are no simple means that, in themselves, give a higher state of consciousness, nor are there any automatic methods.

It is also important in spiritual work that special care be taken when there sometimes appear, particularly to beginners, certain euphoric phenomena that can occasionally accompany inner work. While such states are not abnormal they should not be mistaken for higher knowledge or higher energy just because they are new. They are a by-product and, though perhaps pleasant or fascinating, they should not be a distraction. The Philokalia contains frequent warnings against 'beguilement', 'mirages', or 'beauty'. Once again it is a question of the right guidance.

> He who works at the prayer from hearsay or from reading, and has no instructor, works in vain (St Gregory of Sinai, fourteenth century).[82]

> It is necessary to seek a teacher who is not himself in error (Nicephorus the Solitary, fourteenth century).[83]

The various writings in the Philokalia are about a way of knowledge. The Philokalia is not itself the way, nor does it purport to be a systematic exposition of the way. The different passages, which span a period of a thousand years, are notes, commentaries and advice; experiences shared among fellow participants. To enter the thought of these writings it is necessary to be oneself sincerely in search of true meaning in one's life. At the same time they are not exclusive. Although not everyone is on the way, the way is in everyone. The Philokalia is a universal treasure house.

We will leave our brief study of the Philokalia with a few quotations whose general relevance is as much for our own times as for those spiritual men who sought and found the truth a thousand years ago.

Constantly remember the nearness of death (St Isaac of Syria, sixth century).[84]

Men should be careful not to die like dumb animals (St Antony the Great, third century).[85]

We have neither memory of death, nor attention on ourselves, we do not question ourselves about how we spend our time, but live heedlessly (St Abba Dorotheus, sixth–seventh century).[86]

Constantly say to yourself 'there already at the door is the messenger come for me. Why am I idle? My removal is for ever; there will be no return' (St Isaac of Syria, sixth century).[87]

6

Plotinus and Neo-Platonist Philosophy

THIS chapter does not intend to be a complete study of the philosophy of Plotinus. Our more limited aim will be to try to understand something of the ideas by which it is claimed that Plotinus is the father of western mysticism. We shall try to see that through Origen, who may have been his fellow pupil, and through Dionysius the Areopagite, through St Augustine, and through the mystics of the Alexandrine School, Plotinus' vision of the universe, which had come down to him from Pythagoras and Plato, became integral to Christian philosophy.

In the third century, just before the foundation of the first monasteries and the Hesychast movement, the authentic way for seekers of reality was taught by the philosopher Plotinus. He evidently considered himself to be a Platonist though subsequent generations have referred to his ideas as neo-Platonism. During his active life Plotinus taught by direct oral method to the group of followers who came to his school outside Rome. Only at the end of his life, at the insistence of his pupils, did he commit his teaching to writing. After his death his pupil and biographer Porphyry organised Plotinus' essays into a systematic form which we know as the 'Enneads'.[1] It is through this book that Plotinus is recognised as an incomparable genius whose philosophy deeply influenced the greatest minds of the Middle Ages in Byzantium, in Renaissance Italy and in the Arabic world.

Plotinus was not a writer in the conventional literary sense, he seems to have cared little for style, nor was he willing to simplify for the sake of his readers. But his philosophical stature is supreme

and, rather than descending to our level, he invites us to ascend to his. We have to attune ourselves not only to his thought but to the higher states to which he undoubtedly had access.

There are definite indications that Plotinus lived and practised the life of a spiritual master and that the cosmic and psychological ideas that he spoke about were real experiences of his inner life. A revealing statement to this effect is made by Porphyry who tells us that 'he was able to live at once within himself and for others: *he never relaxed his interior attention*', and, further, that he maintained an 'unbroken concentration on his own highest nature'.[2] Plotinus himself tells us in a passage on imagination that 'philosophy's task is that of a man who wishes to throw off the shapes presented in dreams, and to this end *recalls to waking* the mind that is breeding them'.[3] In this case the word 'philosophy' means 'true philosophy' or spiritual work, and not speculative philosophy.

Elsewhere he says that 'our task is to work for liberation' from the sphere of 'all this evil',[4] by which he means man's identification with the body and the senses and his ignorance regarding the soul. The psychological side of Plotinus' teaching is often close to that of the Hesychasts. For him the fall of the soul accounts for its state where it is

> unstable, swept along from every ill to every other, quickly stirred by appetites, headlong to anger, hasty to compromises, yielding at once to obscure imaginations, as weak in fact as the weakest thing made by man or nature, blown about by every breeze, burned away by every heat.[5]

Such an observation is typical not only of Hesychasm but of any mystic actively engaged in spiritual endeavour.

According to Plotinus the soul of man is a particle of the All Soul which is one of the three Persons (or Hypostases) of the Divine Realm. This particle has fallen from a higher cosmic place into one of the lowest places in the universe, namely matter.

> This is the fall of the Soul, this entry into matter: thence its weakness: not all the faculties of its being retain free play, for Matter hinders their manifestation; it encroaches upon the soul's territory and, as it were, crushes the soul back; and it turns to evil all that it has stolen, until the Soul finds strength to advance again.[6]

He compares the experience of the soul fallen into matter with that higher level which must be our spiritual goal. He makes a sharp distinction between our 'sense-bound' life and the higher life of the soul.

> Thus far the beauties of the realm of sense, images and shadow pictures,

fugitives that have entered into matter . . . But there are earlier and loftier beauties than these. In the sense-bound life we are no longer granted to know them, but the Soul . . . sees and proclaims them. To the vision of these we must mount leaving sense in its own low place. [7]

Plotinus eloquently calls us to see that the possibility for spiritual evolution is found in the inner life.

He that has the strength let him arise and draw into himself, forgoing all that is known by the eyes, turning away for ever from the material beauty that once made his joy. When he perceives those shapes of grace that show in body, let him not pursue: he must know them for copies, vestiges, shadows and hasten away towards That they tell of.

'Let us flee then to the beloved Fatherland' [Plotinus is quoting Homer] this is the soundest council. But what is the flight? How are we to gain the open sea? For Odysseus is surely a parable to us when he commands Circe or Calypso – not content to linger for all the pleasure offered and all the delight of sense filling his days.

The Fatherland to us is There whence we have come, and There is the Father.

What then is our course, what is the manner of our flight? This is not a journey of the feet; the feet bring us only from land to land; nor need you think of a coach or ship to carry you away: all this order of things you must set aside and refuse to see: you must close the eyes and call instead upon another vision which is to be *waked within you*, a vision the birthright of all, which few turn to use. [8]

This passage continues with the invitation to 'withdraw into yourself and look' and proposes an inner work of self perfecting which he compares to the work of a sculptor who

cuts away here, smooths there, he makes a line lighter, this other purer, until a lovely face has grown upon his work. So do you also: cut away all that is excessive, straighten all that is crooked, bring to light all that is overcast. [9]

He speaks with authority about working on one's inner self and the aim of achieving a state

when you are self-gathered in the purity of your being, nothing now remaining that can shatter that inner unity. [10]

Plotinus, concurring always with authentic spiritual tradition, takes the view that the senses and the bodily organs are useful functions in so far as they can aid man in his search for right

perception. To indulge the senses for the sake of pleasure or curiosity he considers 'a waste of energy' and to be the 'sign of suffering or deficiency'. He refers to the inner world as 'an area' where 'we cannot be indolent'.[11]

However, the Enneads of Plotinus are not primarily commentaries on the practice of spiritual life as, for example, is the Philokalia. The Enneads are a dense and sometimes bewildering exposition of the Platonic doctrines of man and the universe whose common link is the Soul. Plotinus assumes in his hearers at least a familiarity with the practice of spiritual work. He makes occasional references to 'mastery of our emotions and mental processes',[12] 'conscious attention',[13] and so on, while his main preoccupation is to understand man's extension, or possible extension, in eternity. From this lofty viewpoint, the life of earthly man is of little interest except that it defines the lower reaches of the universe and is the starting point of the Soul's return journey to its origin.

We shall try to set out, in simplified form, Plotinus' version of Greek philosophy's vision of the cosmos, known as the Doctrine of Degrees. The main principles will already be familiar to the reader: the gradations of the universe from higher to lower; the soul, fallen from a high place, making its return journey; the relatedness of everything.

A theme that frequently recurs is that of the image. This is especially relevant to the idea that the lower imitates, or is an image of, the higher. Hence the role of the symbol which describes, by reference to the knowable and visible, that which cannot be known and seen: 'All teems with symbol.'[14] The idea that things and events in the universe are similar but exist at different levels implies a unifying principle by which everything is related; everything, including man, is part of the whole.

The Totality, or One, or The All, is the Divinity from which flow 'all the forms and phases of Existence';[15] at the same time they 'strive to return Thither and remain There'.[16] The Divinity, or Divine Realm, in neo-Platonism is approached through an idea, a philosophical concept, or possibly a mathematical symbol, but it is not personified.

In the Enneads the universe is understood as an absolute totality, a perfect and ideal being. It consists of a hierarchical scale of cosmic beings some of which are perceptible to the senses, such as planets and stars; but the higher more 'divine' beings are beyond the range of ordinary human perception. Man himself is placed low down in the cosmic system, though in his soul he bears a particle of the

great cosmic being known as the 'All-Soul', with which he has the possibility of ultimately reuniting himself.

The All-Soul is one of the three beings or 'hypostases' who together constitute the Divine Realm. It is generated by, or is the emanation of, the hypostasis that stands next highest in the cosmic hierarchy and who is the second hypostasis of the Divine Realm. This second hypostasis is named the Divine Mind or the Intellectual Principle (in Greek *nous*).

The first hypostasis of the Supreme Divine Triad is variously referred to as the One, the Absolute, the Infinite, the Unconditioned; also sometimes the Father.

At the same time we have to try to grasp that the Absolute, or the One is also the Many, since it is itself the Totality of all that exists and contains all within itself. Likewise the Divine mind contains all intelligences. According to MacKenna, Plotinus' translator,

> the Intellectual or Intelligible Universe contains, or even in some senses is, all particular minds or intelligences; and there, in their kinds, are images, representations, phantasms, 'shadows' of this universal or Divine Mind. All phases of existence – down even to matter, the Ultimate, the lowest image of Real-Being – are all 'ideally' present from Eternity in this realm of the divine Thoughts, this Totality of the Supreme Wisdom or 'mentation'.[17]

In a similar way, the All-Soul is the origin and container of all souls, who by the fact of their identity with the Universal Soul of the All are themselves potentially divine. The All-Soul is known as the Eternal Cause of All that Exists, the Vital Principle of all that is lower than the Divine Triad.

Below the three hypostases of the Divine Realm comes the 'Material or Sense-Grasped Universe'. The highest stage of this level is the Gods; also known as Ideas, Divine Thoughts, Archetypes, Intellectual-Forms of all that exists in the lower spheres, the Spiritual Universe, Real Beings, Powers.

Descending further from the Divine Realm we come to the stage of beings known by the following names: Supernals, Celestials, Divine Spirits, or Daimones.

Yet further down comes Man, who is constituted in three phases, or images of the Divine Soul:

1 the Intellective-Soul, or Intuitive, Intellectual or Intelligent Soul; or the Intellectual Principle of the Soul;
2 the Reasoning Soul;

3 the Unreasoning Soul.

In the terminology of the Philokalia these three phases of man correspond to:

1 Spirit (or Mind)
2 Soul
3 Body

Below Man comes Matter, the 'lowest and least emanation of the creative power'.

And beyond Matter there is the level of 'Absolute Non-Being'.

A simplification, and an approximation of this scheme can be expressed in a diagram (see Fig. 4). A further simplification produces this final reduction which remains a true image of the universe:

>The Absolute
>
>The Divine Mind
>
>The All-Soul
>
>The Intelligible Universe
>
>Celestials
>
>Man
>
>Matter
>
>Absolute Non Being

The higher levels of the universe have progressively more being and less matter and, conversely, the lower parts of the universe have less being and more matter. Matter is described as indefinite: 'matter is essentially indefiniteness',[18] also 'in the lower Sphere there is less Being'.[19] The higher spheres come progressively closer to the Reason-Principle which defines and delimits matter, bringing it under order. Throughout the whole universe the presence of matter (or Indefiniteness) is one of degree or 'phase' according to the level of being in relation to the Reason-Principle. Plotinus defines the difference between phases of Indefiniteness as 'the difference between Archetype and Image'. Thus each cosmic phase is at once an image of the phase superior to it and the archetype for the phase inferior to it.

This correspondence of the lower to the higher is probably the most ancient and universally held philosophical idea, expressed, in the Hermetic formula 'As above so below' and in the words of the Lord's Prayer, 'Thy will be done on earth as it is in heaven'.

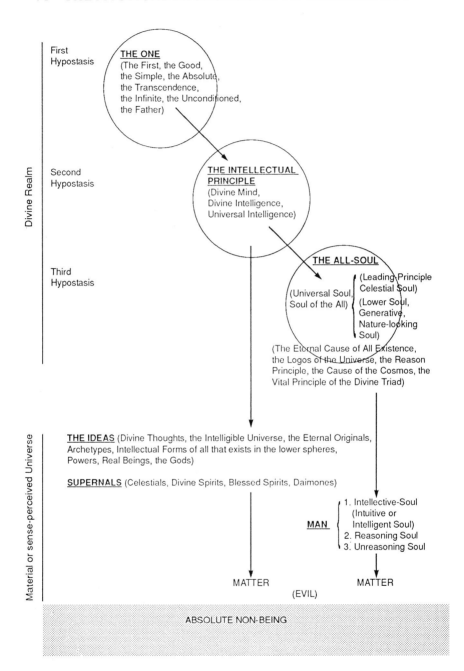

Figure 4. Plan of the Universe according to the neo-Platonic vision. (See also Figs. 3 and 13.)

The idea of *archetype* and *image* seems not far from the teaching of the Christian theologians who, in defence of icons, spoke of *prototype* and *image*. In the latter case the icon is understood to be the image, made in the lower world of a heavenly principle or prototype whose actual existence is in the divine world.

In a passage on 'the Universe which has a ruling principle and a first cause operative downwards through every member' Plotinus calls us to understand the structure of the universe, the relationship of the parts to the whole, and our relationship with everything that exists.

> We may think of the stars as letters perpetually being inscribed on the heavens or inscribed once and for all and yet moving as they pursue the other tasks allotted to them: upon these main tasks will follow the quality of signifying, just as one principle underlying any living unit enables us to reason from member to member.
>
> All teems with symbol; the wise man is the man who in any one thing can read another, a process familiar to us all in not a few examples of everyday experience.
>
> But what is the comprehensive principle of co-ordination? Establish this and we have a reasonable basis for the divination.
>
> All things must be enchained; and the sympathy and correspondence obtaining in any one closely knit organism must exist, first, and most intensely, in the All. There must be one principle constituting this unit of many forms of life and enclosing the several members within the unity, while at the same time, precisely as in each thing of detail, the parts too each have a definite function, so in the All each several member must have its own task – but more markedly so since in this case the parts are not merely members but themselves alls of great power.
>
> Thus each entity takes its origin from one principle and, therefore, while executing its own function, works in with every other member of that All . . . each receives something from the others, every one at its own moment bringing its touch of sweet or bitter. And there is nothing undesigned, nothing of chance, in all the process: all is one scheme of differentiation, starting from the Firsts and working itself out in a continuing progress of kinds.[22]

The idea of the soul's descent into matter and its striving to return to its high origin show that man is a dynamic element in the universe and that his position is neither fixed nor static. His possibilities for cosmic mobility are emphasised in the imagery of the icons where we see man, either as Christ or Adam, or sometimes as saint or prophet, as 'fallen' or 'risen'. We see him in caves, beside mountains and on mountain-tops. We see him borne up into the sky by angels. These higher and lower 'places' are symbols describing the soul's relationship with Eternity.

7

Dionysius the Areopagite

IN some Christian circles St Dennis, 'Pseudo-Dionysius', or Dionysius the Areopagite, is ranked among the greatest bishops of the early Church. For example he is present, with three other bishops, among the company of the twelve apostles in icons of the Dormition of the Mother of God. Part of the reason for such eminence is that during the Middle Ages and down to quite recent times it was believed that Dionysius was the disciple of St Paul. Modern scholarship has now established that he lived in the fifth century and that he was probably the disciple of Proclus, the greatest neo-Platonist philosopher after Plotinus. But tradition was not wrong in assigning an important position to Dionysius for he is probably the greatest single contributor to Christian mysticism outside the New Testament.

Only some of Dionysius' writings have survived: *Mystical Theology*, *Divine Names*, *Ecclesiastical Hierarchies*, and *Celestial Hierarchies*. These, and perhaps other works now lost, were translated into Latin by Duns Scotus Erigena in the ninth century and became the basis for the mysticism of such western writers as Meister Eckhart, and the anonymous author of the *Cloud of Unknowing*. In the East his literary and spiritual heir is considered by historians of theology to be St Maximus the Confessor whose works, as we have noted, are included in the Philokalia.[1] We will see that Dionysius is central to the ideas we have been exploring in the previous chapters and that his thought can be an important key to the interpretation of mysticism in icon painting. The foundations of his ideas are: (1) Hellenistic cosmology; (2) the practice of contemplation and self-knowledge through inwardly

turned attention; and (3) the mystical or allegorical interpretation of sacred literature.

Although the *Symbolic Theology* is now one of the lost works, we have Dionysius' own summary on the application of symbolism as a method to investigate truth:

> In *Symbolic Theology* we have considered what are the metaphorical titles drawn from the world of sense and applied to the nature of God; what is meant by the material and intellectual images we form of him, or the functions of activity attributed to him.[2]

In the following passage from the *Celestial Hierarchies* he discusses the case for the use of literary images as a means of approaching and understanding the 'Divine Powers'. We note that he refers to the different possibilities of understanding between the 'few' and the 'many'. By this distinction, which is an echo of one of the hard sayings in the gospels, Dionysius shows us that the scriptures contain 'secret doctrines'[3] or an *esoteric teaching* which cannot be approached by those of 'feeble intellectual (spiritual) power'. Like Origen, his main concern is to point out the absurdity of taking the symbolic images of the scriptures literally.

> We must say under what holy figures the descriptions of the sacred writings portray [the] Celestial Orders, and to what kind of purity we ought to be guided through those forms lest we, like the many, should impiously suppose that those Celestial and Divine Intelligences are many-footed and many-faced beings, or formed with the brutishness of oxen, or the savageness of lions, or the feathers of birds, or imagine they are some kind of fiery wheels above the heavens or material thrones upon which the Supreme Deity may recline, or many-coloured horses, or commanders of armies, or whatever else of symbolic description has been given us in the various sacred images of the scriptures.
>
> Theology in its sacred utterances concerning the formless intelligences does indeed use poetic symbolism having regard to our intelligence . . . providing a means of ascent fitting and natural to it by framing the sacred scriptures in a manner designed for our upliftment.
>
> But some prefer to regard the Divine Orders as pure and ineffable in their own natures, and beyond our power of vision, and may consider the imagery of the Celestial Intelligences in the scriptures does not really represent them . . . We may say the theologians . . . should not endue the Celestial and God-like Principles with a multitude of low and earthly forms . . . For we might even think that the super-celestial regions are filled with roaring songs of praise, and

contain flocks of birds and other creatures and the lower forms of matter, and whatever other absurd, spurious, passion-arousing and unlike forms the scriptures use in depicting their resemblances.

Nevertheless, I think that the investigation of the truth shows the most holy wisdom of the scriptures in the representations of the Celestial Intelligences which makes the most perfect provision in each case, so that neither is dishonour done to the Divine Powers (as they might be called), nor are we bound more passionately to earth by the meanness and baseness of the images. For it might be said that the reason for attributing shape to that which is above shape, and forms to that which is beyond form, is only the feebleness of our intellectual power which is unable to rise at once to spiritual contemplation . . . but also because it is most fitting that the secret doctrines, through ineffable and holy enigmas, should veil and render difficult of access for the multitude the sublime and profound truth of the Supernatural Intelligences.[4]

Elsewhere in the same work Dionysius points out that

No acute mind would have any difficulty at all in finding the correspondence between the visible symbols and the invisible realities.[5]

The *Celestial Hierarchies* is Dionysius' best-known and most influential work. It establishes, within a Christian context, the neo-Platonic doctrine of degrees by which the whole of the universe is related, through a series of ascending cosmic and spiritual stages, to the Ultimate One or Absolute. With obvious intention Dionysius varies the terminology when he refers to the higher powers. For example, in the passage quoted above, we find 'Celestial Orders', 'Celestial and Divine Intelligences', 'Divine Orders', 'Celestial and God-like Principles', 'Supermundane Natures', and 'Divine Powers'. All this variety implies the difficulty of finding ways to describe what cannot be known or described at the material level. But Dionysius tell us that we can 'rise' or 'ascend' to higher understanding by what he calls 'mystical contemplation'. Contemplation here means the special inner disciplines of mental attention which precondition a higher state of consciousness. He describes this inner work as 'diligent exercise' and points out the necessity to 'leave behind the senses and operations of the intellect [mentation], and all things sensible and intellectual'.

What might be called a *higher state* of being (or consciousness), which is within the human psyche, is also known as the *higher world*, which is in the cosmos. According to mystical ideas which we have already noted, both are the same. Dionysius calls it the

'Celestial Regions' and, whether in man or in the universe, it is
inhabited by the higher beings or intelligences that constitute the
Celestial Hierarchies.

He begins the *Celestial Hierarchies* by describing the influence
that comes down through the universe in a passage reminiscent
of Plotinus. The highest being is described as the Father and the
Divine One. From it flows 'every divine procession of radiance'.
Elsewhere we find such expressions as the 'Superessential One',
the 'Supreme Power which is the source of power', and the 'Super-
Original Principle and Cause of Every Essence'.

> The Divine First Power goes forth visiting all things and irresistibly
> penetrates all things, and yet is invisible to all, not only as superessen-
> tially transcending all things, but also because it transmits its Providen-
> tial Energies in a hidden way through all things.[6]

Beneath the One (Dionysius rarely uses the term 'God') comes
the famous angelic order, the Nine Choirs of Angels.

> Seraphim
> Cherubim
> Thrones
>
> Dominions
> Virtues
> Powers
>
> Principalities
> Archangels
> Angels

This hierarchy, also known as the 'Divine Ray' is an image of
the stages by which the human ascends to the divine. And at the
same time it is through these stages that the divine is transmitted
to the human. This progress, both ascending and descending,
comes about according to 'orderly and unconfined order in the
divine reception'.[7]

> [the] regulation of intellectual and supermundane power . . . is
> irresistibly urged on in due order to the divine. It beneficently leads
> those below it, as far as possible, to the Supreme Power which is the
> source of power, which it manifests after the manner of Angels in the
> well ordered ranks of its own authoritative power.
> The knowledge which is said to be imparted by one angel to another
> may be interpreted as a symbol of that perfecting which is effected from

afar and made obscure because of its passage to the second rank. For
. . . the direct revelations of Divine Light impart a greater perfection
than those bestowed through an intermediary; and in the same way
I consider that the order of Angels which is established nearest to
the Godhead participates directly in a more resplendent light than is
imparted to those who are perfected through others.[8]

The trans-cosmic principle, as set out by Plotinus, whereby each
phase of the universe is the image of the phase above it and, at the
same time, the archetype for the phase below, becomes, in the
Celestial Hierarchies, the 'imitation of Divine Power'.

According to the same law of the material order, the Fount of all
order, visible and invisible, supernaturally shows forth the glory of
its own radiance in all-blessed outpourings of first manifestation to the
highest beings, and, through them, those below them participate in the
Divine Ray. For since these have the highest knowledge of God, and
desire pre-eminently the Divine Goodness, they are thought worthy
to become first workers, as far as can be attained, of the imitation of
Divine Power and Energy, and beneficently uplift those below them,
as far as is in their power, to the same imitation by shedding abundantly
upon them the splendour which has come upon themselves; while
these, in turn, impart their light to lower choirs. And thus, throughout
the whole hierarchy, the higher impart that which they receive to the
lower, and through the Divine Providence all are granted participation
in the Divine Light in the measure of their receptivity.

The holy orders both lead and are led, but not the same ones, nor
by the same ones, but that each is led by those above itself, and in turn
leads those below it.[9]

PART II

Interpretation of Icons

8

Fayum Portraits

UNTIL now we have tried to approach certain mystical and philosophical ideas associated with esotericism through words. And we have seen that, according to some schools of thought, there is a level beyond which the written word ceases to be a useful vehicle for the communication of very high ideas. At this stage, which may be called the level of silence, ideas take on some of the qualities of emotion and intuition, qualities that proceed at a different tempo from the mental functions. This is why the greatest sacred writings are not written according to the conventions of literature, and seem to speak in riddles, full of mystery and poetic enigma; they are speaking to levels in us that are beyond our ordinary mind.

A limitation of books is that they communicate in a situation where human contact between writer and reader is absent. Neither one has the opportunity to take into account the experience, knowledge, emotional and spiritual possibilities of the other. And yet, for the transmission of higher knowledge, such a relationship is essential. Beyond the preliminary stages, transmission cannot take place without direct teaching from person to person. Christ, like all great teachers, taught orally. And those who received the teaching directly, also, in their turn, taught orally. From this was established the *oral tradition*, which is more important and more direct than the written tradition, but which is invisible to the historian.

A teacher knows how to prepare the ground, he knows what are the preliminary studies and exercises that will enable the student

to understand higher ideas and to grasp thoughts which cannot be perceived by the ordinary part of the mind. As we have seen in our study of the Philokalia, this preparatory work includes the physical and emotional sides of a man as well as the mental. Without such a balanced, all-sided approach the mind alone cannot ensure that the esoteric ideas will not be distorted.

Participation in higher knowledge is conditioned by a higher state of being. At this level words have a different value than they do at our ordinary level. They may be vehicles for a certain nuance of feeling, a moment of insight or intuition, an emanation of a quick and highly refined psychic energy. Having served their purpose they are instantly disposable; it is the energy, and not the words, that can continue to act positively.

Such ideas are necessarily at the basis of genuine sacred art. According to the traditional ideas we have been considering, an artist's first task, if he wishes to transmit authentic ideas, must be to find, by spiritual work and exercises, inner balance and a harmonious state of being; by these qualities truth becomes organic in him. Such a man lives the truth because the truth is incarnated in him and will be manifested in everything he does, in words, gestures, actions and deeds.

It is here that the role of the artist can serve the tradition of higher knowledge. Plotinus expresses this idea when he writes that the Beings of the Divine Realm cannot be thought of by 'our apparatus of science'. He continues

> All that realm (the very Beings themselves), all is noble image, such images as we may conceive lie within the soul of the wise – but There not as inscription but as authentic existence. The ancients had this in mind when they declared the Ideas (Forms) to be Beings, Essentials.
>
> Similarly, as it seems to me, the wise of Egypt . . . indicated the truth where, in their effort towards philosophical statement, they left aside the writings – forms that take in the detail of words and sentences . . . and drew pictures instead, engraving in the temple inscriptions a separate image for every separate item: thus they exhibited the absence of discursiveness in the Intellectual Realm.[1]

For the artist the attainment of wisdom is conditional on his submitting to the disciplines of self-knowledge and spiritual search. Without the application of mental and psychological schooling, taking priority even over the techniques and theories of his craft, the work of the artist will be limited to his own subjectivity. Thus

Plotinus advises us to study 'works of beauty' not for the 'labour of the arts but by the virtue of men known for their goodness . . . You must search the souls of those who have shaped these beautiful forms'.[2]

In studying the origins of icon painting, we will see how the work of the artist is undertaken in parallel with the art of self-perfection. Just as we find the origins of style in early Christian art in the Mediterranean culture of the first to fifth centuries AD, so we will seek the origins of artistic philosophical meaning in that Hellenistic milieu. At that time the forms of religious expression in visual imagery emerged from an understanding of the objective and universal truths contained in gnostic, esoteric and mystical teachings. We shall see how all the ideas of the Alexandrian school we have explored, from Plotinus, from the Gnostics, and from the Christianity of Clement and Origen, of the Philokalia and of Dionysius the Areopagite, remain as the philosophical basis of icon painting from the sixth century until its fall from traditional standards a thousand years later.

We will begin with a study of those earliest paintings, undoubtedly forerunners of the icons, which are known as Fayum portraits (see Figs. 5 and 6). Many hundreds of these exist since they were first discovered by Sir Flinders Petrie in the late nineteenth century. They are dated from approximately the first to the fourth centuries AD. They often have great beauty and museum curators have long sought to acquire them, though mainly for archaeological and historical reasons. What is perhaps surprising is that so little is known about them. Only one book has been written about them and in it the authors complain that

> after nearly a century since the Fayum portraits were brought to light how many questions remain unanswered! Are they to be ascribed to the tradition celebrated by Pliny,[3] or are they more related to the taste of the educated rich of a far flung province? Who were the painters of the Fayum oasis? Where did they come from? What were their philosophy and beliefs?[4]

Hilde Zaloscer, writing in *Apollo* (1964), gives an interpretation from which the following is extracted.

> The unusually strong, even fascinating effect which all the por-traits have is gained not only by the intense accuracy of human

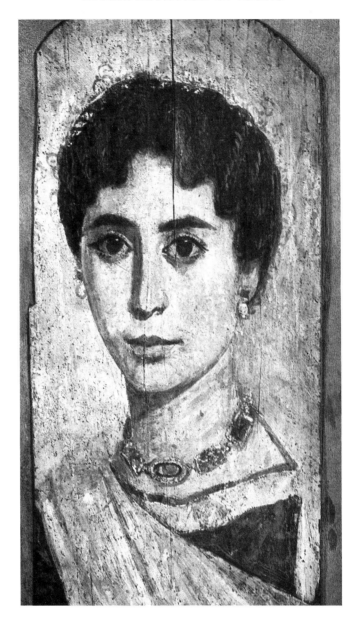

Figure 5. Portrait of a young woman from Fayum. Painted in wax encaustic, *c.* AD 200. British Museum. The 'gaze on Eternity' is concerned with the mystery of life, death and life beyond death.

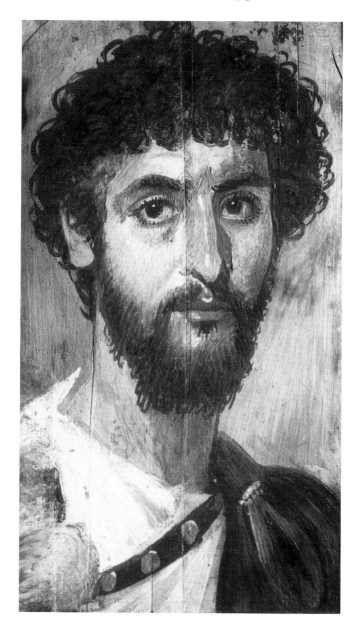

Figure 6. Portrait of a young man from Fayum. Painted in wax encaustic, *c.* AD 200. Eton College. 'I know because I am known.'

representation, the truth to reality, the extraordinarily large eyes with their visionary gaze, but, above all, by a well defined composition, which never changes. On closer examination it will be realised that this composition, which by its simplicity and uniformity and, above all, by its repetitiveness, might become monotonous, reveals subtle contradictions and ambiguities. But these occur with such emphasis that they must result from a definite and significant intention. The contradiction lies first of all in the relationship of volume to space, by which the former is logically conditioned. The faces with their rounded cheeks, the spherical eyes, the columnar neck, are modelled by means of light and the shadows they cast. But however much the figures are conceived in the round, the background, devoid of all spatial depth, offers no correspondence. Whether painted in gradations of blue or of gold, the background has no space-value; nor is any decorative use made of it as in modern painting. The plane before which the painted figures appear has no equivalent in the world of reality; it is so to speak the 'nothingness' of ethereal space. Even though iconographically it can be interpreted as Heaven or as the Light of Paradise, creating a meaningful relationship with the represented persons, looked at as pure form, the contradiction between rounded bodies and plane remains, and it is this which destroys the volume. A kind of volume comes into being which appears corporeal and incorporeal at the same time, a new substance which lacks all density. The last and quite logical stage in the formulation of this ambivalent volume is later revealed in the icon.

A further contradiction in the portrait exists between the relentless realism and truthfulness of the representation of the figures and their immobility which places them outside time and space. If, on the one hand, the impression is created that the model is the dominant and principal value, it is at once removed by a higher will from its ambience and transferred to another, where abstract laws of composition rule, such as frontality, symmetry and composition on one plane: these estrange the model from its natural order and subject it to a common law, which deprives them of their uniqueness and makes them equal with one another. Motionless and impassive, as if frozen in timeless vision, they offer the highest degree of solemn frontalism. The formal principle with the greatest power of expression is their frontality. All other formal values, like axial symmetry and two dimensional composition, are subordinated to it. The figures appear at all times, and quite exclusively, in the same frontal attitudes, and the fascinating spell which no spectator can escape – the lofty pathos and saintly dignity which endow these portraits with religious significance – emanate from this frontality, this face-to-face and eye-to-eye attitude, which turns into a relationship between the 'I' and the 'thou', the person represented and the beholder.[5]

The great Eastern civilisations, Egypt, and Mesopotamia, were unfamiliar with the formal principle of frontality; while in Greece it

only appears during the archaic period, proof that it is not a question of significant value, but of a primitive phase. As a deliberate principle of style and as a vehicle of expression, frontality appears in the Mediterranean world at the beginning of our era simultaneously with the mummy-portraits at Palmyra and Doura-Europos and the early catacomb paintings. But the exclusiveness with which it is employed at first in early Christian art and then in monumental form at Byzantium, can only be explained by the supreme spiritual concept which, from now on, forms the basis of all religious and artistic creation.[6]

Given the geographical location as well as the spiritual ferment of the second and third centuries, it would seem reasonable to suppose that the Fayum oasis was the centre of a spiritual community or psycho-religious school. The Egyptian desert is known to have harboured Essenes, Therapeuts, Gnostics, the earliest Christian monastic communities and other esoteric schools.

Mead points out that there were at this period numerous communities of mystics and ascetics such as the one near Lake Mareotis described by Philo.

> Others may have been tinged as strongly with Egyptian, or Chaldean, or Zoroastrian, or Orphic elements, as the one south of Alexandria was tinged with Judaism. It is further not incredible that there were also truly eclectic communities among them who combined and synthesised the various traditions and initiations handed down by the doctrinally more exclusive communities . . . It is in this direction that we must look for the light on the origins of Gnosticism and the occult background of Christianity.[7]

The Fayum portraits are achieved by the subtlest artistic means, yet their effect is strikingly natural and unaffected. Apparently this very naturalness, this absence of worldliness and pretension is central to the meaning of the images that present to us young men and women freed of negativity, false sentiment and worldly passions; they appear before us revealing their truest and innermost selves. Neither angels nor saints, they are people who have become able to be themselves. Such self-realisation, which esoteric tradition considers to be the ultimate threshold of spiritual mystery, seems here to be simple and natural. For once the curtain that hides the unfathomable secret has been drawn aside, and what was unknown is for ever known; it is the self eternally contemplating itself. And in confronting these portraits, in the encounter between 'I' and 'thou', there is awoken in me that which until now slept so that I also, for a moment, 'know', just as 'I am known'.

9

The Sinai Christ

WE have seen that the 'supreme spiritual concept', in a gnostic and esoteric sense, is self-knowledge; and self-knowledge, as the mystics of all traditions hold, is synonymous with knowledge of God. With this idea we have a key, not only to the meaning of the Fayum portraits, but to a number of portrait images of the late Hellenistic and early Christian periods. One of the most notable of these is an icon of Christ, discovered in comparatively modern times, in St Catherine's Monastery on Mount Sinai (see Figs. 7 and 8). Opinions on its date vary widely though Weitzmann, the foremost authority, considers the icon to have been painted in Constantinople at the beginning of the sixth century and that it was probably a gift to St Catherine's from its founder, the Emperor Justinian.[1]

This earliest known icon of Christ has nothing 'original' in its composition. Even when first painted it was a *traditional* image, and we shall see that is made up of traditional elements, some of which came from recent Hellenism, some from antiquity and some from ancient Egypt. The icon's title, PANTOCRATOR, the Ruler of All, is a Hellenistic concept.

The basic form, with its axial symmetry, frontality and bust-length portraiture, is not far in composition from the Fayum portraits of Egypto-Roman tradition. From the same origins are to be sought the wax-encaustic technique, and the 'unaffected' look.

From Greek antiquity comes the type of the bearded philosopher-teacher with the two fingers of the right hand raised in the 'teaching' gesture. From the same period comes the book, symbolising

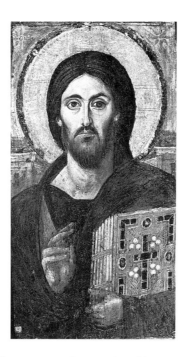

Figure 7. Christ Pantocrator. Icon painted in wax encaustic, *c.* 600. St Catherine's Monastery, Mount Sinai. Hellenistic and Egyptian traditions were the foundations of early Christian icons.

knowledge and wisdom. In some icons this is the scroll or *rotulus* of antiquity. The voluminous cloak or *himation* was the traditional garb of the philosophers while its purple colour indicates royalty. Also reflecting classical antiquity are the wall and throne behind Christ. Above, in the background, in a Pythagorean or neo-Platonic allusion to cosmic powers, is the solar disc or halo, a form that can be traced back to ancient Egypt, while the two stars may have astrological connotations associated with Zoroastrian magic.

Each one of these elements is present, not through historical chance or stylistic convention, but because of the deep inner ideas of which they are the external expression. They are the forms which serve the mystical content or Reality which is actualised here through art. All this obeys laws which demand that the spiritual energies of the painter conform to the spiritual realities of the universe. By spiritual energies we mean ordinary energies that have been *transformed* by the refining process of the spiritual work that the Hesychasts write about in the Philokalia and which Plotinus refers to when he speaks of 'withdrawing into oneself'.

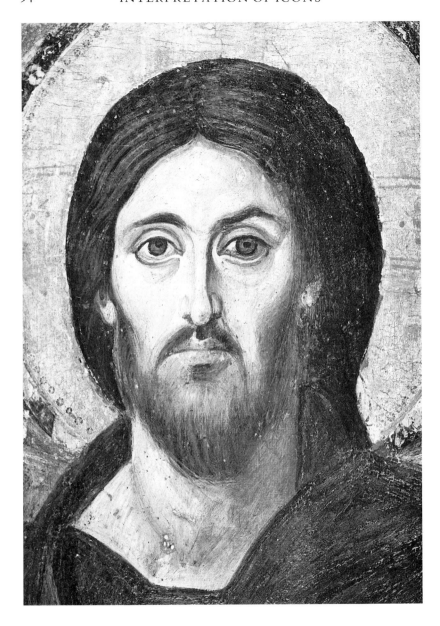

Figure 8. Christ Pantocrator (Detail Fig. 7)

Without this process, which can only take place under specific conditions, as a study of the Philokalia or the Enneads makes clear, the painter's artistic gifts, however great in the ordinary sense, will remain untransformed at the human level. This is the subjective state of man where the divine spark is lost within the multiple and contradictory aspects of his being. In this condition of dispersal, conformity between the lower and higher cannot take place.

The creative act will only take place where the lower or material level is penetrated by energies from the higher or spiritual realm. This penetration 'endows' form that has shape and body. 'If *Matter* has been entered by *Idea*, the union constitutes a *body*' is one of Plotinus' many formulations that express this universal law of three forces. Elsewhere he says '*Spirit* penetrates *Matter* to endow *Form*'.[2]

In an icon such as the Sinai Christ, the forms that we see are the visible expression of creative spiritual forces whose origin lies in a realm higher than the ordinary mind can perceive, and which the painter, acting as intermediary between the lower and the higher, interprets at the level of the senses. Thus he performs here in a priestly function and it is only in this sense that art can be genuinely sacred. Both the abstract constituents of the picture: its forms, rhythms, colours, proportions and so on; and the concrete images: face, hands, book, wall, sky, and stars, are combined together under an ordering and unifying principle, brought into being through an inwardly focused attention situated deeply within the soul of the painter. The source of the sacredness is not in the art but in the artist. In neo-Platonic terms it would be said that the ordering principle is that part of the painter's soul that is a fragment of the Universal Soul. In Christianity it is called the 'divine spark'.

A very high, or divine, intelligence and purpose are at work in the cosmos which need to reach humanity and which human beings need in order not to lose their humanity or have it destroyed by lower forces. This intelligence appears to us in the icon only as a result of having appeared first within the psyche of the painter whom we assume to have been a Hesychast adept working on his own inner transformation.

All this is expressed for us in the look. Christ gazes on eternity while, at the same time, the onlooker feels that this gaze is directed intimately and personally on himself. Here the self is not the ego, the small self that belongs to the material world and to time, but the Self, the true 'I' that came from, and will return to, eternity. It is wisdom looking at itself; it is the Self looking at itself.

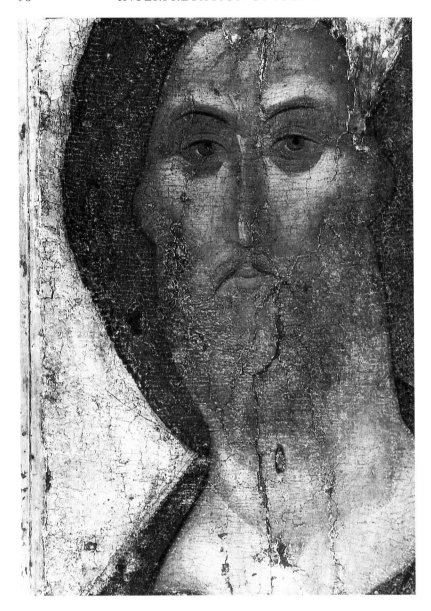

Figure 9. Christ Pantocrator. Tempera. Painted in 1408 by Andrei Rublyov, the pupil of St Sergius. Tretyakov Gallery, Moscow. Style and technique have changed but the personal regard (cf. Fig. 8) and its deep meaning remain constant.

We are brought to the threshold of the mystery of existence. This is why traditionally, in icons of Christ, the nimbus around the head contains letters signifying the mystery of Existence: *Ho on* meaning 'Existence', 'The Being', or 'I AM THAT I AM', as the authorised version has it. The sense is similar to the 'That Which Is' of the Brahmins, and is related to the *path of self-knowledge* of Hindu mysticism and to the Socratic '*Know thyself*'.

Although the idea of self-knowledge is the basis of all authentic spirituality of the ancient traditions, it has been less stressed by the Christian West which has tended to repudiate mysticism or to deny its essential importance as the basis from which the higher truth of religion proceeds. But in the fourth century, although this controversy was already threatening such men as Clement of Alexandria and Origen, we find Evagrius writing in the desert: 'if you wish to know God, first know yourself'.[3]

It could be said that the whole of the Philokalia is a study in self-knowledge and that Hesychasm is the Christian spiritual path of self-knowledge. We shall see that Hesychasm and icon painting were intimately related in certain Greek and Russian schools, particularly in the fourteenth and fifteenth centuries.

In this context it seems appropriate to illustrate here Andrei Rublyov's icon of Christ, originally painted for the Zvenigorod Monastery at the beginning of the fifteenth century and which is today in the Tretyakov Gallery in Moscow (see Fig. 9).

The technique has changed from the use of wax-encaustic medium to egg tempera. And in the place of the full-bodied style of late Hellenistic art we have the refined linearity of the Moscow school. What seems unchanged, however, is the shock of the encounter. In both cases the onlooker is startled into the realisation that he exchanges looks with silence and living truth.

These two icons, coming from opposite ends of the historical spectrum, demonstrate, by their essential similarity, that for each artist, an identical inner vision of a universal truth was granted.

10

The Sinai Mother of God:
an Image of Celestial Light
and Spiritual War

T H E next icon for us to consider is the Enthroned Mother of God which is also on Mount Sinai and also dated to the sixth century by Weitzmann (though to the seventh by Kitzinger)[1] (see Fig. 10).

But before we consider this icon in detail let us return to Dionysius the Areopagite. We find him writing not far away in Alexandria at about the same time, or perhaps a few decades earlier, that this wax-encaustic icon was painted.

One idea, from among the many spiritual truths that we find in Dionysius, and which had passed into Christianity from Hellenistic mysticism, was the principle of light as a symbol of divine influence radiating outwards and downwards through successive celestial regions of the universe. Dionysius and other Christian writers follow Plotinus in making a distinction between invisible, spiritual light and its symbol, physical light.

The Philokalia, as we have seen, tells us that apart from the physical sun that exists in the visible universe there is a spiritual sun in the invisible universe. In other words the action and energies of light in the external world are images of inner energies whose actions take place in the spiritual world and within the psyche of spiritual men. Likewise Plotinus, basing himself on Plato, states that the light of the sun 'is a corporeal substance but from it there shines forth that other "light" which, though it carries the same name, we pronounce incorporeal'.[2] It is just this inner light, imperceptible to the senses, that the early Christian philosophers and truth-seekers conveyed through the techniques of depicting light in their icons. The analogy is exact because the laws of the

higher cosmos reproduce themselves in the lower so perfectly that the handling of light and colour in the work of a master icon painter become a demonstration of spiritual truth on the material plane.

Allusions to the symbolic meaning of illumination, through suggestions from the imagery of light, are so commonplace that we rarely give them full consideration. We forget that even physical light, without whose nourishment organic life could not exist, has extraordinary properties.

In traditional philosophy light was considered to be incorporeal and therefore divine, that is, belonging to those levels of the cosmos that are above matter. We need not dismiss such thinking lightly even though modern physics, by measuring the vibrations of solar light, establishes its materiality. Even so this materiality is of a finer degree than any earthly substance and has extra-terrestrial properties. Its source is the sun and it transcends earthly limitations of space and time. Light, therefore, can be said to exist in a universe that has more dimensions than sense perception can comprehend and on a time scale that is, for us, eternity.

We find Dionysius, quoting from what he calls 'sacred writers', by which he means Plotinus or his teacher Proclus, defining 'the quality of the Supra-Divine Godhead':

The sun . . . by the fact of its existence, gives light to all those things which have any inherent power of sharing its illumination, even so the Good (which is above the sun, as the transcendent archetype . . . is above the faded image) sends forth upon all things according to their receptive powers the rays of its undivided goodness.

From the Good comes the light which is the image of goodness; wherefore the Good is described by the name of light, being the archetype thereof which is revealed in that image. For as the goodness of the all-transcendent Godhead reaches from the highest and most perfect forms of being unto the lowest . . . remaining superior to those above and retaining those below in its embrace . . . and is the Measure of the Universe and its eternity, its Numerical Principle, its Order, its Embracing Power, its Cause and its End; even so this great, all-bright and ever shining sun, which is the visible image of this divine Goodness, faintly re-echoing the activity of the Good, illumines all things that can receive its light.

The Good is called Spiritual Light because he fills every heavenly mind with spiritual light, and drives all ignorance and error from their souls where they have gained a lodgement, and giveth them all a share of holy light and purges their spiritual eyes which are fast shut and weighed down with darkness, and giveth them . . . illumination . . . he constraineth them according to their powers of looking upward.

And so the Good which is above the Light is called a Spiritual Light because it is the Originating Beam and an Overflowing Radiance, illuminating with its fullness every Mind above the world, around it, or within it, and renewing all their spiritual powers, embracing them all by its transcendent elevation. And it contains within itself, in a simple form, the entire ultimate principle of light, and is the Transcendent Archetype of Light.[3]

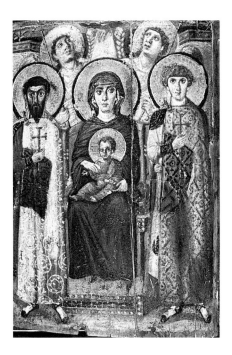

Figure 10. Virgin and Child Enthroned with Warrior Saints and Angels. Wax encaustic, 7th century. St Catherine's Monastery, Mount Sinai. The presence of SS Theodore and George signify the 'inner warfare' of spiritual endeavour. (See Fig. 11.)

The icon preserved at St Catherine's Monastery shows the Enthroned Mother of God with the Christ Child on her knee. On either side stand St George and St Theodore Stratelates, and behind her are two archangels. The style reflects Egypto-Roman characteristics of the late Hellenistic period. In this painting can be observed many of the elements which go into the foundations of early Christian art. The two archangels, with their curled hair and full faces are derived from Hellenistic art. The idea of the enthroned central personage supported by two standing figures can

be found in imperial Roman art though it is oriental in origin. The wax-encaustic technique is the same as that of the Fayum portraits and their influence can be seen in the faces, especially those of the two standing warriors. These two saints are richly dressed in imperial court costumes that go back to Rome. The Virgin, on the other hand, is simply dressed in the robes of a maiden of Alexandria and Christ, though a child, wears the robes of a Greek philosopher-teacher and carries a *rotulus*.

At the top of the picture is a lunette-shaped segment from which appears God's hand. This has an important cosmological significance and is an element that we shall return to in subsequent chapters. For the moment let us note that from God's hand descends a shaft of light which falls directly on to the Virgin, illuminating her face and that of Christ. She remains still, inwardly calm and majestic, receiving the light. The two warrior saints stand firmly, with wide-eyed and intense expressions, as if making an inner effort to maintain their spiritual equilibrium. They gaze intently at us who look at the picture.

The composition is based on a hierarchical structure. The highest level – the Divine Realm – is suggested by a circle; or rather by the lower rim of a circle the rest of which is out of sight. From this appears the hand of the deity and from this, in turn, light emanates outwards and downwards. Next in the hierarchical order come angels who properly represent the intermediary world between heaven and earth. They are 'nearest to the light' while below them are the Mother of God and the Christ Child in their human forms. Below them, for we note they are not on the same level as the raised throne, are the two warrior saints.

Figure 11 shows the completed circle that extends beyond the frame of the icon. From this diagram we easily see the degrees of the Hierarchy or Divine Ray.

All the elements are connected by their common relationship to the light.

The 'front stage' placing of the figures, together with the directly personal challenge of their looks has the effect of including the onlooker. This is further enhanced by the high wall at the back of the picture, which not only cuts off the space behind them but helps to create the place in front where the onlooker is standing. The wall encloses the area in which Christ and his entourage appear so that no extraneous elements can come in. Nothing from outside enters within this enclosed space, which can be understood as spiritual, rather than actual. Nothing distracts our attention from the strength and balance of the symmetry which can be regarded

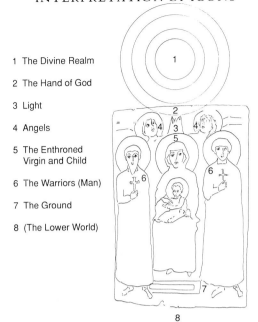

1 The Divine Realm

2 The Hand of God

3 Light

4 Angels

5 The Enthroned
 Virgin and Child

6 The Warriors (Man)

7 The Ground

8 (The Lower World)

Figure 11. Diagram showing the Descent of Light from the unseen Higher World. The entire scheme represents the Universe.

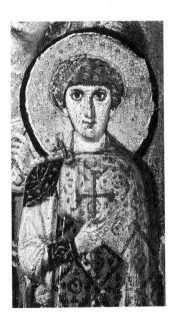

Figure 12. St George (Detail Fig. 10).

as symbolising a psychological state. The one exception to the 'hermetic sealing' of the inner from the outer is the shaft of light descending from above.

A striking feature of the icon is the expression of the eyes in the various persons depicted. The two angels look upwards, the Mother of God and Christ seem to gaze into the remote distance, while the two warriors directly confront the onlooker.

Can we relate these looks to the contemporary teaching of Dionysius on the influence of spiritual light? Can we suppose that the look in the eyes of St George is the sign of the 'spiritual light that stirs and opens the eyes'? (See Fig. 12.) Can we think that the angels 'look upwards according to their stance nearer the light that shineth in more abundance on them'? Is it possible to see in the eyes of St Theodore the expression of a man who wishes to be 'truly good and gentle and always united with God (cultivating) with all power the virtue of attention'? These two men are famed in legend as warriors, but surely the idea of war, introduced here in a context of profound spiritual symbolism, means the 'inner warfare' or 'spiritual warfare' of the Hesychasts?

11

Cosmas Indicopleustes
and the Diagram of the Universe

WE have seen that the Plotinian Doctrine of Degrees and the
Great Chain of Being of the Gnostics become, in the Divine
Ray of Dionysius the Areopagite, the foundation of Christian
cosmological thinking.

We will try to see now how these ideas, which show where
man's place is in the universe, were given diagrammatic form and
passed into the pictorial symbolism of Christian iconography.

Preserved in the Vatican is a seventh-century copy of an early-
sixth-century MS book called the *Christian Topography*. It is the
work of the Alexandrine scholar Cosmas Indicopleustes and it
displays the combination of Hellenistic erudition and Christian
theology typical of that city. The work shows us how the Platonic,
or neo-Platonic, plan of the universe had been introduced into
the canon of Christian imagery. This is illustrated in the work
of painters whose images accompany the text on the Days of
Creation in two early-Byzantine Psalters, the *Vatican Octateuch no.
746* and the *Vatican Octateuch no. 747* reproduced by the Russian
scholar D. V. Ainilov.[1]

We have seen that according to the tradition transmitted by
Plotinus the entire universe can be stated as an octave or eight-
stepped ladder connecting God, or Absolute Being with Outer
Darkness or the level of Absolute Non-Being. This plan can be
observed in the two MSS illustrating the Creation.

In the application of neo-Platonist cosmological thinking to the
Genesis myth some alteration of detail has occurred, most notably
in the nomenclature that defines the different stages that

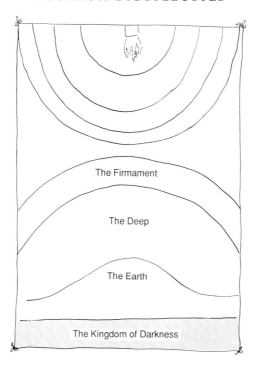

The Firmament

The Deep

The Earth

The Kingdom of Darkness

Figure 13. Diagram of the Universe according to Christian cos-
mology based on illustrations in the *Christian Topography* of Cosmas
Indicopleustes. The terminology has changed but the scheme is
essentially Platonic. (See Figs. 3 and 4.)

divide the higher from the lower. For example, the 'Absolute
Non-Being' of Plotinus has become the 'Kingdom of Darkness';
'Matter' has become the 'Earth', the 'Intelligible Universe' and
the 'Celestials' are now the 'Firmament', and the 'Absolute' is
now graphically depicted as the hand of God (see Fig. 13). The
principle of emanation or radiation, which is fundamental in both
Plotinus and Dionysius, is illustrated here in the form of actual
rays emitted by God. Theologically, these were understood by
Christian philosophers to represent God's 'energies'.

 In a characteristically Alexandrine fashion Cosmas has provided
an illustration of the First Day that corresponds both to the first
eight verses of the Book of Genesis and to the neo-Platonic
Doctrine of Degrees. We shall see later that this combination
entered the language of icons where its forms remained, even if
its meaning was not always consciously remembered.

 It is from the *Christian Topography* that a number of Christian
traditional themes appear for the first time as illustrations. We

see that a number of familiar scenes in iconography originate with Cosmas Indicopleustes. It was also through him that the neo-Platonic vision of the universe was laid out in schemes and diagrams that served as vehicles for depicting 'events' such as the Last Judgement or the Ascent of Elijah.

It is from Cosmas that we see how, in icons, the personages and events are all presented as taking place within in a cosmic setting and not an earthly one.

But, apart from Ainilov, Cosmas has received little serious regard from modern historians and he is generally regarded as obscure; perhaps because his diagram of the world, which he shows as an oblong box with an arched lid seems, at first glance, to be absurdly naive. Actually, this diagram shows that Cosmas, even though he may not have been fully aware of it, worked within the tradition of the ancients. The case has been put forward by Giorgio di Santilla and Hertha von Dechend that the sages of remote antiquity knew of the Precession of the Equinoxes (by which the axis of the earth shifts like a wobbling top in periods of 2,600 years) and that they understood that the real measurement of the world has to be made according to the cosmic associations of the four seasons.

De Santillana and von Dechend have shown this in their remarkable book *Hamlet's Mill* from which the following is quoted.

> On the zodiacal band, there are four essential points which dominate the four seasons of the year. They are, in fact, in church liturgy the *quattuor tempora* marked with special abstinences. They correspond to the two solstices and the two equinoxes. The solstice is the 'turning back' of the sun at the lowest point of winter and at the highest point of summer. The two equinoxes, vernal and autumnal, are those that cut the year in half, with an equal balance of night and day, for they are the two intersections of the equator with the ecliptic. Those four points together made up the four pillars, or corners, of what was called the 'quadrangular' earth.[2]

The authors of this work (which must be regarded as a major contribution in our own times to the theory of the Perennial Philosophy) show that the ancients understood the 'earth' as quadrangular because the ideal plane passing through the four points of the year, the equinoxes and the solstices, is measured by the four corresponding constellations that rule its four 'corners'. But this did not mean they thought (as Cosmas did) that the earth was either square or flat: 'geography in our sense was never meant,

but a cosmography of the kind needed even now by navigators. Ptolemy, the great geographer of antiquity, had been thinking of nothing else. His *Geography* is a set of coordinates drawn from the skies.'[3]

Cosmas' knowledge was incomplete, as is shown in his writing where he justifies his belief that the earth was flat,[4] and inferior to that of the ancients whose concepts he none the less perpetuates in his schematic drawings and diagrams. Thus the images that were to form the foundation of iconography for the next thousand years were 'correct' even when the thought that justified them was erroneous. Today scientific thought, unable to grasp the spiritual and cosmic realities of the world, would dismiss both the diagram as well as the thought.

12

Orpheus-Christ and the Mystical Body of the Church

THE cult of portraits was a long-established convention in the East and also in the Roman Empire where images of the Emperor were accorded a degree of respect that was more or less religious.

> The portrait had always been the most interesting creation of Roman art. In Imperial times, every market place was resplendent with statues of Emperors, officials and local worthies, the libraries were full of portrait busts of Greek and Latin authors, and the private houses were full of ancestors, some in the guise of mythological heroes, but usually as marble busts in a small gallery.[1]

This convention naturally prepared Christianity for the cult of images.[2] But in the transition a radical change took place in the portraits:

> The unique feature of the Christian portrait is the expression of the eyes. The new man, illuminated by faith and born again of the Spirit, is a man of the inner life. It is as if the inner life were looking out at us . . . They exert a strange fascination on us. We almost forget the world of flesh and blood; they make the secular portraits of an earlier, richer time seem like men of another universe . . . How very different . . . is the unaffected look, betokening inner peace, that is shown in the eyes of the saints . . . There are hundreds of expressive faces in Roman art: faces that are witty, supercilious, serene, highly intelligent, malicious, or supremely noble . . . but the highly charged gaze of so many of even the most modest Christian faces, often primitively executed, as in the catacombs, cannot be found among them.[3] [See Fig. 14.]

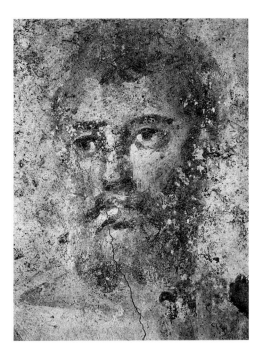

Figure 14. Head of a man. Fresco, 3rd century. Tomb of Aurelius, Catacombs, Rome. The profoundly spiritual look expresses the mysticism and humanity of earliest Christianity.

Other examples of painting in the second, third and fourth centuries convey this special quality of spirituality in varying degrees. At this period when formalised church Christianity had not yet emerged, the gnostic and 'occult background' are often apparent in the works that have remained. Different 'churches' existed in the major centres of culture: Rome, Alexandria and Antioch, as well as in remote and provincial areas. In each case the beliefs and practices varied according to whatever local traditions were maintained. We will briefly consider examples from the various paintings that have survived.

The earliest art that is definitely Christian is the group of wall paintings in the baptistry, usually referred to as the 'Christian House', at Doura-Europos. They are dated to around AD 200 and were discovered in the 1930s. Doura-Europos was a small frontier town in Mesopotamia, its population was mixed in a way that was probably typical for an eastern Roman provincial community. Other buildings at Doura are a Synagogue and a Temple dedicated to the Iranian god Mithra.[4]

Christians, following the Judaic rule, had until the beginning of the third century avoided any use of imagery, though it was otherwise prevalent throughout the Hellenised pagan world. We do not know how, or by whom, the decision was taken to adopt the radical course of introducing images as part of the religious cult. Interestingly, the Jews themselves also relaxed this hitherto severe rule. Whatever was going on in Doura was probably a reflection of trends in Alexandria.

Only a handful of scenes from the Christian House remain: the Good Shepherd, Adam and Eve in the Garden of Eden, the Woman of Samaria at the Well, the Three Marys at the Tomb, Christ Healing a Paralytic, and Christ and St Peter Walking on the Water. These paintings were executed long before the conventional programmes of Christian iconography had been established and it is interesting to ask what philosophical or theological reasons prompted their choice for it is likely that a gnostic or esoteric group of ideas must be sought. Five hundred years later, most of these scenes would occupy the least important places in the visual theology of a church, if indeed they were used at all. The Good Shepherd was to be dropped altogether.

These are Christianity's oldest paintings and their choice of subject matter presents us with questions about their symbolism and spirituality. Artistically they seem to be hardly more than curiosities and it is difficult, at first, not to be disappointed by the apparently rather poor quality of these few fragments.

Better, or at any rate, more complete paintings can be found at Doura in the neighbouring Mithraeum and in the Jewish synagogue. Here is Hellenised sacred oriental imagery (see Figs. 15 and 16). The painting thought to represent Zoroaster is distinctly iconic with its formalised, but far from stiff, posture, symbolic attributes, and profoundly spiritual look. The portrait of Heliodorus from the House of the Scribes conveys a similar idealised spirituality. The wide-open eyes and calm face, seeming to gaze into the far distance while, at the same time, calling us intimately and directly, have that special look which is typified in the Fayum portraits and which will characterise the Christian portrait icon for the next thousand years.

This expression of spirituality arose newly, and apparently spontaneously, throughout the Hellenised world around the beginning of the second century. Examples are found in Italy, Egypt, Syria and elsewhere, in which all those portrayed share the look of a calm, untroubled gaze on the outer world; a world which they view with compassion while holding firmly to their

Figure 15. Fresco showing Zoroaster enthroned and with symbolic attributes of power. Doura-Europos, 3rd century. Such images are forerunners of the icons of Christ Enthroned.

Figure 16. Wall painting of Heliodorus the Actuary. Doura-Europos, 3rd century.

own inner peacefulness and confidence. What was this expressive and unaffected look that passes across barriers of culture and belief? Can we say it was an incipient esoteric Christianity, a true gnosis? Was the inner quality that links these portraits a common and universal truth?

The art of the Catacombs provides us with another source of earliest Christian paintings. These paintings date from the beginning of the third century and continue throughout the fourth. They vary in quality and reflect Roman artistic style and conventions except that the themes are Christian, or partly Christian, depicting events from both Old and New Testaments. There are also, in some tombs, mythological subjects and occasional representations relating to pagan philosophy. The tomb of the Aurelii is just such a complex of heterodox imagery. It is a puzzle that leaves doubt as to whether the patrons who commissioned the paintings were Christians or not. But this tomb contains one of the most touching and expressive examples of the spiritual look to be found in Rome. André Grabar offers a clue to the meaning of the Aurelii frescoes when he remarks that the eclectic imagery 'suggests a possibility that the earliest Christian art may have originated in a para-Christian milieu, presumably Judeo-Christian or Gnostic, before being taken up by the church'.[5] (See Fig. 14)

Other Christian groups whose spirituality we trace through the art of the catacombs identified themselves through a special kind of cryptic sign-language and through cyphers: the bread, signifying the eucharistic feeding of Christ; the sailing ship whose masts and crossed bars made the sign of the cross; the fish, for which the Greek letters ICTHUS give the initial letters of the words of the Jesus Prayer: Iesous Christos Theu Uios Soter (Jesus Christ Son of God, Saviour).

 The fish also signified the age of Pisces which, according to the Precession of the Equinoxes whose period or 'cosmic year' is renewed every 2,600 years, was ushered in by Christ.[6] Virgil, among others, had known this when he foretold the return of the Golden Age:

 Now the Virgin returns, the reign of Saturn returns, now a new generation descends from heaven on high. Only do thou, pure Lucina, smile at the birth of the child, under whom the iron brood shall first cease, and a golden race spring up throughout the world.

For this poetic vision, inspired by a mysterious knowledge, Virgil has a special place, in the medieval Christian world outlook. We find him, for example, ranked among the saints and prophets in the fifteenth-century frescoes of the Annunciation Cathedral in Moscow.[7]

In the catacomb paintings of the third and fourth centuries are many images where the interpretation of meaning relies on gnostic and esoteric ideas. During the first three centuries of our era such ideas were closer to the origins of the gospel teaching. After the fourth century the spiritual essence of the Christian mystery was gradually overlaid by the institutionalisation of the Church as a social and political organisation. This was inevitable and necessary in the monumental cultural and cosmological changes that were taking place. Secret Christianity did not disappear with the advent of state Christianity but it had to retreat into areas where, as far as possible, it would not provoke the wrath of heresy hunters nor compromise itself through well-intentioned misunderstanding. These are among the reasons why the origins of Christianity are so obscure. We forget that we know little about the actual events of the life of Christ and the few people who knew him other than the incomplete accounts given by the Evangelists who wrote them almost a century after they had occurred. Esotericism is a truth hidden and yet which is available for anyone who truly seeks it. At certain times, such as the present spiritual crisis through which humanity is passing, it briefly becomes more generally available. Further on we shall see that the esoteric tradition reappeared in the art of icon painting in the fourteenth and fifteenth centuries. This period saw both the end of the life of Byzantium and the development of intense cultural activity among the Slavs.

It was in an esoteric sense that the theme of the Good Shepherd, which was soon to be suppressed from the iconographic canon, was often used in this early period. We have referred in Chapter 1 to the idea of the shepherd and sheep as an analogy for the inner world of man. We have seen in our study of the Philokalia that an inner ordering principle, governing random thoughts, feelings and other dispersed psychic energies, is a central feature in the practical discipline of spiritual science. But it will have no meaning for the man who considers that his spiritual and psychological world already functions with clarity and order. And so the meaning of the shepherd and sheep will only take on its archetypal significance for those few who could be initiated into the mysteries of Christian

gnosis. There appears in the third and fourth centuries both in the catacombs and in some early churches the haunting image of a shepherd-like figure playing a musical instrument and surrounded by sheep and goats (see Figs. 17 and 18). The presence of this 'Orpheus-Christ', as he is known, appearing in Athens and in Rome, points to an established school of thought within Christianity that understood, in the image of the underworld, the symbol of that psychologically low place where man exists within himself. Orphic and Old Testament myths are a means of conveying to a seeker something of the possibilities and necessary steps by which he may hope to rise to a higher spiritual level.

These very early and very spiritual Christians used several different images to express this, for them, all-important idea of inner escape – or ascent – from inner death. For them the death and resurrection of Christ was not primarily important as a historical event; it was far more important as an image of what would be their own spiritual experience. They understood the story of Jonah and the Whale in this sense and it is often found at this

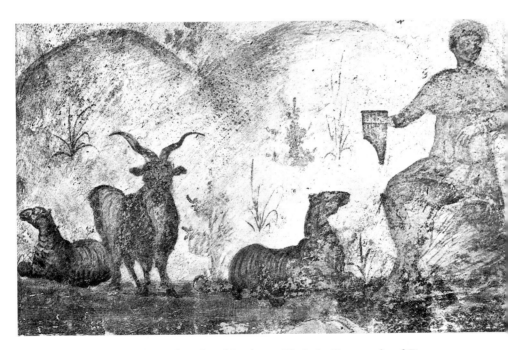

Figure 17. Fresco showing 'Orpheus-Christ'. Catacomb of Domitilla, Rome. He holds a musical instrument (harmony) with which he tamed animals (man's lower nature).

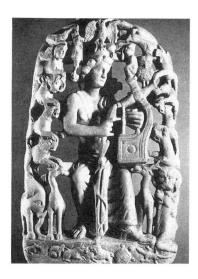

Figure 18. Orpheus from a marble screen in a 4th-century Christian church, Byzantine Museum, Athens. Orpheus, who like Christ 'descended into Hell', was a cult figure to early Christians.

Figure 19. 3rd-century carved stone sarcophagus showing Jonah and the Whale. This theme, with its connotations of lower and higher worlds, was frequently represented in early Christian art.

Figure 20. Daniel in the Lions' Den. Terracotta lamp-holder, 3rd century.

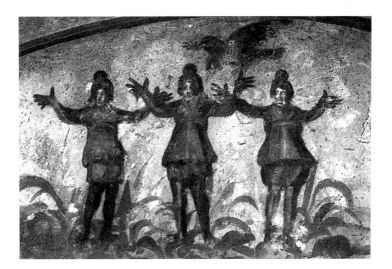

Figure 21. Three Children in the Fiery Furnace. Wall painting, 3rd century.

These two themes, together with Jonah and the Whale and Orpheus, were the first cult images in Christianity. Their true meaning depends on realising that they represent states of being and not historical events.

period, together with the stories of Daniel in the Lions' Den and the Three Children in the Fiery Furnace (see Figs. 19, 20 and 21.) These events are what theology calls prefigurations of the death and resurrection of Christ; esotericism would say that even that event is itself a prefiguration of our own death and resurrection.

At one time these were among the principal icons of Christianity; their importance lies in the fact that they are mystical allegories, or images, of escape from spiritual death, a situation which should not be confused with the physical death from which no one from the natural world escapes. Later, around the fifth and sixth centuries, the significance of these images was held in less prominence; they are found illustrating the pages of illuminated books but are hardly ever found in icons and only rarely in frescoes.

It would seem that, around the fifth century, the most deeply esoteric aspects of Christianity returned to the hidden source from which they had briefly emerged. Having played their proper role they gave way to ideas that could be more easily and more widely accepted. Or, if they stayed, they lent themselves to less difficult interpretations. Questions of purely spiritual truths and the psychological investigations of inner realities could not be elucidated publicly in the forums of doctrinal polemics and intellectual debate. The church had, in a brief time, added to its mystical body an immense multi-national corporation. By definition, esotericism could not have a prime place in the new order. It rightly, and in conformity with the laws of world events, adopted a hidden position so that the exoteric church could organise its administration and discipline at the human level and on a human scale. Esoteric Christianity continued, as we learn from the existence of the Philokalia, for the most part, unhindered and in silence until it resumed a visible identity in the fourteenth century.

The esoteric path aims at a level of existence that is beyond the senses and above the rational mind. It is not bound by any convention or man-made rules; it employs no ritual or ceremony, it can use any form or none. It is usually disguised, often hidden behind borrowed external forms through which it can usefully function. The moment the form ceases to be useful the guardians of the germ of esotericism withdraw invisibly, apparently disappearing. Those who claim to follow its path have to be alert at such moments so that they may find it again when and where it reappears.

The phenomenon of esotericism is not available to the historian.

Its presence, or the traces of its presence, is a matter of subjective interest, intuition and above all, personal search. Each must find for himself.

What follows in the next part of this book is a personal attempt to see in the tradition of icon painting such traces of the mysterious presence of esoteric ideas as have, whether by chance or by intention, remained. This next part of our study will be based on the following essential features that condition the inner meaning of icons.

1 The idea of *self and self-knowledge*. There is nothing beyond or outside the self that cannot be known within. If I look at an icon of Christ (or an icon of a saint who by his saintliness has become 'Christ-Like'), it is Christ who looks at me. All esoteric teaching points to the fact that if I wish to know God I will do so by inwardly knowing myself. For thus it was said: 'The Kingdom of Heaven is within you.'

2 *The Divine Ray*; the idea of higher and lower levels. The placing in the icon's composition of the various features and persons according to the place in the cosmos to which they correspond. The 'ladder ascending from Earth to Heaven' is as much within a man as outside him.

3 *The Warrior*. 'Secret war': the inner struggle for attention against the distractions of mental disorder and the distractions of the senses and of 'passions'; 'ceaseless prayer'; 'self-mastery'; and *the Shepherd*: 'guarding the pastures of the heart' – 'guarding thoughts'.

4 The idea of *inner and outer* as distinguishing the spiritual from the material. The architecture that encloses space signifies withdrawal from the outer world and the awakening to the life within. The 'inner chamber' of prayer and active meditation.

5 *Light*. Physical light dispelling physical darkness symbolises spiritual light dispelling spiritual darkness. The illumination and, thereby, transformation of man's inner life.

6 *Unity and multiplicity*. The disposition of the shapes, forms, rhythms, colour and line; the strong central axis and the balanced symmetrical compositions have the effect of relating all these elements into a harmonious and single whole. The icon is always complete and enclosed within itself.

7 *Silence and stillness*. The precondition for all of the above.

13

St George and the Dragon

IN our study so far we have seen that a model of Creation known as the Divine Ray was central to the cosmological view of Hellenistic and early Christian thought. Through the teaching of Dionysius the Areopagite we have learned how Christians in the fifth century understood the integral relationship of everything in the universe according to its place in the cosmic scale. We have also seen that this concept of the universe was also a working model that could be applied on any scale, and that it was especially useful when applied to man himself. It gave him the possibility, sensing this model within himself, of understanding his own 'fall' into darkness, the incarnation of Christ within himself and the steps necessary for his own 'ascension'.

The idea of the 'universe in miniature' is a master key that unlocks many mystical truths. It has been applied to Byzantine and medieval Russian church architecture and also to the arrangement of fresco programmes decorating their interiors, though not, as far as I know, to icons themselves. A number of writers have commented on the hierarchical elements of architecture whereby the descent of cosmic forces, from the divine to the human level, is laid out according to the traditional scheme.

In a commentary on the frescoes in the fourteenth-century church at Volotovo Polye, the Russian art historian M.V. Alpatov suggests that the master painter tended 'to treat the evangelic legend as a meeting of the heavenly and the earthly'.[1] Further on he speaks of the wholeness of the overall design: 'All the space of the dome, the band, the walls and the pillars was covered by

frescoes arranged in *seven tiers*. Each picture was closely connected with the whole. Their arrangement was logical and harmonious.'[2] (See Fig. 22.)

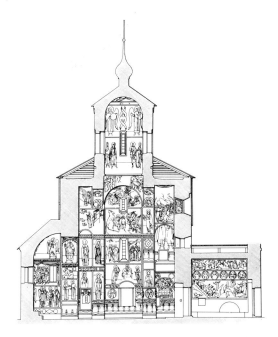

Figure 22. Cross section of a Russian Orthodox church.

This fragment gives no more than a hint and it is in the writing of Philip Sherrard that the idea is revealed in greater detail:

> The Church itself is an image of the universe – an icon of the universe according to the Christian pattern. According to this pattern, the universe is built up on a hierarchic scale; or rather it may be said that in the universe there are different levels of being, each level issuing from and depending from the one above it. This scale is often regarded as threefold. The highest level of the scale is the heavenly and uncreated world of divine being; the next level corresponds to the world of paradise, to the world as it was created 'in the beginning' – a world which was lost through the 'fall' of man and was reformed through the Incarnation and the whole cycle of events which make up the life of Christ, or the New Testament. The third level is that of human and terrestrial existence – of this existence not in its fallen state but in the process of that 'deification' through the activity of the Holy Spirit by which it comes to realise that state of human nature

'recreated' by the Saviour.

These three levels can be clearly distinguished in the iconographic (and architectural) scheme of the church. First, there is the divine world shown forth in the dome and on the high vaults; second, on the squinches, the pendentives, the upper parts of the walls are scenes dedicated to the life of Christ, to that 'recreating' of human and other nature in Christ, and to that 'regaining' of Paradise in the heavenly Jerusalem; third, on the lower or secondary vaults and on the lower walls are images of the saints and martyrs, holy men and women who already have a part in the redeemed world. In this way, on entering the church the worshipper has before him a whole picture of the universe, hierarchically graded according to the degree of being possessed by the various figures occupying the different levels.[3]

As we have already noted, the composition of the icons themselves is founded on the hierarchical principle. We shall try to explore this in more detail by taking, as an example, the fifteenth-century Novgorod School icon of St George and the Dragon that hangs in the Russian Museum in Leningrad (see Fig. 23). We should remember that this is an example only and that the ideas revealed in this icon are not unique to it alone; once the principle of cosmic hierarchy has been grasped it should be easily apparent in all authentic icons.

In the centre of the icon is St George; he is the central figure of the ideas latent in the icon as well as being the centre of the composition. The relationship between these ideas and the composition is such that no feature of the painting is without its special significance; at the same time the inner significance can be interpreted through a study of the composition.

The icon presents before us a diagram of orders of forces in the form of a ladder ranging from heaven to hell. Between these two cosmic opposites, the drama is enacted: St George, mounted on a white charger, spears the dragon. In the background is a red sky and a mountainous, desert landscape.

The event is depicted in a setting far removed from 'reality', that is, from the external reality we perceive with the senses. The narrative elements have a token significance only and there is nothing in the picture which can be taken for a literal or natural presentation of itself. The figures, casting no shadows and set in a moon landscape, give the scene an unearthly quality. But there is nothing absurd about the picture, our eyes readily accept its beauty and the disproportion between the figures and the landscape. There are no techniques here for recreating natural effects: no perspective,

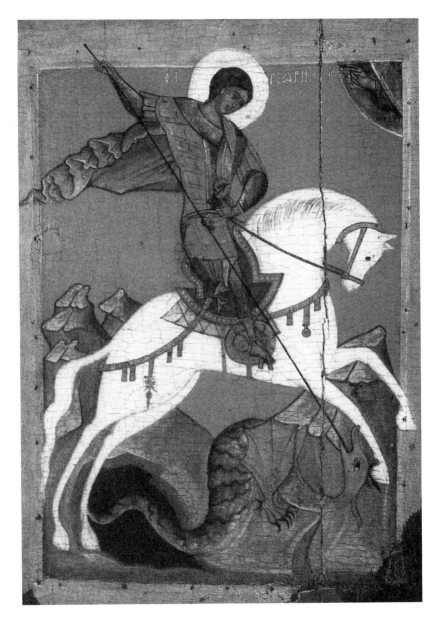

Figure 23. St George and the Dragon. Novgorod School, 15th century. Russian Museum, Leningrad. Behind the mythology is the diagram of the Universe with its higher and lower worlds (cf. Fig. 24).

no light and shade, no anatomy. The scale, including heaven and hell, is logically inconceivable. Nevertheless, our imagination is glad to enter that 'other world' into which the artist leads us. This is not the world of sense-perceived realities but the world of cosmic and spiritual reality, the unseen world of a struggle in man's inner life: 'inner warfare'.

A horse represents strength and power, but a man riding a horse is a traditional symbol of controlled strength and power. St George is the figure with whom we identify; he is ideal man; he struggles for supremacy over lower forces. The various features of the story are depicted in a specific order, one above the other, so that we see clearly the ladder of descending forces between higher and lower. Between these two poles is St George, who belongs neither to the lower world nor to the higher, but who maintains an equilibrium between the two. We begin to see that the painting is not a pictorial narrative of a man killing a beast, but a commentary, by symbolic implication, on the higher and lower forces that act in the spiritual world, and how it is man's role to maintain a balance between the two.

What are these forces? Can they not simply be designated as good and evil? Reference to the icon shows how subtle is the artist's understanding of what we naively tend to see as no more than a folkloristic moral tale. A simplistic approach would designate the dragon as evil but not the horse. Yet both horse and dragon are in a similar situation; they are both under the saint's control, the horse, through the reins in his left hand, and the dragon through the lance in his right. Each symbolises a 'power' that is mastered by the saint. Furthermore, the dragon has no look of evil; rather, it seems to look lovingly at the saint as though gladly acknowledging his superiority. For the painter there is no such thing as good and evil; there are only forces – levels of forces that must be in a correct relationship with each other in the harmony of the universe. Thus St George does not kill the dragon but pins him to the ground, demonstrating that he masters him (but does not destroy him), just as he masters the horse. St George, by thus carrying out this cosmic work – which, in practice, is spiritual work – shows us, by his example, man's meaning and true place in the universe. The saint, in his turn, is beneath the heavenly influences above him. They descend via the cosmic ladder on which he is already standing on the fifth step.

The ladder is an octave of seven distinct stages or steps that has two beginnings. One, which descends, begins with God –

represented by the blessing hand – beneath whom are the heavenly spheres, or divine realm, which is represented by the quadrant in the upper right corner. Beneath this the firmament, or celestial world, is indicated by the red background. Thereafter comes the saint beneath whom are the forces which he has mastered. The other, which ascends, begins with man, that is, ordinary man, who has not yet subdued the 'dragon' nor mastered the 'horse' in himself. He can be said to be no higher than the cave into which, through Adam, he has fallen and from which, through Christ, he is raised.

God

The heavenly spheres

The celestial world

The saint (Man)

The charger

The dragon

The level of the earth

The cave or subterranean depths

The central stages signify the transition where a man becomes what the Philokalia calls 'intelligent' (i.e. spiritual). Only then, according to St Antony the Great, can he properly be called a man.[4] He is born, as the icon of the Nativity testifies, on the level of darkness and must ascend, by subduing the dragon and the horse, to the level where he can begin his ideal work.

It is interesting to note that there is no violence in the action as it is shown in the icon; hatred and fear are not expressed between the combatants as they would be in a western, naturalistic painting. In an icon it would be impossible to depict such qualities since the world that the artist depicts is not the natural, external world but the spiritual world which he 'sees' within himself. All the elements that constitute the icon: saint, horse, dragon, as well as the dark cave and the higher world and God – all this is to be found within the self through the methods, diligently and attentively applied, that the spiritual masters of the Philokalia describe. The icon – always the image of spiritual life and never the picture of natural life – shows that once the proper equilibrium has been achieved each character expresses only his acceptance.

The idea of equilibrium, so fully understood by the painter, is given expression in both colour and design. All is harmony and balance. The horse's swift leap fills the ascending diagonal from left to right, but this movement is quickly arrested by the opposing diagonal of the lance. Static balance is also given by the division of the red ground into three areas arranged triangularly. Elsewhere we see an infinitely varied system of motifs and counter-motifs such as the delicate curve of the horse's quarters and neck that are balanced by those of the dragon, or the curve of the saint's halo by the curve of the saddle. Wherever in the painting one looks, each form, each line has its corresponding echo. The effect, as in a landscape reflected in still water, is one of peace and stillness.

And so the impression of the scene, which takes place in a world far removed from the everyday sphere of violence and hate, gives us a feeling of love, silence and stillness. St George's face is not contorted with fury but, on the contrary, radiates light and spiritual joy.[5]

The icon of St George is a profoundly mysterious image that affords a glimpse into what is normally unseen – the 'spiritual combat' or 'secret warfare' of the mystics.[6] The warrior is the man who, having established attention and silence within himself, tames his earthly nature in order to become the recipient of divine influences. When this state is achieved man truly becomes the universe in miniature. He transforms his inner chaos into the cosmos.

If we lay out the scheme of the icon's background (see Fig. 24) we see at once that it corresponds with the symbolic topography of Cosmas Indicopleustes. The central axis has swung from vertical to diagonal but the main features of the 'topography' remain. Emanations from the hand of God contained within concentric circles are, as we would expect, in the upper part; only the proportion has changed in comparison with the sixth-century version. A truer image appears when we extend the circle. The firmament, or celestial regions, is represented by the red background while the earth remains as a mountain. The dark cave is in the lowest part of the icon and corresponds to the Kingdom of Darkness.

The icon of St George is a commentary on the cosmic meaning of the spiritual warrior. We understand this if we grasp fully what is spiritual warfare. The Philokalia speaks of the need for attention in order to achieve a state of complete detachment from any movements of desire or of thought. This does not mean absence of desires and thoughts and the mystic has to find

Figure 24. Diagram showing the 'cosmic landscape' in the icon of St George and the Dragon (Fig. 23). The elements shown in Fig. 13 (and also Figs. 3, 4, and 11) are all present.

this state while surrounded by the circumstances of his ordinary mental and emotional life. Normal human reactions to people and the events of life cannot be sent away just as life itself cannot go away. But, for the spiritual warrior, it is possible to let such events continue while remaining independent of them. In other words he is inwardly separated; his divine nature is not sullied by his human nature, yet both co-exist in him.

This idea is beautifully illustrated in an icon of St George in Moscow where we see him standing in the accoutrements of a warrior while, all around him, on the borders, are scenes from his life (see Fig. 25).

Here the painter's prime concern has been to render the spiritual state of silence and the unseen warfare needed to achieve this. That he does so depends on two essential factors: (1) the mastery of his craft; and (2) his personal skill as a spiritual warrior. Without the second factor his work, however gifted he may have been as a painter, will be only art, for he will not have participated

in the events he describes and they will not express his own experience.

At the centre of the icon itself is a space in which St George stands freely. Wearing the armour of a Roman centurion he is fully equipped for war and carries an arsenal of weapons which, if we took them literally, would seem excessive: sword, lance, bow, shield and two quivers. Beyond this the analogy with military hostility ends. St George stands poised in a calm and impassive state; we see that he is silent, alert, and without agitation. His habiliments and weaponry are rendered in a delicate linearity and in curiously sweet colours – vermilion red and orange red countered by pistachio green and verdigris – that are quiet and harmonious. Everything is balanced and integrated so that our attention finally comes to rest on the face where we encounter the steady gaze of spiritually centred attention.

Gradually our awareness takes in the series of strangely beautiful torture scenes that record the events of the saint's life. But the

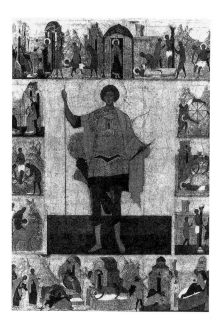

Figure 25. St George and Scenes from His Life. Moscow School, 16th century. Rublyov Museum, Moscow. St George represents spiritual warfare. He is not agitated by the violent events of his life but occupies an inner space with poise and alertness.

racking, flailing, stone-pressing, freezing and scourging, the red-hot bronze bull and other scenes are painted in a way that does not disturb the icon's stillness. All remains golden and luminous – a world without shadows. The violence of these happenings has been rendered ineffectual; they have no power to harm St George and cause him no agitation. The spiritual warrior has transformed violence into non-violence.

14

The Topographical Background: the Divine Ray and the Descent of Light

THE cosmic and spiritual topography that we have seen in the icon of St George is the setting in which a number of iconographic events take place. The 'landscape' illustrated on the following pages is the background to such icons as St John the Evangelist, the Nativity and the Baptism (see Figs, 26, 27 and 28).

We have suggested that the topography of these icons comes from Cosmas Indicopleustes and from the Hellenistic intellectual milieu of Alexandria, whose thought was imbued with the Plotinian Doctrine of Degrees, and that the context in which these events are shown should be understood in a cosmic and spiritual sense and not in a literal or naturalistic way. In each case the narrative elements of the story are secondary; their function is to draw our attention to the threshold of another level of understanding beyond which we may pass into the world of spirituality. In this world the laws that regulate phenomena do not obtain; space and time do not exist. Eternity abides here and space is multi-dimensional and infinite. There can be no shadows since the beings and events depicted are themselves sources of light; their luminosity fills the space in which they appear not with physical light but with a radiance that comes from the Greater World that lies beyond the sun.

The icon is thus the doorway that stands between the world of appearances and the inner world. And it is in the latter that we will understand the archetypal cosmic truths that lie deep in our psychical being.

The 'landscape' is clearly the same in every case. And we cannot doubt that this is the same topography that we first observed in

Figure 26. The background of the Nativity (see Fig. 1) is made up of the same elements that constitute the cosmic landscape of iconography.

the art of Cosmas Indicopleustes, the elements of which we have already analysed in our discussion on St George and the Dragon.

ST JOHN THE EVANGELIST: THE DESCENT INTO HELL

In the icons of St John the Evangelist, as we see in Figures 29–31, we again find the figures placed within the cosmic landscape and, as ever, it is here that we must search for the meaning that lies beyond the suggestion that the landscape represents the island of Patmos.

Since the background tells us that the event portrayed takes place in the spiritual world, we will find its principal meaning exclusively in that psychological context and we will make no concession to the idea of an actual geographical location. Similarly, we will not consider the event as having happened in historical time.

What kind of time exists in icons? In the rational world the horizontal line of time going from the past to the future is the

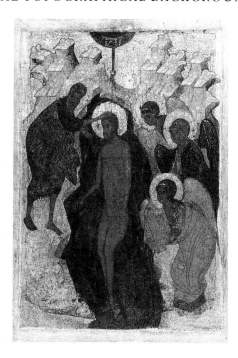

Figure 27. The Baptism. Russian, 16th century. Private collection, Hollywood, Florida.

only time that our literal minds can conceive. But in the spiritual world only 'now', a phenomenon independent of linear time, is real. Our earthly time, consisting of hours, days and years, is measured by the diurnal rotation of our planet on its own axis together with its rotation around the sun. Linear time is, for us, a uniquely subjective phenomenon relative only to our planet and its relationship to our sun. Beyond the solar system, our time, and the factors by which we measure it, have no meaning. Consequently the 'historical' factor in religion becomes irrelevant on the cosmic scale. 'Now', that is, *the present moment*, can be thought of as the entry of eternity into time and the only time that exists in icons therefore is the 'eternal present'.

In the icon, God's 'energy' is indicated by the light which we see emanating from the divine realm, the edge of which is seen in the upper left corner: the highest 'place' in the universe. The icon also emphasises the cave, or 'lowest place' in the universe, which, in

Figure 28. The Baptism (see Fig. 27) with the protagonists removed. The same 'cosmic landscape' can be observed when the foreground figures are removed from the icon of St John the Evangelist (Fig. 30).

contrast to light, is indicated as darkness. However, the light and the dark, or the highest and the lowest, are connected with each other according to the principles of the Divine Ray. And we see that the Evangelist and his disciple Prochorus are significant links in it. Without them the material world cannot be spiritualised by the penetration of divine light. This means that man is a vital link in the chain of transmission by which the lower is illuminated and brought to life by the higher. From this we learn of man's cosmic responsibility: if he neglects his spiritual nature he neglects the true purpose of his existence which is to 'help God' by becoming a channel for the emanations of his energy.

But man fails to fulfil this highest sense of his existence because spiritually he falls into the cave which, as we shall see in discussing the iconography of the Harrowing of Hell, is the psychological prison into which he falls when he is expelled from Paradise. Or we may say it is the dark place in ourselves where God has not yet entered.

The rocky ground represents the earthly or material level, and the feet symbolise the point of contact we have with the material world. In sacred art these images represent psychological states of being; thus certain details, such as the bared feet, or the feet not touching the ground but placed on footstools, take on a special meaning. This was a familiar idea to Alexandrine Christianity. For example we find the great Cappadocian Hierarch St Gregory of Nyssa pointing out that 'sandaled feet cannot ascend that height where the light of truth is seen, but . . . [sandals] must be removed from the feet of the soul'.[1] St Isaac of Syria, writing in the sixth century, uses the same image when he says

> When your soul is nearing its way out of darkness . . . be diligent in your work, stand watchfully on guard, that grace may increase in you from day to day. But until you see this you have not yet accomplished your journey nor reached the mountain of God.[2]

We see that both St John and Prochorus are already at a higher level than the earthly or material plane. Of the two, by his disproportionate size, St John is the greater. The fact that he is on a mountain, which we may take to be what St Gregory calls the 'mountain of the knowledge of God',[3] and that his feet do not touch the ground, indicates a level of spiritual achievement where he can receive directly the divine influences that are typified in the icon as light flowing down through the universe. This influence is passed on to the disciple Prochorus who, in turn, by writing on paper, may be thought of as inscribing the divine word on matter. The icon is thus a description of the Divine Ray and a commentary on the transmission of divine knowledge according to the doctrine of degrees.

> The Light World
>
> The Firmament
>
> The Mountain
>
> St John the Evangelist (Man)
>
> Prochorus (Man)
>
> The Book
>
> The Earth
>
> The Cave

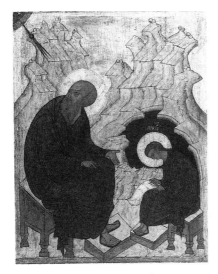

Figure 29. St John the Evangelist and Prochoros. Russian, 15th century. Menil Museum, Houston, Texas. (See Fig. 30.)

Figure 30. The cosmic landscape in the background of the icon of St John the Evangelist (Fig. 29).

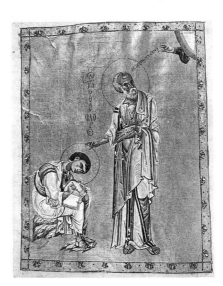

Figure 31. 12th-century Byzantine manuscript of St John and Prochoros, Monastery of Dionysiu, Mount Athos. In this composition the stages of transmission are more clearly stated than in the icon.

The icon shows us here the ideal for which we aim. It can only be achieved when man finds his proper place in the universe. We see two stages of man's spiritual life where he really is man as he is intended to be.

In order to understand man as he actually is, we need to study the icon of the Harrowing of Hell, the Easter icon. Here man, represented by Adam and Eve, is in that psychologically low place signified as a tomb.

If we first of all inspect the background in which the drama is set, we at once recognise the familiar imagery that denotes the psycho-cosmic world (see Figs. 32 and 33).

In this icon an essential element, the higher world, usually represented by the quadrant in one of the upper corners, is absent while the lower world is emphasised as we see when we extend the circle implied by the form of the cave. However, as we observe in the icon itself, the divine realm has by no means gone from the icon but has dramatically reappeared in a different place: the higher world of light, containing Christ, has appeared in the darkness of

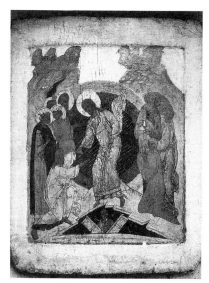

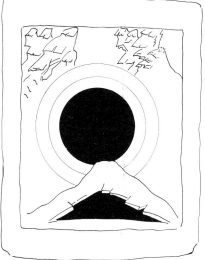

Figure 32. Descent into Hell. Russian icon, 15th century. Private collection, London.

Figure 33. The Universe turned inside out by the descent of Christ (the Logos of the Cosmos) into Hell, the Kingdom of Darkness.

the cave – the lowest place in existence.

Man is symbolised here by Adam and Eve and various Old
Testament figures who, taken together, constitute humanity in
general. According to tradition they or, more accurately, we,
have 'fallen' into the state of non-being symbolised by the cave
or kingdom of darkness, where we are imprisoned by 'Satan' and
'Hades'. A further image for this condition is death, and this idea
of our spiritual state of death is suggested by the tombs from which
Adam and Eve, with the help of Christ, are raised.

All the narrative elements in this icon, down to quite small
specific details, come from the non-canonical Gospel of Nico-
demus. This is an apocryphal book whose origins are obscure and
which some scholars have dated to the late second century. Recent
work, however, indicates a later date.[4] The part that tells the story
of the Descent into Hell is an account by some of the dead who
had been raised and who had appeared in Jerusalem. It relates how
they had been in Hades 'with all who died since the beginning of
the world'. All the Old Testament Prophets are there and they are
finally joined by John the Baptist. They are joyful at the prospect
of their release. Hades, the 'insatiable devourer of all' and Satan,
the 'heir of darkness, son of perdition, devil', are already anxious
and are discussing the loss of Lazarus who was 'snatched by one
of the living'. Suddenly a 'voice like thunder' sounds: 'Lift up your
gates, O ye rulers, and be lifted up, O everlasting doors, and the
King of Glory shall come in' (Ps. XXIII, 7 Septuagint). Hades and
Satan plan to make fast the gates of Hell with bars of iron and with
locks. But Isaiah reminds them of his prophecy. The thunderous
voice and the quotation from the Psalms are heard again:

> and immediately . . . the gates of brass were broken in pieces and the
> bars of iron were crushed and all the dead who were bound were loosed
> from their chains, and we with them. And the King of Glory entered
> like a man, and all the dark places of Hades were illuminated.

> The King of Glory stretched out his right hand, and took hold of our
> forefather Adam and raised him up. Then he turned also to the rest and
> said: Come with me, all you who have suffered death through the tree
> which this man touched. For behold I raise you all up again through
> the tree of the cross. With that he put them out. And our forefather
> Adam was seen to be full of joy.[5]

The Gospel of Nicodemus, in some parts at least, is a work
of great literary merit, offering us powerful and poetic images.
The narrative is obviously not to be taken at face value and it

is certainly not historical. However, the icon remains one of the most important images in the Orthodox iconographical canon. All this may entitle us to conclude that its originators, perhaps in the ninth century, understood its power as a cosmic allegory within the psyche of man. The icon tells us that the true resurrection is a spiritual event whereby the lower parts of the universe, which correspond to and which are, in a certain sense, the lower parts of ourselves, are raised up and illuminated through the unifying action of the descent of the Logos.

15

Two Worlds: Inner and Outer

ALL religious and philosophical systems have recognised that there are two realities: one seen and another which is hidden. Many different expressions have been employed to distinguish these two worlds. For example, in our own times Immanuel Kant used the terms phenomenon and noumenon. The phenomenal world is the world we perceive with the senses, the world that complies with the laws of three-dimensional reality and time. Its antithesis, the noumenal world, is one whose realities are perceived by intellectual intuition only. The noumenal world is not perceptible to the senses and has none of the attributes of phenomena.

In Christian mystical literature a similar idea is expressed by the imagery of 'inner' and 'outer' and the passage from one to the other is signified by an opening such as a door or window.

Man passes, or should be able to pass, between the outer and inner worlds; though too often he only lives in the outer world and, believing only in appearances, rejects or denies the significance of the inner world. Hence the necessity for intervention from another level. Christ says: 'I am the door: by me if any man enter in, he shall be saved, and shall go in and out' (John X, 9), and in the Psalms we read 'The Lord shall preserve thy going out and thy coming in.' These and many similar sayings refer to the idea of access to the higher life within.

Let us try to see how the idea of two worlds, of two realities, is symbolised in architecture introduced into the background of such icons as the Annunciation, the Presentation of the Virgin in the Temple, Christ Teaching in the Temple, and many others.

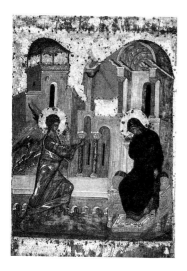

Figure 34. The Annunciation.
Moscow School, 15th century.
Tretyakov Gallery, Moscow.
The enclosed space indicates an
'inner' event. The icon is thus
a commentary on the festival's
spiritual meaning and does
not stress the literal, narrative
sense.

Figure 35. The Annunciation
with the protagonists in the
foreground removed. The
mysterious buildings repre-
sent the 'house of spiritual
architecture'.

The architecture in these icons has the function of telling us that
the events portrayed are taking place within an enclosed space (see
Figs. 34–37). Thus any building represents the closing off of the
outer world, or world of phenomena, and the opening on to that
which is hidden within. The inner or psychic world is the only
real place in us where spiritual events, not dependent on the laws
of time and three-dimensional space, can take place. This is why
the mystical injunction to 'withdraw into your inner chamber' or
references to the 'inner chamber of the soul' are significant to the
man who wishes to cross the threshold to real prayer and to a
higher spiritual level. It is in this sense that the Monks Ignatius
and Callistus in *Directions to Hesychasts* (fourteenth century) speak
of Christ's help in building 'the house of spiritual architecture'.[1]

The mystics teach that a man must become capable of adjusting
his inner state to accord with the real needs of the moment. As a
human being he must strive to satisfy his bodily and mental needs

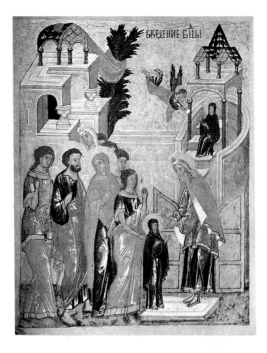

Figure 36. The Presentation of the Virgin in the Temple. Russian, 15th century. History Museum, Novgorod. The future Mother of God separates from her parents, enters within the Temple, ascends the Stairway and is nourished by an Angel. These represent stages in the evolving inner life of the future Mother of God.

and those of the world around him. As a spiritual being, he must satisfy his spiritual needs and those of the beings around him. In the gospels this double way of living is described as 'rendering to God what is God's and to Caesar what is Caesar's'. In the psalms, as we have noted, it is called 'going out and coming in'.[2]

Almost all religious controversy stems from our failure to understand rightly the inner side of ourselves that belongs to the world beyond appearances. This lack of understanding leads us to take literally certain descriptions in the gospels whereas they are intended to be allegorical. Sacred art uses a special imagery that comes from a very old tradition in describing places. If we apply this tradition to the gospels we may understand that the locations where the events take place often refer to the inner or noumenal world and not to external life and phenomena.

One well-known example in ancient Jewish sacred literature was the term 'Egypt' which traditionally symbolised the body.[3]

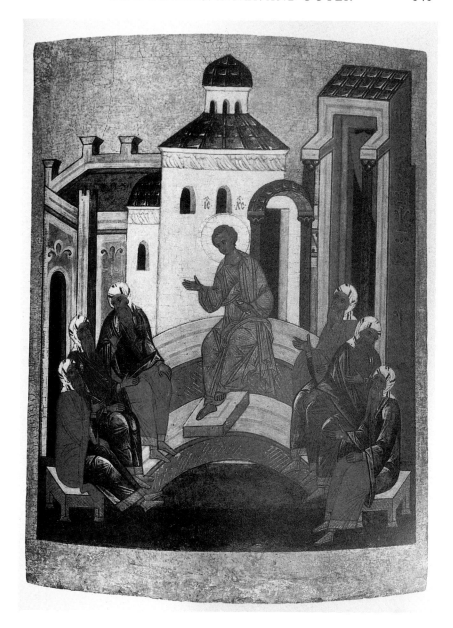

Figure 37. Christ Teaching the Doctors. Novgorod School, 15th century. Private collection, New York. 'The house of spiritual architecture.'

Psychologically the body means that part of man which is tied to earthly values and the material world. It is the natural level of our being from which, according to mystical ideas, we have to ascend to a higher, incorporeal level. At this higher level we are freed from the tyranny of the senses and can contemplate the divine.

The exodus of Moses and the people of Israel out of the land of Egypt thus becomes an allegory of a journey 'not of the feet', as Plotinus says, but of the soul. On such a journey we pass from the life of the body to that of the spirit. This is the passage where we relegate the priority that natural life holds to a secondary place; the body and sense perception now submit to a 'master' who is 'not of this world' but who belongs to the spiritual realm. This master, in Christianity, this authority or higher power, is God together with his son the Divine Logos and the third person of the Trinity, the Holy Ghost.

We have seen Origen pointing out that the tradition of allegory is also used in the New Testament and we will understand that deep meaning can be obtained from a study of the locations described in the gospels. We read that Christ travelled to and from various places, that he crossed lakes in boats and on foot, that he went up and down mountains and entered various buildings. All these details, which can hardly be relevant at the literal level, may be taken as references to psycho-spiritual states of being.

Let us take as an example the event that in the West is called Palm Sunday and which Orthodoxy calls 'The Entry into Jerusalem' (see Fig. 38.)

It is characteristic of sacred scriptures that each smallest detail can contain many levels of meaning. In this case, the palm branches genuinely contain the idea of the victor's acclaim by the crowd. And the victory is, without doubt, to be understood in a spiritual sense. This is emphasised by the idea of the entry within the city, the transition from the outer world to one enclosed within walls.

To understand fully the psychological impact of this idea we need to remind ourselves that in ancient and medieval times the city was an enclosed and well-ordered community that shut out the dangers of the outer world with a continuous wall. For the traveller in those times a journey was a hazardous and often dangerous undertaking. Roads were unreliable, there was no protection against bandits and wild animals. We have to imagine the sense of contrast for the traveller when he finally arrived at his destination. The moment he passed through the gates he entered a world that differed dramatically from his previous situation. In the city there was order; the rule of law controlled

Figure 38. The Entry into Jerusalem. Novgorod School, 15th century. History Museum, Novgorod. This icon is a spiritual commentary on the transition from the outer world to the inner world.

the multitude through legal powers, the court and the ministers. In the medieval city society was graded so that every member had his place in the common order. Here a man could conduct his affairs in security, whereas beyond the walls, there were danger and disorder.

All this provided an apt analogy for the study of spiritual states of being. Sacred literature specifically refers to the 'heavenly Jerusalem', which is not to be confused with historical and geographical Jerusalem.

Biblical texts frequently refer to cities and houses. Phrases such as:

Except the Lord build the house, their labour is but lost that make it.
Except the Lord keep the city the watchman waketh but in vain.

and

Jerusalem is a city built at unity within itself.

need not be taken as pious sentiments but as referring to the
spiritual distinction between the different levels of reality which
exist and the obligation man is under to pass from one to the
other.

St Isaac of Syria (sixth century) is clearly referring to these two
different worlds of reality when he says:

> He who gains victory in external warfare – I mean the war waged by
> the soul against the senses – hearing, sight, and so on – need have no
> fear of inner warfare.
>
> When a man has barred the city gates, that is, the senses, he fights
> within and does not fear those devising evil outside the city.[4]

Christ's Entry into Jerusalem, therefore, can be understood
as a description of a mystical transition.[5] In contemplating his
entry into the city, we understand Christ's conquest of his own
lower nature and thus his arrival at the complete state of self-
containment, the necessary interior condition for the supreme
spiritual events that were about to unfold.

The icon of the Entry into Jerusalem shows Christ on the colt
or horse and accompanied by the disciples. He is riding towards
Jerusalem where he is greeted by the citizens at the gates. In the
background are familiar elements of the cosmic landscape: golden
sky, mountain and cave. In addition to this we have the tree from
which the palm branches were cut and in which we see small
children climbing. To the right is the city of Jerusalem enclosed
within walls and fortifications. In the foreground are children,
some of whom take off their clothes to lay in the path of the
horse.

The icon takes the main narrative elements from the gospel text
that describes the event. But no attempt is made to present the
story literally and the details take on their true meaning when
understood as allegories. The Divine Ray is present in the 'cosmic'
elements that we have already mentioned. The presence of the
lower world is implied by the small cave that opens in the side
of the mountain. The higher world is not shown by the quadrant
such as we saw in the St George icon because the higher world
is actually present, incarnated in the person of Christ. Christ is
shown, not in the garments he would have worn as a Nazarene
carpenter, but garbed in the robes of a philosopher-teacher. And it
is not unreasonable to see in the horse the submission of animality
to spirituality in the same sense as we understand the symbolism

of St George mastering the horse while he tames the dragon. The single, minute branch proffered by the leading citizen and the restrained gestures of all the group around him suggest that the 'triumph' is hardly a worldly one.

In the language of allegory, clothes and outer garments can be understood as psychological descriptions of the inner state of the person depicted[6] and the removal of clothes or the outer garments may be understood as signifying a psychological change of state, a transition from what is outer and seen to that which is covered and within. In the icon we see the children in the foreground removing their clothes to lay under the feet of the horse. These outer garments are red or multicoloured, and, when removed, reveal pure whiteness. And so the detail where we see the children removing their coats restates, in another key, the main theme of the Entry into Jerusalem, namely spiritual transition.

Why children? They are not mentioned in the gospel (Matt. XXI, 8) where we read 'a great multitude spread their garments in the way'. However, the tradition goes back at least as far as the sixth century where we see the same detail in the Rossano Gospels.[7] This suggests that its origin may be sought among the allegorical thinkers of Alexandria and the traditions of antiquity they had brought to Christianity.

The meaning is suggested when we understand that all the phases of natural human development are paralleled in the images that symbolise our spiritual lives. Having reached physical maturity we must now seek to be reborn 'of the spirit'. This means another conception, another birth, another childhood, another education, and so on. These are mystical events and, in so far as they refer to our own inner lives, they are not physical ones.

If we take the background of icons such as the Annunciation or other icons with architecture in the background, removing for a moment the personages from the foreground, we see that this 'architecture' has many curious and unreal qualities. The forms are fantastic and dreamlike. The different features: columns, corridors, perspectives, colonnades, atrium, pediment, have only a token resemblance to the actual forms of classical architecture and their strange mergings and non-sequential relationships could not exist in 'reality'. And yet they are painted with assurance and impressive mastery and, in their own surreal or supra-real way, they have great beauty. We feel we are stepping into a world of pure enchantment.

This art demands from us – and we readily give it – suspension

of belief. As in the theatre or at the ballet, we accept to put aside knowingly the world of mundane values so that we may be led, childlike and unresisting, into the world of wonders.

The spaces created by these buildings convey no anecdote or narrative. They are not documents that record anywhere or anything we could know in the ordinary world. The absence of the narrative element, when combined with the curious and fascinating beauty, opens in us intuitions which prepare us for the meaning of the event that is to be enacted.

We have entered a world whose values cannot be comprehended at the level of our physical nature where the truth of everything is only approximate and relative to the distortions and limitations of sense-perception. In this new world everything is seen in its transfigured state. Ordinary reality has been dismantled in order to recreate a context for higher truth. This conscious distortion leads us away from the external world in order to show us the inner.

One of the best examples of intentionally distorted, non-physical architecture is to be found in the small, fifteenth-century icon of the Annunciation of the Moscow School in the Tretyakov Gallery in Moscow (see Figs. 34 and 35). One scholar has described this architecture as 'bizarre'[8] but, from the mystical point of view, it would be our vision of the world, with its insistence on literalness and logic, which is bizarre. Neither the Mother of God nor the archangel are comprehensible to us and to reduce them to the level of our own understanding is to deny the cosmic influences that they represent. We know from our studies of Dionysius the Areopagite that the archangel, himself imitating the Divine Power, through his position in the Divine Ray, has the role of imparting Splendour and Divine Light. The Mother of God, as we see from the throne and footstool is already higher than the level of matter. The painter here uses a convention that shows the Virgin has *tiny feet*, which means that she does not walk on the ground. That these are psychological and spiritual realities is especially emphasised by the house of the Mother of God which is at the back of the icon. This building does not show us her house in the three-dimensional sense as a western painting would. It shows us something far more important than historical anecdote. The architecture in the icon is a commentary on the accessibility of the spiritual life and the necessary state without which divine influences cannot be received. We see simultaneously both the outside as well as the inside aspects of the house and, by the entry of the angel, we understand that Divine Power and Energy reaches us when we open ourselves inwardly and withdraw from the distractions of the outer world.

The birth that is announced here is the rebirth, offered to all men, of the spirit. For us, ordinary human beings, this possibility is more important than the historical narrative which the icon, at another level, also represents.

16

Light

FROM the point of view of the spiritual seeker the ideas that we have been discussing have to be taken in relation to man because it is to man – to ourselves – that they ultimately refer. The visual conventions and techniques of icon painting are intended to create symbolic or anagogic contexts within which a man may try to perceive what is invisible at the level of material life but which exists deeply within his being.

We perceive the world by the mind and the five senses. But these instruments are neither suitable nor accurate for orientation in the world that lies beyond appearances. If we rely on the mind and the outer senses only, we get a distorted picture of reality.

All religions and spiritual ways teach that man's soul has to make a transition which is portrayed in icons and in allegorical literature as the passage from lower to higher, from outer to inner, from darkness to light and from death to life. All nativity scenes, whether of Christ or the Mother of God, or of certain saints, refer to rebirth in the spiritual sense. This idea of a transition or ascent is central to the mystical meaning of icons and the theology of gnosis. It is the basis of the ideas on which mysticism is founded and it depends, if it is to have an action on our lives, on our understanding that the physical world of the body, sense-perception and rational thought are, from a certain point of view, illusory.

We cannot apprehend reality in our ordinary way of living. The poverty of our spiritual circumstances is such that all our beliefs and values must be regarded as provisional and ultimately of limited consequence. Objectively, the only thing of real consequence for man, while on earth, is the possible role for him in the maintenance

of cosmic harmony within the order of the universe.

God helps man to realise this possibility by sending down to him his Divine Energies. These are symbolised in Christian literature and art as light. He also, in a way incomprehensible to us, sends himself as Christ, the Divine Logos and Second Person of the Trinity. We see in the icons that Christ is depicted in the attributes of light.

What does our ordinary knowledge tell us about light and can it help us to understand how light is treated in icon painting?

Light is a vibration or radiation. Its source is the sun; it fills the entire observable universe and gives warmth and life to the solar system. We know its source but not its destination since its vibrations never cease or diminish. We can calculate its speed and some of the distances it travels even though those distances involve figures such as the 50,000,000,000 years that it takes to travel from the furthest stars. But such figures are irrelevant since, for us, time, the product of the relationship of our planet to the sun, is a phenomenon that has no meaning outside the solar system. So we may say that light is outside time, and therefore eternal; also that it is unbounded by physical space.

It is difficult to say where physical, sense-verifiable light passes into philosophical analogy. Whether we think of it as religious symbol or life-giving, cosmic element, it passes across the threshold between phenomenon and noumenon. All religions and philosophies have recognised this; the Buddhists strive for illumination; the Sufi mystics seek enlightenment; Jesus said: 'I am the light of the world.'

The mysterious life of Christ takes on a special meaning for those who, wishing to awaken to a new life within themselves, identify a certain kind of inner experience with the so-called Christ within. From this moment the nourishment of this newly born inner life becomes a matter of inner disciplines and exercises. A difficulty arises here for those who continue to approach spiritual ideas with the mind only; they are in a quite different situation from the spiritual worker or Hesychast for whom the approach is now a matter of practice and not of book-learning. Such a man need not be concerned with intellectual and philosophical speculation which no longer has any significance and which may actually hinder practical work. (In the same way a musician need not necessarily be concerned with musicology or an artist with art history.)

It would seem, from all we have said, that icons aim to depict different cosmic or psycho-spiritual stages, not only in the historical life of Christ but also in the life of Christ within ourselves. We have seen that he is born in darkness, in a cave, though under the direct influence of the higher spheres and light.

In the scenes that show Christ after his earthly life and Crucifixion we see that he occupies the higher worlds and that he has now assumed his cosmic status as the Logos of the Universe. Thus in the icons of the Dormition or the Ascension he is shown surrounded by blue concentric spheres known as the mandorla[1] or glory (see Fig. 39).

Most striking is the presence of the mandorla in the icon of the Descent into Hell; here the Divine Realm has come down into the lowest level of the universe. Christ is shown 'rescuing' Adam – that is, humanity – from the grave and thus emphasising that the Redemption reaches the ultimate depths into which man has fallen. The Gospel of Nicodemus tells us that 'all the dark places of Hades were illuminated' and the icon does indeed show Christ illuminating the lower world, turning it from darkness to radiant colours and light.

The same light radiates from Christ in the icon of the Transfiguration. This is the theme associated with the feast which celebrates the Church's blessing in the fourteenth century on the Hesychast traditions of Mount Athos. Hesychasm, as we have seen, dates from at least the fourth century and some would say is of far greater antiquity.

The Desert Fathers, and later the Athonite Fathers, being primarily interested in practical methods and direct experience, concerned themselves little or not at all with speculative theology and doctrinal questions. No serious confrontation with doctrinal authorities in Constantinople arose until the later part of the fourteenth century when the Italian monk Barlaam of Calabria visited Mount Athos and, scandalised by the mystical practices he witnessed, denounced them as heretics to the patriarch in Constantinople.

It was Barlaam who originated the taunt, still used today, that derides the art of spiritual contemplation as 'contemplating your own navel'. The controversy raged for twenty years between, on the one hand, St Gregory of Palamas and the Hesychasts on Athos and, on the other hand, Barlaam and the various factions in the city of Constantinople.[2] There the debate rested mainly on politics and personal struggles within the circles of power around the Imperial throne. Theological and spiritual arguments were for

the most part subverted to the aims of ambitious political men and women. The fact that Palamism 'triumphed' was incidental and the outcome was scarcely more than a matter of chance. We mention this only in order to remind ourselves that, from the point of view of Hesychast silence, the drama of the Palamite controversy was as irrelevant as any other worldly matter and of no consequence at the level of objective reality. The governments and laws of men have no meaning for the Hesychast whose stillness and mystery they cannot penetrate. They stand respectively in two different worlds: one exoteric and the other esoteric.

The event of the Transfiguration on Mount Thabor is recounted in the synoptic gospels. Some early images exist, such as the mosaic at Ravenna,[3] but such examples are rare and the icon does not become widely known until the triumph of Palamism at the end of the fourteenth century when it was included among the feasts represented on the iconostasis. The icon (Fig. 40) shows Christ transfigured and radiating light. He stands within a pentacle contained within an aureole and on either side of him are Elijah and Moses. Below, in various postures of awe and dismay, are the apostles James, John and Peter. The latter group, who belong to a

Figure 39. The Ascension. Moscow School, 15th century. Tretyakov Gallery, Moscow. The horizontal line of mountains emphasises the distinction between the Divine Realm, where Christ reassumes His status as the Logos of the Universe, and the Earthly World where the Apostles and the Mother of God remain.

different stage of the spiritual ascent, are shown lower down from the summit of the mountain.

Lossky, in a commentary on the Transfiguration, points out that the light emanating from the transfigured Christ is to be equated with the definition of St John of Damascus, St Gregory Palamas, and others who stressed the unearthly and insensible nature of uncreated light and its function in conveying God's energy.[4]

A clear account of the Palamite controversy, considered from both an historical as well as a theological point of view, is given by Runciman.[5] By an apt quotation he clarifies Palamas' claim that beyond the stage of purification (which we may understand as spiritual perfection) lies the possibility for man to be united with God: through being

> above ourselves, having abandoned everything that pertains to the sensible world and having risen above all ideas and reasoning and even above knowledge and reason itself . . . He who participates in

Figure 40. The Transfiguration. Russian, 15th century. Tretyakov Gallery, Moscow. The emanations from the transfigured Christ are the 'uncreated light' that conveys God's energy down to the human world.

this grace becomes himself to some extent the Light. He is united to the Light and by that Light he is made fully aware of all that remains invisible to those who have not this grace.[6]

Runciman points out that the Light was identified by the Hesychasts as the light that shone on Mount Thabor. 'The divine reality which is manifested to the holy mystics is identical with the light that appeared to the Apostles at the time of the Transfiguration.'[7]

Other scenes from before the Ascension, that is, during the earthly life of Christ, do not show the spheres representing higher light worlds either in the upper part of the icon or enveloping Christ. In these icons the source of light, if one observes the scatter of highlights and colour reflexes, originates from the human Christ. We see this, for example, in the Raising of Lazarus.

In the example which we have chosen (see Fig. 41), which can be seen in the Menil Foundation in Houston, Lazarus himself seems to be the source of illumination. The reflections of white on the draperies of the large group of figures and on the rock facets, both

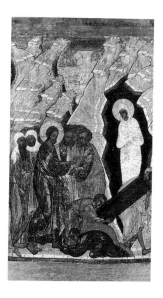

Figure 41. The Raising of Lazarus. Novgorod School, 15th century. Menil Museum, Houston, Texas. Light, initiated by Christ and emanating from Lazarus, fills the entire world.

in the mountains and along the ground, indicate that light radiates from the figure emerging from the cave.

The theme of the Raising of Lazarus is the only one of the miracles recounted in the gospels that finds its place among the great Church festivals represented on the iconostasis. We shall see, in our discussion on the iconostasis in Chapter 18, that the main theme running through all the festival icons is that of death and of rebirth, shown either as a nativity or as a resurrection. The spiritual context of these images does not allow for the idea that it is natural birth and natural death that are depicted. These events do not take place in the natural world and Lazarus does not represent the physical impossibility of a dead man stepping out of the tomb, but the possibility of spiritual resurrection from spiritual death.

It is interesting that, while Lazarus seems to be the centre of the action, he is not the source of light but the vehicle through which it is manifested. He looks, with an expression of joy and wonder, at the comparatively understated figure of Christ who is the initiator of the events and the real centre and source of light in the icon.

It should be remembered that in true icon painting light, regardless of its extraordinary physical properties, is, for the painter, no more than the analogy for quite another substance that Dionysius calls Divine Light and which other theologians such as St Gregory Palamas call uncreated light. To the Hesychast this other substance, which we cannot know by the senses, is a concrete reality that can be experienced as an inner energy. It functions, for the practitioner of secret warfare, according to known and calculable laws.

Knowledge, even if only theoretical, of the existence of this, for us, unknowable energy is essential for the study of light and colouring in icon painting.

According to ideas that early Christian philosophy inherited from Plato and neo-Platonism, an incorporeal substance or Divine Energy radiates outwards from the centre of the universe, from God. As it comes down through the stages of the Divine Ray it encounters matter which, according to Plotinus, is very fine in the higher spheres and is progressively more dense in the lower spheres. Plotinus taught that where 'light' encounters 'matter' a penetration takes place resulting in a third independent creation which he calls 'form'. This great law which encompasses the principle of the interaction of energies in the universe is formulated thus: *light endows matter with form*.

Still following Plotinus and applying now the law of the relationship between image and archetype ('each entity takes its

origin from one principle'),[8] let us look at the parallel between the light of the visible sun and the other kind of light that exists higher up in the cosmic scale ('most intensely in the All').[9]

We may also remember that parallel with the energies of the solar system are the functions of yet another cosmos that stands lower down in the scale, namely the microcosmos or man. According to gnostic and esoteric ideas, it is in this parallelism that we can understand man's relationship to the universe and why he has to wake up to a life that is in him and around him but which is not the life of his earthly organism.

Bearing all this in mind, let us try to imagine the master icon painter taking from nature various mineral and vegetable substances which he will transform into an icon. He does this according to traditions that he has learned through long apprenticeship. Only certain trees may be cut and only when at a certain stage of maturity. The wood has to be prepared, stored, seasoned and cut so that the strengths of its organic properties are available. Likewise the master painter must know the properties of many different varieties of plants and flowers, where they grow, when they should be cut, how to extract from them their essential colours, how to expose them to the sun or moisture and for how long. Further he must know the exact configuration of certain rock strata and from which crystallisations he may obtain the purest colours after grinding down. Then he must know which clays from exactly which part of the fields and river beds will give him the best range of ochres for browns, yellows and reds.

These are the first steps in a long process which, in completion, can be understood as a transformation of matter. While thoroughly knowing the organic and natural properties of his materials the master painter breaks them down at one stage of their existence in order to recreate them on another level. And for this he needs to know the laws of creation.

At the same time a parallel transformation takes place within himself also according to the laws of creation. We have seen in our study of the Philokalia what is the work of the true monk and Hesychast: while he works for the perfection of his techniques on mineral and vegetable matter, so does he inwardly work on maintaining a state of equilibrium so that his mind is protected from random mental distractions and his feelings from being lost among 'passions'.

Intense psychic work, when rightly conducted, brings an inner state which is described as one of illumination. And so in the painting of an icon two illuminations take place: one visible in

paint and the other invisible in the painter. Though one takes place in the material world and the other in the psychic world the two processes are intimately bound up with each other. We shall try to see that the properties and qualities of light and colour in the material part of a sacred painting will correspond to the spiritual qualities and energies active within the painter himself.

To the Hesychast the development of inner energies is an exact science. Psychic energies and psychic matter, like their physical counterparts, have varying tempos and densities. They obey the same laws as those on the physical plane and only differ from them in degree. Higher energy, that is, the energies associated with spiritual states of being, can penetrate and act on lower states of energy. An example of this is the way matter absorbs light. Both are energies; light having less density and finer vibrations than, say, wood.

The master painter's knowledge enables him to assemble and prepare his materials so that they can be transformed by his work and artistry. At the same time he prepares the materials that constitute himself, that is, his mind and his body, which can now begin to submit to spiritual influences that come down to him from above. In both cases the lower receives an inpouring flood of higher energies. In the case of the physical pigments and painting materials this will be light, and in the case of the psychic matter that constitutes the inner life of the painter it will be spiritual light.

This is why the quality in good early icons which has the widest and most general appeal is that of luminosity. Many visitors to churches and museums in Greece and Russia have been struck by the 'glowing colours' whose luminous purity emit vibrations that strike us directly and independently of the subjects they illustrate. We can be similarly moved by sacred music sung in a language we do not understand.

The vibrations of colour, like the vibrations of sound, combine, in the hands of the icon painter, to produce harmonies that act on us through the vibrations that they arouse within us. We observe parallels to this in nature where, for example, photo-synthetic cells in plant life respond to light.

But in the ages before technology, in the periods of antiquity and of Byzantium, there were schools that developed knowledge of working with psychic and spiritual energies and of creating analogies in the arts that demonstrated their actions. Such knowledge was the basis of art in the Byzantine world and in medieval Europe and was later the foundation for the art and philosophy of certain Italian schools.

COLOUR

In our own times we tend to take colour for granted since the mass production techniques, developed in the last hundred years, made it a universal phenomenon. But in former ages colour was a rare and precious material commanding a respect and appreciation that today is partly lost. The respect that a medieval icon painter gave to colour was partly in deference to its rarity and cost, either in labour or in money. But there was another reason to respect colour that came from the painter's study of the laws and properties of light. In ancient times the painter understood that colour was the prime product, in the visible world, of the interaction of light and matter. The cosmic law formulated by Plotinus, 'spirit penetrates matter to endow form', is given perfect expression in the manifestation of colour.

Let us try to see how the icon demonstrates this law.

With the help of a stereo-microscope set at ×90 magnification we can enter the world of colour and light in which the painter worked. The stereoscopy gives us a three-dimensional view and this, together with the high degree of magnification, gives us the impression, as we look down the viewfinders, that we are inspecting the geology of a new and unknown world. It is as though we are flying low over the surface of a distant planet of strange and unearthly beauty.

The basic substance that forms our new planet's surface is glassy and opaque; it is the crystalline, egg-tempera medium through which the light passes – though not all of it, for, as we watch, we see the light undergoing a transformation as it strikes the materials of the pigments. We have penetrated the cellular cosmos where the world of molecular and atomic particles is one step nearer. It takes a few moments to accept the relationship with elements apparently invisible to our ordinary seeing. Slowly this astonishing world of new colours and textures unfolds and we find ourselves witnessing secrets of unimaginable beauty. Here the light encounters clustered molecules of sulphate of mercury and many particles are absorbed, almost the entire scale except for the first note – red in its purest form, called by the painters 'flaming vermilion'. These radiations of red that have not been absorbed are now flowing back. They pass through the opaque medium and through the air into our eyes where, in us, new systems of response are activated at submolecular and psychic levels.

Elsewhere the atoms of other substances are taking out different sections of the scale of light particles so that other, different colours

are given back to the eye. From terre vert and malachite we get green, from ground azurite or lapis we get blue, and so on. In each case the law of spirit and matter is served in these transformations of light into colour.

The colours in medieval icons show us that the painters of those times had a working knowledge of the white ray and the properties of its constituent elements. It is interesting to note that their compositions balanced complementary tones, especially reds and greens, many centuries before Helmholtz demonstrated the spectrum cast on a screen after passing the white ray through a prism. This experiment gave the Impressionists a 'scientific' basis for their study of colour. But the knowledge of medieval icon painters was not based on scientific discovery. For them knowledge of the laws of colour, which was synonymous with knowledge of the laws of the universe, had never been lost. The traditions of Alexandria had guaranteed the continuity of the true philosophy for Christians and Christian art in the early centuries of our era.

For the icon painter who was initiated into the esoteric traditions of mysticism, the colours with which he worked were sacred. For him colour was a vehicle by which the living action of higher laws could be rendered in visible form, where matter served spirit and demonstrated, at the material level, the action of energies descended from the Divine Realm.

17

The Mother of God

THE life of the Mother of God is depicted in the sequence of icons known as the Festival row on the iconostasis. (The iconostasis itself is discussed more fully in the next chapter.) Here the events of the life of Christ are inserted in the series that begins and ends with the life of the Virgin, implying that the life of Christ is contained within the life of a human being.

Once again the form and content of the icons in which 'events' in the Virgin's life are depicted are such that their higher meaning will elude us if we take them only on the literal or historical level. We shall see that the deepest meaning of the icons of the *Theotokos* (Bringer of God) transcends the physical aspects of her being and is purely spiritual. At the same time we need to understand that transcendence is a process, a passage or journey towards spirit that begins at the lower level of matter. According to tradition, the Mother of God is associated with the earth and matter. It is at this level, in the ground of humanity, that the life of the spirit is planted as a seed, takes root and grows upwards.

The Virgin's humanity is more accessible to us than Christ's. At the same time, that aspect of the Virgin's being so stressed in the sacred tradition, namely her purity or 'spotlessness', is the difference between her and ourselves. That she achieved the state of purity shows us the level of spiritual perfection that the Hesychast can reach through the disciplines of interior attention and prayer. Indeed, in this study, we shall consider the idea that the Mother of God actually was herself a Hesychast.

The events of the Virgin's story depicted in iconography come mainly from the Protevangelium and from the Pseudo-Matthew.[1] These early apocryphal works are taken by the Church as 'tradition' but, according to doctrinal theology, the events they recount are not considered as historical facts and are officially relegated to the category of pious legends.

The Hesychasts, on the other hand, obviously considered them to have a far greater importance for it was in a period of intense Hesychastic activity, that is, in the revival in the fourteenth century, that these non-canonical stories achieved the prominence they have held ever since.

We see a wonderful manifestation of this new movement in the mosaics and frescoes of the famous Karyie Djami, or Church of the Chora, built between 1320 and 1340 in Constantinople.[2] The Hesychast revival, which had begun on Mount Athos under St Gregory Palamas[3] flourished in Constantinople under the Paleologue emperors and was given artistic expression under the patronage of such intellectuals as Theodore Metochites, the philosopher and statesman, whose Church of the Chora is widely considered to be the greatest surviving monument of Byzantine art in the Paleologue era. This impulse, together with its artistic expression, soon passed to Russia where it was the foundation, not only for the spirituality of St Sergius and for the art of his disciple Andrei Rublyov, but for all spiritual and iconographic activity in Russia for the next hundred years. It would not be an exaggeration to say that all Russian icons, from the end of the fourteenth to the beginning of the sixteenth century, contain a dimension of spirituality that stems from Hesychasm and which is absent, or declining, in most later works.

Scenes from the life of the Mother of God then, of fourteenth- and fifteenth-century iconography, are vehicles whose primary function is to convey spiritual meaning.

The Nativity of the Virgin, in the example that we have illustrated (see Fig. 42), has a remarkable and immediately striking feature. The central figure of St Anna, together with St Joachim and all the attendants, as well as the newly born Theotokos herself, all look pointedly out of the picture towards the spectator. That these looks are an invitation drawing us into the event is direct and inescapable. This sense of personal participation in the birth of the Virgin is exactly the point of departure for the spiritual meaning. The personages in the icon seem to say: 'We enact this scene *for you personally*; without your participation there is no meaning to

Figure 42. The Birth of the Virgin. Russian, 14th century. All the
figures look pointedly at the spectator, calling on his spiritual
participation in the event.

what you are seeing.'

The birth of the Virgin means here the spiritual birth of which all
traditions speak. It is the birth of a new life within that of a human
being. This new life can, in turn, if it is properly nourished, give
birth to a yet higher kind of new life: Christ.

The idea of the possibility for several different lives, one within
another, co-existing within one person is a very subtle and unusual
one, though it is not unique in esoteric tradition.

The next event in the life of the Virgin is the well-known theme
of the Presentation of the Virgin in the Temple (see Fig. 36 on page
140). This composition simultaneously combines the two spiritual
'dimensions' on which the language of iconography is founded.
The sense of enclosed space is provided by the architecture while
the idea of ascent to a higher level is suggested by the seven-stepped
stairway which the Mother of God ascends. Some icons of this
subject stress the transition from one world to another as in this
example where she is placed exactly half-way between the group
headed by her parents which she is leaving behind, and the temple
towards which she is going and where the priest Zacharias waits
to receive her. He is already on the first step of the stairway

which the Virgin ascends. We also see her at the top of the stairway where she receives food from an angel. This is a way of telling us that her spiritual level is such that she is nourished by the celestial energies that cannot reach human beings in their natural state.

The transcendence of the natural state, leading to 'purity' in the sense used by the Philokalia, is the state for which the Hesychast strives when he wages a ceaseless and unseen war against the passions and thoughts that chain him down in the world of illusion.

The Protevangelium tells us that the Virgin was three when she was given over to the priests of the temple. Three, in the language of allegory, means completion, and we can understand here not so much that she was a little three-year-old child, but that she was an adult who, in her spiritual self, had completed a necessary phase of psychical growth and was now ready to leave the world. Leaving the world, or 'dying' to the world is, in the spiritual sense, a state of being inwardly free and not attached to material things. The presence of architecture in the icon indicates that the Virgin has access to the 'inner chamber of the soul' while the stairway leads to that higher world that the neo-Platonists called Celestial Intelligences and which Dionysius called Angelic Powers.

One of the main themes throughout the infancy of the Virgin is that of spiritual purity and the efforts made by her mother Anna and later by the priests to preserve this. A characteristic detail is recounted in the Protevangelium. When the Child Mary was

> six months old her mother stood her on the ground to try if she could stand. And she walked seven steps [see Fig. 43] and came to her bosom. And she took her up saying: 'As the Lord my God lives, you shall *walk no more upon this ground* [my italics] until I take you into the Temple of the Lord'. And she made a sanctuary in her bed-chamber, and did not permit anything common or unclean to pass through it.[4]

We understand from this that the 'temple of the Lord' is an inner level already higher than the 'ground' on which is lived the life of the senses and our attachment to them.

Several details described in the Protevangelium text are rendered in the iconography of the Virgin's life. One of these recounts how the Mother of God, together with seven other virgins,

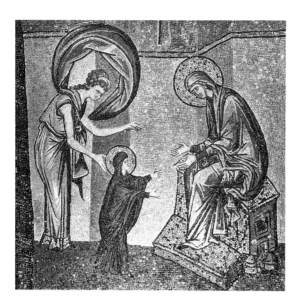

Figure 43. The First Seven Steps of the Virgin . Mosaic, 14th century.
The Kariye Djami, Istanbul.

was given wool to spin to 'make a veil for the temple of the
Lord'. There were several different colours and it fell by lot
that the Virgin worked on the 'pure purple and scarlet'. It is
on this skein of wool that she is working at the moment of the
Annunciation when, in her surprise and perturbation, it falls from
her hand.

The Protevangelium gives this mysterious account:

And to Mary fell the lot of the 'pure purple' and 'scarlet' [see Fig.
44]. And she took them and worked them in her house. At that time
Zacharias became dumb, and Samuel took his place until Zacharias was
able to speak again. But Mary took the scarlet and spun it.

And she took a pitcher to draw water, and behold a voice said:
'Hail, thou that art highly favoured, the Lord is with thee, blessed
art thou among women.' And she looked around on the right and
on the left to see whence this voice came. And trembling she went
to her house and put down the pitcher of water and took the purple
and sat down on her seat and drew out the thread. And behold,
an angel of the Lord suddenly stood before her and said: 'Do not
fear Mary; for you have found grace before the Lord of all things

and shall conceive of his word.' When she heard this she doubted in herself and said: 'Shall I conceive of the Lord, the living God, and bear as every woman bears?' And the angel of the Lord said: 'Not so, Mary, for a power of the Lord shall overshadow you; Wherefore also that holy thing which is born of you shall be called the son of the Highest. And you shall call his name Jesus; for he shall save his people from their sins.' And Mary said: 'Behold, I am the handmaid of the Lord before him: be it to me according to your word.'

And she made ready the purple and the scarlet and brought them to the priest.[5]

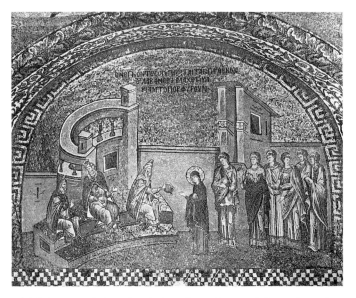

Figure 44. Mary receiving the skein of purple wool from the priests. Mosaic, 14th century. This and the preceding scene (Fig. 43), like all the imagery for the scenes from the life of the Mother of God, is taken from the apocryphal Protevangelium. The Kariye Djami, Istanbul.

We see this red veil stretched across the towers of the architecture in the background of icons associated with the Virgin. It is not mentioned hereafter in the Protevangelium and not mentioned at all in the gospel except in the accounts of the Crucifixion where it was 'rent in twain'.

The veil is an important esoteric symbol referring to the idea that there is something hidden, not yet revealed to humanity and which is therefore unknowable through our sense organs. The mystery

can only be known through spiritual knowledge or gnosis that can be acquired through methods of practical mysticism which, in Christianity, are inner warfare and ceaseless prayer.

We have seen, in the Presentation of the Virgin in the Temple, that the Mother of God was already communicating with the angelic world at the beginning of her life. Is this a pious convention or can we, in this case, take the text literally? Such a reading is suggested when we read that the apocryphal Pseudo-Matthew

> devotes a chapter to Mary's special virtues and describes her daily life in the temple in terms of monastic practices. As regards her intellectual (spiritual) accomplishments . . . it is said that there was no one more learned in the wisdom of the law of God and that Mary 'was always engaged in prayer and in searching the law' . . . It should be noted that the same source twice speaks of the daily visitations of the angels of God, who 'were often seen speaking with her'. Mary's precocity is described as being so great, and her daily life so fully ordered by divine rather than human means, that instruction, it would seem, could be given only through angels of God.[6]

Apart from describing mystical inner energies as 'angels of God' the text here has slipped out of the allegorical mode and gives what may be a direct and factual account of the Virgin's Hesychastic life.

The iconography of the Annunciation returns us to the language of symbolic imagery where the Archangel, who, as we know from Dionysius the Areopagite, is a cosmic power one degree higher than angels, appears at a stage in the Virgin's inner life where she can receive the message that God himself will appear at the earthly level through her. The Virgin thus fulfils the role for which her humanity is intended; she has perfected herself to the degree where she has become the channel for the descent of divine energy.

The appearance of this energy in the lower spheres of creation is a cosmic necessity without which there is disorder in the world. The true meaning of human life is revealed here in the submission of lower and chaotic forces to God's creative power which descends via the Divine Ray. At a certain stage this descent can only take place through spiritually perfect human beings. Without such men and women divine creation ends prematurely and with lamentable results for humanity.

The story of the life of the Virgin, much of which we only know through iconography, cannot be sought in historical facts. Most of its imagery comes from non-canonical sources written long after the supposed events. For example, the textual source for the Dormition is the apocryphal *Discourse of St John the Divine* which dates from the fourth or fifth century.[7] Historians therefore feel bound to relegate it to the status of mythology or cult.[8] Until as late as 1950, when it was officially made part of the dogma, the Dormition was, for the Roman Catholics, a 'pious option' of belief. In the Church of England it is rejected on the grounds that it is neither early enough to be considered 'tradition' nor otherwise 'founded on any warrant of Holy Scripture'.[9] But in the Eastern Church it was accepted by the fathers since early times and has been a major festival since 582.

Even so, its origins remain obscure. Lossky tells us that the apocryphal *Discourse* is not reliable and, for doctrinal authority, refers us to the homilies of later writers such as St John of Thessalonica in the seventh century and St John of Damascus in the tenth.[10]

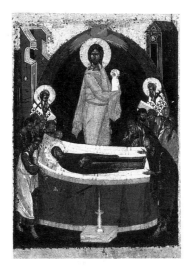

Figure 45. The Dormition of the Virgin. Russian, 14th century. Tretyakov Gallery, Moscow.

So it is especially interesting that one of the earliest 'witnesses' for the Dormition is Dionysius the Areopagite who, writing in the sixth century or earlier, has a passage on the Dormition in the *Divine Names*.[11] We have seen that Dionysius is a Christian neo-Platonic writer whose interpretation is *only* mystical. This is a firm indication that the meaning of the Dormition is to be sought at the esoteric level. It also shows that this element is present from the beginning of the tradition and, in this case, free of the distractions of a lower, or historically literal meaning. The idea of an esoteric meaning is endorsed by Lossky who writes unequivocally of the 'mysterious character of the event . . . a mystery not destined for "those without" [i.e. the exoteric circle], but revealed to the inner consciousness'.[12] On this basis we may interpret the imagery as representing a psycho-cosmic reality that properly corresponds to actual spiritual experience but not to any experience in the rational and physical world. The icon of the Dormition may be seen as a commentary on what the Hesychast confronts within himself through the practice of what Gregory of Palamas called 'scientific prayer'. (See Fig. 45)

The soul of the Mother of God, or the essence of that which gives birth to Christ within ourselves, is taken up by the angels, the archangels, the seraphim, and finally by the Divine Logos.

18

The Iconostasis: Unity and Multiplicity

THE iconostasis is the screen that separates the nave from the sanctuary in Orthodox churches. On it are tiers of icons that present, in visual form, all the theology of the Church; the sacred history and personages of the past existing eternally in the present. The total impression of the icons gives the spectator a sense of himself as though standing before the whole cosmos whose laws and energies are personified by the saints, personages and events of the Old and New Testaments and of the Church.

The development of the iconostasis is a Russian phenomenon of the fifteenth century, growing from the sanctuary screen of Byzantine churches which, in earlier periods, had consisted of only one or two rows of icons. Full-size icon-screens in Greece did not appear until the sixteenth century when the form was imported from Russia. In its full height it consists of five tiers of icons ranging from floor to ceiling; each tier stretching across the entire width of the church.[1] (See Fig. 46.)

The upper row shows images of Old Testament patriarchs and prophets; all of them face in towards the icon of the Mother of God with Christ Emmanuel at her breast, the 'Virgin of the Sign' and the result of the prophecies of the Old Testament. The Prophets row was not added to the iconostasis until the fifteenth century and was thus the last to come into existence. The figures of the prophets are otherwise rarely found outside the pages of illuminated manuscripts. In psalters and lectionaries they were presented in the full-face tradition of portrait images and did not need to be shown looking sideways as they did after the fourteenth century when they appeared on the iconostasis. The figures in the upper rows of the

Figure 46. Iconostasis. *c*.1500. Chapel of the Birth of the Virgin, St Sophia, Novgorod. The history of the Old Testament, the New Testament and the Church can be taken in at a glance.

icon screen, therefore, belong to the portrait type of icon except that the axis of the body and the direction of the gaze have been turned so that the icon's place in the row, and the subject's relation to the central image of the Mother of God, are taken into account.

The next group of icons constitutes what on the iconostasis is called the Festival row. The Feasts or 'holy days' illustrate a series of events – mostly taken from the life of Christ and the life of the Mother of God – that fall periodically within the liturgical calendar. Apart from the twelve major feasts there are numerous minor feasts, several of which find their place on the iconostasis. The number of scenes is partly dictated by the width of the screen and the number of spaces available. Beyond that, the choice of the subjects, which seems arbitrary at first glance, contains hidden meanings, both in the variety of subject matter and in the order in which the images are placed on the screen.

We have said that the historical aspect of the life of Christ, as depicted in the icons, is less important than the spiritual. Many of the scenes depicted on the Festival row are actually non-historical, that is, they come from apocryphal sources and not from the gospels. After the fourteenth century some of these

scenes, such as those depicting the Infancy of the Mother of God, were accorded greater prominence than hitherto. This was in the period of a renewed influence of Hesychasm in icon painting.

The development of the iconostasis and the introduction of new elements in Russian sacred art coincide historically with the spread of Hesychasm in the monasteries under the direction of such men as St Sergius of Radonejh, St Nil Sorsky and the founders of the White Sea Monastery, Saints Zossim and Savatii. It is therefore likely that a Hesychast influence dictated the choice of subjects and that this choice aimed to emphasise spiritual meaning in the visual forms rather than literalism or anecdote.

The sequence of the festival scenes begins with events from the life of the Mother of God and it ends with the Dormition. This has a certain historical correctness since the birth and death of the Virgin precede and succeed the birth and death of Christ. But another idea emerges here when we see that the earthly life of Christ is contained in, or takes place within, the life of the Virgin.

The following sequence, forming a 'feasts row' would be typical on a fifteenth-century iconostasis. (The non-canonical and Old Testament scenes are marked with an asterisk.)

Birth of the Virgin*

Presentation of the Virgin in the Temple*

Annunciation

Nativity

Presentation of Christ in the Temple

Baptism

Entry into Jerusalem

Crucifixion

Descent into Hell*

Ascension

Old Testament Trinity*

Dormition*

Of these twelve scenes we note that four are from the life of the Virgin, seven from the life of Christ and one from the life of Abraham. It is also interesting that seven of the scenes are provided

by the New Testament, one from the Old Testament and four from the Apocrypha.

A full-scale fifteenth-century iconostasis, such as the one decorated by Rublyov in the Trinity-Sergius Monastery at Zagorsk,[2] included a further group of minor feasts commemorating New Testament events and two further apocryphal scenes:

> Conception of the Virgin*
>
> Pentecost
>
> Raising of the Cross*
>
> Christ Washing the Feet of the Disciples
>
> Last Supper
>
> Communion of the Apostles
>
> Descent from the Cross
>
> Entombment
>
> Doubting of Thomas
>
> Three Marys at the Tomb

The order in which the icons were placed is only approximately chronological and sometimes varied as did the option for including some of the minor feasts. It would seem that some motive other than literal historical and anecdotal sequence was behind these choices.

It is interesting that none of the didactic elements of the gospel is included in the series. Illustrations of the teachings and parables of Christ are absent from the iconostasis though, of course, they are found on the walls of the church and in illuminated books.

Also absent are the miracles, the exception being the Raising of Lazarus, and we see that this scene is included, not because it dramatises an unnatural or impossible event, but rather because its inner meaning is central to the common theme of the festival scenes. This theme, which unites the meaning of all the icons, is that of birth, death and resurrection to eternal life in the spiritual sense. It applies throughout the festival scenes whether the subject is the Mother of God or Christ. It also applies – as we see in the case of the Descent into Hell and the Raising of Lazarus – to man.

Below the festivals tier is the group of icons constituting the Deesis row. These icons, whose monumentality and power are

visually so striking to visitors to old Russian churches – believers and tourists alike – were not found on icon screens before the end of the fourteenth century and are part of the revival of that period. Hitherto figures on the Deesis icons were represented head and shoulders only. The word Deesis means prayer and in the central group, which shows us the composition in its original form, we see the Virgin and St John the Baptist mediating on behalf of humanity at the throne of Christ.[3] In its extended form, as we see here, archangels, apostles, saints and hierarchs of the Church are included.

The central image is that of Christ Pantocrator, the Ruler of All (see Fig. 47). We see him majestically seated on a throne surrounded by apocalyptic animals, cherubim and seraphim and various geometric forms constituting a mandorla or aureole of glory.

Scholars suggest that this composition is based on passages in the Old Testament book of Ezekiel and on a similar passage in the book of Revelation. Ezekiel (I,4–28), with much repetition, describes 'four living creatures' each of whom had four wings, straight legs with calves' feet. Later on he identifies them as cherubim (X,20). Each had four faces the front one of which was that of a man and the others were those of an ox, a lion and an eagle. He also describes wheels within wheels with rims and spokes and eyes on the rims. Above the four-headed men was the firmament. And above the firmament was a sapphire throne and above that was the 'likeness' of a human form, later identified as the 'God of Israel' (X,20), whose upper part appeared to be of bronze and whose lower part was apparently fire. Around him was a rainbow.

In Revelation IV there is a heavenly description of 'one seated on a throne' around which is an emerald rainbow, twenty-four further thrones and 'four living creatures, full of eyes in front and behind'. In this case they are not four-headed but individually have the forms of a lion an ox, a man and an eagle.

Fifteenth-century Russian icon painters produced a number of magnificent Christ Pantocrator images that clearly select some elements both from the Ezekiel and from the Revelation passages but are neither entirely nor exclusively based on them. These biblical descriptions only partly correspond with the imagery of the Russian Pantocrators that are to be found on the Deesis range of the iconostasis and a further scriptural or iconographic basis has to be sought.

These images rather closely reflect aspects of fifth- or sixth-century paintings in the apses of Coptic churches in Egypt.

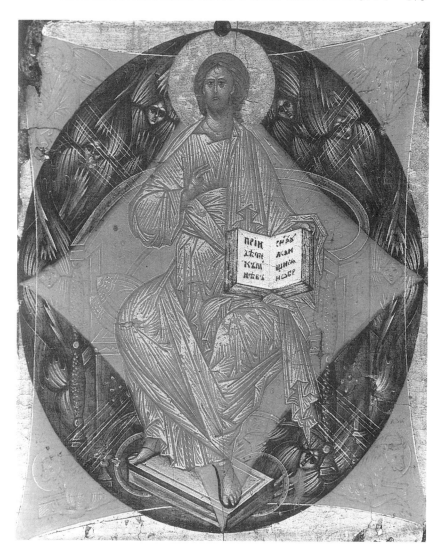

Figure 47. Christ Pantocrator. Andrei Rublyov, 15th century. Tretyakov Gallery, Moscow. The apocalyptic symbols of the four Evangelists, together with angelic powers and radiating light, surround Christ with cosmic attributes.

One of these is preserved in the Coptic Museum in Cairo and the iconography is likely to come from a lost Alexandrian source.[4]

These frescoes are identified by scholars as depicting the Ascension of Christ. This may be incorrect and it is more likely that this is the prototype for the later Pantocrator images. It is easier to see this if we count the painting as two separate scenes: one of Christ Almighty and another, juxtaposed below but not otherwise specially related, of the Mother of God with the Apostles. The two scenes normally exist in their own right in Byzantine art and this is suggested here by the horizontal straight band that separates them, just as the different zones of iconography are separated elsewhere in later Russian and Greek churches. The point is confirmed by a little-known image, dating from the fifth century, that can be seen in St Antony's Monastery remotely situated in the Egyptian Desert (Fig. 48). Here are the principal elements that constitute the Pantocrator icons that were painted in Russia from the end of the fourteenth century. It does not seem to have been known in the Byzantine world.

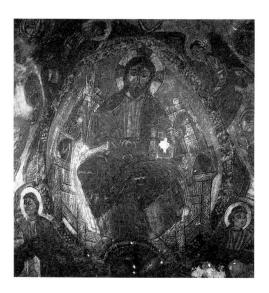

Figure 48. Christ Pantocrator. 5th century. St Antony's Monastery, Egypt.

If we therefore take the upper part as an image in its own right we at once see how close it is to the Pantocrator images of a

thousand years later. But there seems to have been no elaboration in Byzantine art and, as we have pointed out, its final form is a development of Russian art in the fifteenth century.

We do not know which of the existing images of the Russian type is the oldest; though a miniature version, tentatively ascribed to Andrei Rublyov with a suggested date of 1410–15, may be one of the prototypes. An example by his contemporary Theophanes the Greek has also been suggested.[5] In any case we are once again confronted with an important new influence in the development of early-fifteenth-century Russian art. If there was a literary tradition, it has not come to light. So the icon would seem to be the product of an ancient, esoterically preserved spiritual vision granted, perhaps, to Theophanes, or to St Sergius of Radonejh or to Andrei Rublyov from whom it passed, through the Hesychast circles with which these men are associated, into the iconographical canon of medieval Russian art.

Analysing the structure of the fifteenth-century Pantocrator icon, we find that it is made up of different geometric and figural elements, each superimposed on the other. The basis is a square with convex sides in the corners of which are the symbols of the four Evangelists (the four living creatures). Overlaying this is an oval containing the cherubim and inside that is a diamond. Next comes the throne and winged footstool, and finally the seated figure of Christ in Judgement emitting rays of light. (See Figs. 49–56.)

The fifth-century image only lacks the diamond and the square and the angels are rendered outside the mandorla rather than in it. The faces representing sun and moon are absent in the later icons.

The presence in the icons of both the fifth century and the fifteenth century of the angels, the throne and the seraphim, together with the cosmic powers suggested by circles, or light rays, suggest elements of the Hierarchy of Dionysius. Can it be suggested, therefore, that the Divine Ray is the element which, together with those features drawn from Ezekiel and from Revelation, completes the meaning to the imagery of Christ Pantocrator?

Below the Deesis row are the Royal Doors, so called because the King of Glory, in the form of the sacraments, passes through them. On the doors are the four Evangelists surmounted by the Annunciation. The doors are the gateway into the divine world, symbolised by the sanctuary before which the iconostasis is situated. And it is an energy of the divine world, personified as Man, that the archangel announces to Mary and which the Evangelists announce to humanity.

Figure 49 Figure 50

Figure 51 Figure 52

Figures 49–56. Breakdown of the constituent elements which, combined together, make up the image of Christ Pantocrator (see Fig. 47).

Figure 53

Figure 54

Figure 55

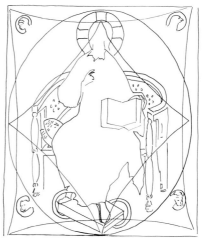

Figure 56

On either side of the Royal Doors are icons commemorating the saint or festival to which the church is dedicated and other subjects associated with local tradition.

The fully developed iconostastis is a truly great artistic tradition bequeathed to us from remote antiquity and available to us through the Russian Church. Its achievement is to unite, in a visual form comprehensible at all levels, the divine world and the human. It places us on the threshold of the mysteries within ourselves. It is a visual recitation of all reality and, like the *legomena* and *deiknymena* of the ancient Mysteries, is capable of initiating us into the way of universal truth.

The symmetry and totality of the iconostasis, like the relationship of the tones of the spectrum to the white ray, is an example of what the ancients and early Christians considered to be a natural law operating everywhere in the universe. This law can be stated by the formula which says that the One contains the Many and it is expressed in ancient philosophy in the idea of Multiplicity being Unity or in the idea that the One contains the All.

All is One (Xenophanes).[6]

There is nought in the world without some participation in the One, the which in its all-embracing Unity contains beforehand all things, and all things conjointly, combining even opposites under the form of oneness (Dionysius the Areopagite).[7]

According to the doctrine of unity within multiplicity everything in the universe is related and, ultimately, even man is united with God.

At the human level the idea of the relatedness of everything is expressed in the principles of order, balance, harmony and rhythm, qualities which were identified as a basis for a right way of living at least as long ago as Plato and which were both the philosophical as well as the practical basis for Greek arts, music and architecture. On this universally accepted idea were also founded the arts of Egypt and other ancient civilisations.

During the nineteenth century, and until recently in the twentieth, it was generally considered that the origins of our culture lay in Greece and that it was the ancient Greeks who first discovered and employed science, art and philosophy. Before the sixth century BC human culture was considered to have been no more than primitive and rudimentary and it was supposed that men were the blind slaves of religion, ignorance and superstition. The argument that

the laws of harmony and proportion, that science and philosophy and other aspects of high culture were known to the Egyptians many thousands of years before the Greeks is, even today, not yet fully understood. This has been proved by Schwaller de Lubicz and there are clear indications that such knowledge belonged to a very much older and, to us, unknown civilisation.[8]

In any case, the continuing existence of a never-ending flow of high culture founded on the primordial wisdom of the perennial philosophy, the source of which is much older and further from us in time than we think, is radiantly present in Byzantine and early Russian icons. In just the same way it is also present in church architecture and liturgical music which, like all that is authentically sacred, were founded on the same ancient principles. For early Christian artists, number and proportion were understood as reflections of cosmic order. Artists were thus more interested in the study of heavenly laws than in the three-dimensional world and nature. This is why icons, like all the arts of ancient traditions, could not be naturalistic. The function of art was to convey divine reality and spiritual truth, which were considered to be attributes of higher realms in the universe than the earth where, at the human or natural level, truth is veiled. It set out to fulfil this function by conforming, as far as possible, to universal unity.

At the level of iconographical form this order is immediately apparent in what Alpatov has called 'axial symmetry'.[9] According to this principle, all icons tend to present images that have a vertical central axis either side of which, laid out in a balanced and equilibriated way, are the energies, colours and figures that constitute the subject illustrated. This form itself reflects that of the iconostasis where the horizontal rows of icons range either side of the central vertical axis that is made by the Royal Doors, the icon of Christ Pantocrator and the Virgin of the Sign.

What we are describing is not in itself unified order but rather its form or symbol that can be perceived with the senses. But there must also be an actual order, an inner unity, that we sense with our spiritual faculties. As we have said, this inner unity can only appear in the icon if it is first present in the artist, through the descent of spiritual powers. Only this gives us the true definition of the icon: it is an image of the reality which has not yet come to exist fully in our world but which exists in the worlds above us. The icon, helping the truth to descend to humanity, is an image of the incarnation.

19

Conclusion: Return to
the Perennial Philosophy

ACCORDING to the esoteric ideas at the heart of religious mysticism, everything we think, everything we feel and everything we believe are illusions. Mystical writings, such as the Philokalia, tell us that, despite the fact that we have a mind and faculties for sense perception, we neither know truth nor see reality. And, in the absence of reality (and not even knowing that it is absent), we permit ourselves to be satisfied with substitution and pretence. This is especially true of what we believe ourselves to be. We do not see it in ourselves but it is often obvious to others.

In our ordinary life we act outwardly with conviction and self-assurance that are not justified by what we inwardly know and understand. Often we defend our beliefs with great passion and even, sometimes, with violence. But it is not the truth that we defend so energetically but our ego.

Our ego belongs to the same level of falsity and substitution as our beliefs. It is the all-powerful but false self that constantly upstages the true self which it pretends to be.

Traditional mysticism teaches, as it has always taught, that there is no true self other than God dwelling within us.

How can this be if God is at the summit of the creation of which we are an infinitesimal fragment?

The student of the origins of traditional philosophies and religions soon sees that they were concerned essentially with this mysterious question. Indeed the practice of true philosophy and real religion is, in itself, the means by which a person engages himself in such questions.

Gnosticism, mysticism, esotericism and various philosophical systems, provided always that they are authentic, only differ in method and terminology according to historical, geographical and cultural circumstances. In their essence, they do not differ; they are the same and, collectively, can thus rightly be called the Perennial Philosophy.

The origins of the teachings we nowadays call Christianity naturally belong to this category. And so there exists the concept of gnostic Christianity, Christian mysticism, esoteric Christianity and so on.

We have seen that these different 'secret Christianities' existed since the beginning of our era and that they conform to the spirit of the Perennial Philosophy. Even so, the inner sense of these ways tends to be hidden from us, disguised behind the official identity with which they have been labelled by history. We too easily read about gnostic Christianity, for example, or the Desert Fathers, or the Christian Platonists of Alexandria without sensing the deep possibilities that these external names cover.

An investigation into these forms of early Christianity can be most rewarding to those who feel the need for faith and meaning beyond the social and moral conventions of external religion with its fixed forms, pre-packaged beliefs, and history of fanaticism and compromise. Such a person is a seeker of truth, whether he knows it or not. But the way to truth is a journey and, at the beginning, the path is a lonely one. People tell you that the way cannot be found, that it is wrong to seek it; they even say it does not exist.

Despite the fact that he feels himself alone and lost, the seeker, in a mysterious way, already knows what he seeks, even if he cannot define it. He is convinced of its existence and he can sense the difference between the counterfeit or the copy and the real thing. What he seeks (and which he already knows) is a knowledge not to be found in books and in histories. It is a taste already in us from birth, a memory retained from earliest childhood though gradually overlaid by layers of what we call our life. Book learning is perhaps the last of these layers and, though retained in the mind, it does not penetrate through these layers and so does not connect with the essential truth already present in us when we are born.

The return to the pre-existent truth is a journey through these many layers (including knowledge acquired from books) towards our essential being. Our true selves belong to Eternity and the celestial world from whence we came down into this material plane with its cycle of endless repetitions. But we do not know the way; we do not remember to listen for its call which, though

now very faint, still sounds.

For some this call can be heard in the icons made far away and by long forgotten people. The wonder is that its vibrations, captured in the forms and colours of their art, can still resonate with that pre-existent truth which exists buried within ourselves.

And from this resonance other notes can be sounded which go in a definite direction. Our search has led us into the thought, not only of medieval Christian religious culture and mysticism, but beyond, to the mysteries of Egypt and to Hellenistic philosophy. We have seen that, for a thousand years, from the fourth to the fourteenth century, civilisation was centred on Constantinople and in the Byzantine world where mystical Christianity flourished and where the monasteries were the heart of the religious culture. At the same time, the lamp of classical learning was not extinguished. It was not even remotely dimmed; Byzantium was the heir to antiquity, and was the guardian of its intellectual and cultural achievements, albeit in Christian forms, until the rise of Europe in the fifteenth century.

It has also been suggested that Christianity, in its formative period, was nourished by another fountain of intellectual and spiritual grandeur. As has been indicated, the great knowledge of ancient Egypt had survived from remote times and was still preserved in Alexandria at the beginning of the Christian era. Schwaller de Lubicz demonstrates this convincingly in his analysis of the Temple of Luxor where he shows that the secret wisdom was as much a real force when the building was finished in Hellenistic times as when it had been started three thousand years before.[1]

We have discussed the allegorical significance of the higher and the lower and, likewise, the meaning in the imagery of the inner and the outer. We have tried to see their significance as symbols in art. We have considered the idea of light and of illumination both as physical entities in the cosmos and as the symbols of an influence in the soul. These, together with the principle of unity within multiplicity, are visible references by which the spirituality of icons can be studied. Also we have tried to understand invisible references that are equally important, namely: silence and stillness, inner warfare, the inner shepherd or guardian of the mind, ceaseless prayer, and the sense of self. All these ideas together constitute an organon by which icons can be studied.

But it is not icons themselves that we study so much as their meaning. Icons exist to convey the highest cosmological, philosophical and theological ideas. They were brought into being and developed a thousand years ago and more in order

to provide insight into the esoteric traditions and scriptures from which grew what we call Christianity. Icons were designed to play the same role as the patristic literary tradition which provided mystical commentaries without which we would have no key to the enigmas of the Bible.

> When approaching scripture one should always pay the greatest attention to patristic and mystical commentaries; then it will be seen how the word-for-word meaning practically never suffices by itself and how apparent *naïvetés*, inconsistencies and contradictions resolve themselves in dimensions of profundity for which one must possess the key. The literal meaning is frequently a cryptic language that more often veils than reveals and that is only meant to furnish clues to truths of a cosmological, metaphysical and mystical order.[2]

I have tried to show, both through historical theory and through indicating the existence, even today, of mysticism as practice, that the painting of icons is founded in this tradition.

This is why it is necessary, in studying icons, to seek out the older examples. Up until the sixteenth century icon painters in remote areas, even if they were ignorant of the tradition they perpetuated, could still be true to its principles. The skills and techniques and, above all, the style of European painting, which dazzles the eye and flatters the beholder or, more accurately, the owner, were founded on quite another philosophical outlook which contradicted the religious basis of Orthodox art. It was a cultural and historical inevitability that icon painters would compromise with western influences. But, though the art of icon could not survive, the perennial ideas on which it is founded are indestructible.

NOTES

FOREWORD

1. Leonid Ouspensky and V. Lossky, *The Meaning of Icons* (Olten, 1952), (from here on referred to as MOI). In this context other works the reader is advised to consult are: L. Ouspensky, *The Theology of the Icon* (St Vladimir's Seminary Press, 1987); Meyendorff, *The Orthodox Church* (SVS, 1981); *Byzantine Theology* (Mowbrays, 1975); and Timothy Ware, *The Orthodox Church* (Penguin Books, 1964).

CHAPTER 1

1. MOI, p. 14.
2. Sir Edwin Arnold, *The Song Celestial (Baghavad Gita)* (London, 1961), p. 9.
3. Plato, *The Republic*, 514A–516C.
4. See note 24, Ch 3.

CHAPTER 2

1. 'Rudiments of the Perennial Philosophy may be found among the traditional lore of primitive peoples in every region of the world, and in its fully developed form it has a place in every one of the world's higher religions' (Aldous Huxley, *The Perennial Philosophy* (London, 1946)).
2. Coomaraswamy's writings are frequently quoted in, for example, *Studies in Comparative Religion*, the quarterly published by Perennial Books Ltd, and *Parabola*, the quarterly magazine published in New York. See also *Coomaraswamy*, ed. Roger Lipsey (3 vols, Princeton, 1977).
3. Coomaraswamy, *The Bugbear of Literacy* (Perennial Books, 1979).
4. Ibid., p. 59.
5. Ibid., p. 60.
6. Coomaraswamy, quoted in *Parabola* (1987).
7. R. A. Schwaller de Lubicz, *Esotericism and Symbol* (New York, 1985), p. 11.
8. Ibid.
9. Jacob Needleman (ed.), *The Sword of Gnosis* (Baltimore, 1974), p. 9.
10. P. D. Ouspensky, *A New Model of the Universe* (London, 1931), pp. 22–32.
11. I. Schwaller de Lubicz, *The Opening of the Way* (New York, 1981), p. 4.
12. Ibid.

CHAPTER 3

1. Hans Jonas, *The Gnostic Religion* (Boston, 1985), p. 25.
2. Ibid.
3. Meyendorff, *Christ in Eastern Christian Thought* (SVS, 1973), p. 110. See also G. Dix,
 The Shape of the Liturgy (London, 1947), pp. 304 ff.
4. For two excellent books see Peter Gorman, *Pythagoras: A Life* (RKP, 1979); and Ward
 Rutherford, *Pythagoras: Lover of Wisdom* (Aquarian Press, 1984). These, together with
 the works of G. R. S. Mead, have provided the basis of my study of Pythagoras.
5. Gorman, op. cit., p. 27. The italics are mine.
6. E. Hennecke, *New Testament Apocrypha* (London, 1963), p. 383.
7. I. V. Gysev: 'Nekotoriye Prieme Postroyenya Kompositse v Drevnyerusskoi Xhiv-
 opisi, XI–XVII Vyekov', in *Drevnyie Russkoye Iskusstvo* (Moscow, 1968), pp. 127–39.
 See also K. Onasch, *Icons* (London, 1967), pp. 31–5. See also E. Sendler, *L'Icone, Image
 de l'invisible* (Paris, 1981), Chs. 6 and 7.
8. Gorman, op. cit., p. 80.
9. Ibid., p. 145.
10. Jocelyn Goodwin, *Mystery Religions* (London, 1981), p. 37.
11. S. Angus, *The Mystery Religions and Christianity* (New York, 1966), p. 46.
12. Ibid. The italics are mine.
13. Ibid., p. 49.
14. Ibid., p. 48.
15. Ibid., p. 48.
16. Ibid., p. 49.
17. Andrew Louth, *Christian Mystical Tradition* (OUP, 1981), p. 18.
18. Philo, *Mut.* 7,10 (quoted by Louth, op. cit., p. 20).
19. Louth, p. 21.
20. Ibid., p. 22.
21. M. Nicoll, *The New Man* (Vincent Stuart, London, 1953).
22. I have been influenced here by Mead's wonderful imaginary picture of Alexandria 'A
 bird's-eye view of the city' in *Fragments of a Faith Forgotten* (London, 1900), p. 96 ff.
23. See p. 10.
24. George Lewis, *The Philokalia of Origen* (Edinburgh, 1911). From here on this work is
 referred to as Ph.O.
25. Charles Biggs, *The Christian Platonists of Alexandria* (Oxford, 1913), p. 86.
26. Ph.O. p. 1
27. Ibid.
28. Ph.O. p. 12.
29. Ph.O. p. 8.
30. Ph.O. p. 17.
31. Ph.O. p. 18. My italics.

CHAPTER 4

1. H. P. Gerhard, *The World of Icons* (London, 1971), p. 18. See also Jacques Lacarrière,
 The Gnostics (Peter Owen, 1977), p. 77, 'St Ireneaus tells us that one of Carpocrates'
 disciples, prettily named Marcellina, came to Rome to spread his teaching there
 "with painted icons, illuminated with gold, representing Jesus, Pythagoras, Plato and
 Aristotle".'
2. *Enneads* (see note 1, Ch. 6), p. 408.

3. Lucie Lamy, *Egyptian Mysteries* (London, 1981), p. 12.
4. Lacarrière, *Les Gnostiques* (Paris 1973).
5. Apocryphon of St John, *Nag Hammadi Library* (New York, 1977; from here on referred to as NHL), p. 114.
6. Lacarrière, op.cit., p. 11.
7. C.G. Jung, *Psychology and Alchemy* (New York, 1953), p. 35. Quoted by Geddes McGregor, in *Gnosis, a Renaissance in Christian Thought* (Illinois, 1979).
8. McGregor, op. cit., p. 55.
9. Lacarrière, op. cit., p. 60.
10. Jonas, op. cit., p. 35. My italics.
11. G. R. S. Mead, *Fragments of a Faith Forgotten* (London, 1900), p. 175.
12. Henri Corbin 'Eyes of Flesh and Eyes of Fire' in *Material for Thought* (San Francisco, 1980), pp. 7–8.
13. Quoted by Mead, op. cit., p. 307.
14. Ibid.
15. Book of Thomas the Contender, NHL, p. 189.
16. Gospel of Truth, NHL, p. 43.
17. Teaching of Sylvanus, NHL, p. 350.
18. See Wisse's introduction to The Teachings of Sylvanus, NHL, p. 346.
19. Charles Norris Cochrane, *Christianity and Classical Culture* (New York, 1957), p. 153.
20. Quoted from two translations: Mead, op. cit., pp. 69–71; *Philo of Alexandria*, translated David Winston (London, 1981), p. 46.
21. Mead, op. cit., p. 84.
22. Quoted from Hippolytus by Elaine Pagels, *The Gnostic Gospels* (New York, 1979), p. xix.

CHAPTER 5

1. Kadloubovsky and Palmer, *Writings from the Philokalia on Prayer of the Heart* (referred to below as PH) (London, 1961); *Early Fathers from the Philokalia* (referred to below as EFP) (London, 1964).
2. Palmer, Sherrard and Ware, *The Philokalia the Complete Text* (3 vols, London, 1979, 1981, 1984).
3. PH, p. 5.
4. PH, p. 13.
5. Nicephorus the Solitary (fourteenth century), PH, p. 22.
6. Ibid., p. 27.
7. See e.g. Maximus the Confessor, EFP, pp. 319, 372, 374.
8. EFP, p. 193.
9. EFP, p. 194.
10. Ibid.
11. EFP, p. 389 ff.
12. EFP, p. 216.
13. EFP, p. 227.
14. EFP, p. 211.
15. EFP, p. 226.
16. EFP, p. 86.
17. EFP, p. 169.
18. EFP, p. 197.
19. EFP, p. 215.
20. EFP, p. 237.

21. EFP, p. 263.
22. PH, p. 77.
23. PH, p. 55.
24. Ibid.
25. EFP, p. 109.
26. EFP, p. 222.
27. EFP, p. 101.
28. PH, p. 75.
29. PH, p. 81.
30. EFP, p. 22.
31. PH, p. 301.
32. EFP, p. 157.
33. PH, p. 301.
34. PH, p. 31.
35. PH, p. 32.
36. PH, p. 157.
37. PH, p. 194.
38. PH, p. 285.
39. EFP, p. 90
40. EFP, p. 206.
41. EFP, p. 208.
42. EFP, p. 353.
43. EFP, p. 357.
44. EFP, p. 371.
45. EFP, p. 396.
46. EFP, p. 402.
47. PH, p. 221.
48. PH, p. 266.
49. PH, p. 386.
50. For a full account of the different passions, see St Gregory of Sinai in PH, p. 51.
51. EFP, p. 209.
52. EFP, p. 367.
54. EFP, p. 390.
55. PH, p. 338.
56. PH, p. 253.
57. EFP, p. 221.
58. EFP, p. 379.
59. EFP, p. 181.
60. EFP, p. 136.
61. EFP, p. 257.
62. PH, p. 49.
63. PH, p. 299.
64. PH, p. 303.
65. PH, p. 302.
66. EFP, p. 145.
67. EFP, p. 371.
68. PH, p. 133.
69. Ibid.
70. EFP, p. 356.
71. EFP, p. 403.
72. EFP, p. 409.

73. PH, p. 220.
74. EFP, p. 405.
75. EFP, p. 402; St Gregory is quoting St Paul I Cor. IV, 19.
76. EFP, p. 276.
77. EFP, p. 101.
78. EFP, p. 88.
79. EFP, p. 406.
80. EFP, p. 276.
81. EFP, p. 147.
82. PH, p. 77.
83. PH, p. 32
84. EFP, p. 212.
85. EFP, p. 27.
86. EFP, p. 212.
87. EFP, p. 160.
88. EFP, p. 207.

CHAPTER 6

1. Plotinus, *The Enneads*, transl. MacKenna (London, 1969); referred to from here on as Enneads.
2. Porphiry, *On the Life of Plotinus*, included in Enneads, p. 7.
3. Enneads, p. 206.
4. Ibid., p. 97.
5. Ibid., p. 76.
6. Ibid., p. 77.
7. Ibid., p. 59.
8. Ibid., p. 63.
9. Enneads.
10. Ibid., p. 63.
11. Enneads, p. 47.
12. Ibid., p. 133.
13. Ibid., p. 269.
14. Ibid., p. 97.
15. Enneads.
16. Enneads.
17. Enneads, 'Explanatory Matter', p. xxv.
18. Enneads, p. 116.
19. Enneads.
20. Ibid., p. 116.
21. Ibid., p. 96.
22. Ibid., p. 96.

CHAPTER 7

1. EFP, pp. 286–384.
2. Dionysius the Areopagite, *Mystical Theology and the Celestial Hierarchies* (Shrine of Wisdom, Godalming, 1965), p. 12. From here on this work is referred to as MTCH.
3. MTCH, p. 24.
4. MTCH, p. 23ff.
5. MTCH, p. 65.

6. MTCH, p. 55.
7. Ibid.
8. MTCH, p. 8.
9. MTCH, p. 44.
10. MTCH, p. 56.

CHAPTER 8

1. Enneads, p. 427.
2. Ibid., p. 63.
3. Pliny the Elder, the Roman historian. He was interested in the contemporary revival of Pythagorean ideas. He wrote the *Naturalis Historia* which includes a section on painting.
4. J. Berger, *L'Oeil et l'Eternité* (Paris, 1977).
5. See M. Buber, *I and Thou* (ET, 1958).
6. 'The Mummy Portrait: An Interpretation', *Apollo* magazine, (February 1964).
7. G.R.S. Mead, *Fragments of a Faith Forgotten* (London, 1900), p. 85.

CHAPTER 9

1. Kurt Weitzmann, *The Monastery of St Catherine at Mount Sinai, The Icons*, Vol. I (Princeton, 1976), p. 13.
2. Enneads, p. 106.
3. EFP, p. 109.

CHAPTER 10

1. Weitzmann, op. cit., p. 18.
2. Enneads, p. 86.
3. Dionysius the Areopagite, *The Divine Names* (London, 1940), p. 95 ff.

CHAPTER 11

1. See D.V. Ainilov, *The Hellenistic Origins of Byzantine Art* (New Brunswick, 1961), p. 46 ff.
2. Giorgio di Santillana and Hertha von Dechend, *Hamlet's Mill, An Essay Investigating the Origins of Human Knowledge and its Transmission through Myth* (Boston, 1977), p. 62.
3. Ibid., p. 64.
4. Ainilov, op. cit., p. 36.

CHAPTER 12

1. F. Van der Meer, *Early Christian Art* (London, 1967), p. 103.
2. For historical surveys of this subject, see E. Kitzinger, 'The Cult of Images Before Iconoclasm' in *Dumbarton Oaks Bulletin*, No. 8 (Cambridge, Mass., 1954); and *Byzantine Art in the Making* (London, 1977).
3. Van der Meer, op. cit., p. 104.
4. See André Grabar, *The Beginnings of Christian Art 200–395* (London, 1966), p. 59ff.
5. Ibid.
6. Santillana and Dechend, *Hamlet's Mill*, pp. 244, 268, 341.

7. O. Zonova, *Khudozhestvennie Sokrovishcha Moscovskovo Kremlya*, (Moscow, 1963), Pl. 48.

CHAPTER 13

1. M.V. Alpatov, *Frescoes of the Church of the Assumption at Volotovo Polye* (Moscow, 1977), p. 21.
2. Ibid.
3. Philip Sherrard, 'The Art of the Icon' in *Sacrament and Image*, ed. Allchin (London, 1967).
4. EFP, p. 21.
5. This essay on St George was first published in *Masterpieces of Byzantine and Russian Icon Painting* (Temple Gallery, 1974), pp. 8–10.
6. See Ch. 5.

CHAPTER 14

1. Gregory of Nyssa, *The Life of Moses*, ed. Malherbe and Fergusson (New York, 1978), p. 59.
2. EFP, p. 243.
3. Gregory of Nyssa, op. cit., pp. 91–4.
4. Anna Kartsonis, *Anastasis: The Making of an Image* (Princeton, 1986), p. 11 ff.
5. Hennecke, *New Testament Apocrypha*, p. 474.

CHAPTER 15

1. PH, p. 181.
2. Cf. St Isaac of Syria (sixth cent.): 'A monk should put himself before God . . . and in the stillness of thoughts discern what goes out and what comes in.'
3. Cf. Nicoll: 'In the Old Testament the passage of the children of Israel from Egypt is used as a "type" or image. St Paul says: "These things happened to them for types" (I Cor. X, 11). It represents the passage of Man from a literal, sensual understanding to psychological or spiritual understanding of his meaning. It is said in Isaiah (XXXI, 3): Egypt is flesh not spirit. "The Egyptians are men and not God; their horses are flesh, and not spirit"', *Psychological Commentaries*, (London, 1957), Vol. 3, p. 933.
4. EFP, p. 235.
5. Cf. Philotheus of Sinai (date unknown) '(The way) leads to the Kingdom – both the Kingdom within us and that of the future,' PH, p. 324.
6. 'In psychological language, clothes, coverings, garments, denote what the *psychological* man wears – that is what truth he follows,'
 M. Nicoll, *The Mark* (London, 1954), p. 5.
7. The sixth-century gospel book in the Cathedral treasury of Rossano, Italy.
8. K. Onasch, *Icons* (London, 1963), p. 381.

CHAPTER 16

1. From the Italian '*mandorla*' = almond.
2. S. Runciman, *The Great Church in Captivity* (Cambridge, 1968), p. 138.
3. Ravenna.
4. MOI, pp. 210–12.
5. Runciman, op. cit., pp. 138–57.

6. Ibid., p. 148.
7. Ibid.
8. Enneads, p. 96.
9. Ibid.

CHAPTER 17

1. Hennecke, *New Testament Apocrypha*, pp. 374–88, 410–13.
2. Underwood, op. cit., Vols II and III.
3. Runciman, *The Great Church in Captivity*, pp. 140–54.
4. Hennecke, p. 377.
5. Ibid., p. 380.
6. Underwood, Vol. I, p. 75.
7. *Apocryphal Gospels, Acts and Revelations*, ed. Walker (Edinburgh, 1870), pp. 504–14.
8. E. Mascal in *A Dictionary of Christian Theology*, ed. Richardson (London, 1969).
9. Encyclopaedia Britannica, 11th ed., p. 787.
10. MOI, p. 215. For a comprehensive list of references see *The Oxford Dictionary of the Christian Church*, ed. Cross (Oxford, 1958), p. 98.
11. Dionysius the Areopagite, *The Divine Names and the Mystical Theology*, ed. Rolt (London, 1940), p. 84.
12. MOI, p. 215.

CHAPTER 18

1. MOI, pp. 59–64.
2. M.A. Ilyin, *Zagorsk Trinity-Sergius Monastery* (Moscow, 1967), p. 26.
3. MOI, p. 63.
4. From the Italian '*mandorla*' = almond.
5. K. Wessel, *Koptische Kunst* (Recklinghausen, 1963), Pl. VII.
6. 'Russian Pictures, Works of Art and Icons', Sotheby's Catalogue (London, Dec. 1989), lot no. 625, p. 222
7. *A Treasury of Traditional Wisdom*, ed. Perry (London, 1971).
8. Ibid.
9. The best introduction to the works of Schwaller de Lubicz is by R.A. West, *The Serpent in the Sky* (New York, 1979).
10. M.A. Alpatov, *Early Russian Icon Painting* (Moscow, 1978), p. 53.

CHAPTER 19

1. R.A. Schwaller de Lubicz, *The Temple within Man* (1977).
2. F. Schuon in J. Needleman (ed.), *The Sword of Gnosis* (Baltimore, 1974), p. 354.

Index